R. H. Fuchs
is Director of the Haags Gemeentemuseum
in The Hague. He is a critic, art historian and exhibition
organizer, and the author of *Richard Long*
(Thames and Hudson, 1986).

WORLD OF ART

This famous series
provides the widest available
range of illustrated books on art in all its aspects.
If you would like to receive a complete list
of titles in print please write to:
THAMES AND HUDSON
30 Bloomsbury Street, London WC1B 3QP
In the United States please write to:
THAMES AND HUDSON INC.
500 Fifth Avenue, New York, New York 10110

Printed in Singapore

Dutch Painting

R. H. FUCHS

with 197 illustrations, 20 in colour

THAMES AND HUDSON

© 1978 Thames and Hudson Ltd, London
Reprinted 1994

ISBN 0–500–20167–6

Printed and bound in Singapore by C.S. Graphics

Contents

Acknowledgments

This book reflects the knowledge accumulated by many. The bibliographical notes to the different chapters list the books I have consulted most often or with most advantage. But friends have also been helpful, sometimes without knowing it, whenever I engaged them in conversation on a particular topic. I am also grateful to my former colleagues on the staff of the Institute of Art History at the University of Leiden, of which I was a member when I started on this book; and to the staff of the Municipal Van Abbemuseum in Eindhoven, where I am working now that the book is finally finished. A special tribute is appropriate to my unfailingly patient editors. My greatest debt is to my late teacher Professor H. van de Waal, of Leiden; he introduced me to ways of thinking and of examining problems. To his memory I respectfully dedicate this book.

R. H. F.

Introductory note

The Dutch state has existed only since the late sixteenth century, when it emerged from a war of liberation waged by the seven northern provinces of the Spanish Netherlands. This book deals with the painting produced in these provinces both before and after their independence, from the fifteenth century onwards. The only painters active in the southern Netherlands who appear here are the fathers of all Netherlandish realism – the visual exploration of reality – Jan van Eyck and Rogier van der Weyden.

Invention and narrative style

The fifteenth and sixteenth centuries

The majority of the Netherlandish paintings produced in the early fifteenth century were still devotional in character. They showed biblical figures or saints, grouped together in a non-narrative group – even when the subject itself could have led to a more dynamic composition. In later ages the subject of the Deposition, for instance, was handled in highly dramatic ways; the structure of the subject, the pale, dead body of Christ carefully brought down and received amid a group of mourners, is, after all, visually very powerful. Yet the most famous Early Netherlandish representation of the subject, painted by Rogier van der Weyden (1399–1464) around 1435 – which I take here as an example of a general mode of representation – exploits few of the many compositional possibilities offered by the subject. The scene is not situated in its proper location, the Golgotha landscape, but is set in a shallow box with only a few objects scattered on the floor to indicate the setting, and a group of mourners which acts, one might say, as an emotional background to Christ's dead body and the swooning Mary held by St John. In its suppression of the actual course of events this painting is typical of its time. This is not a sign of primitivism: certain realistic details, such as the weeping woman on the left, make it clear that Rogier was a very sophisticated artist. But the early fifteenth century was dominated by a conception of painting which led to very serene, richly adorned paintings which did not *narrate* the story but which presented a biblical event in a summarized form. In relation to the biblical text to which this picture refers, one could almost call Rogier's *Deposition* an abstracted image. The relation is a symbolic one. The main characters are brought together within a frame, and they then narrate the story merely by implication. The audience was able to decode the painting because it knew both the story and its conventionalized earlier representations.

 In the course of the fifteenth century, however, this basically medieval conception of painting slowly began to change. The first signs came from Italian art and, maybe equally importantly, art theory. In 1435 the Florentine humanist Leon Battista Alberti published a book on painting which was soon widely circulated. One of the central issues in this treatise is the notion

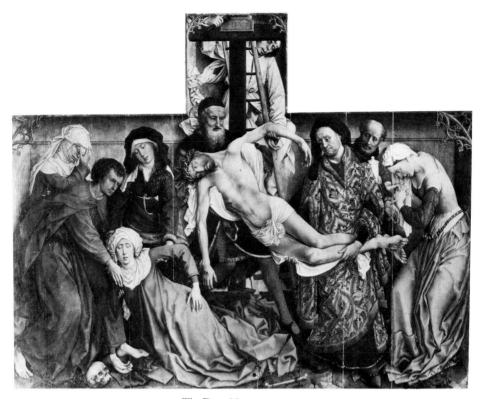

1 VAN DER WEYDEN *The Deposition c.* 1435

of *historia*. By this, Alberti meant a story that should be presented as a course of events. In painting this is, of course, extremely difficult. Alberti must have been well aware of the problem; what he advocated was a narrative style in which the story was presented through the *actions* and *reactions* of the characters – who were then not symbols but actors on an imaginary stage. To fulfil those demands, painting needed a whole new set of techniques, described and defined in Alberti's book.

At first the 'stage' had to be constructed: an illusionistic space in which the 'actors' could really move. The first chapter of the book quite logically deals with the construction of space through the system of perspective. After that it goes on to discuss the several postures and gestures that could be employed, and their significance. (For this last aspect he relied heavily on what classical authors like Cicero and Quintilian had written on rhetoric.) This theoretical conception of the narrative image was not proposed for its own sake. It was

proposed because pictures had now to fulfil a very precise function: they had (like a public speech) to instruct, to move and to please an audience. They had to instruct through the clarity with which a story, as an *example*, was narrated; they had to move through the realistic and persuasive representation of emotional states within the picture; they had to please through the artistry and skill with which the picture was designed.

In Italy this theoretical framework could be defined because it reflected an artistic practice which was already well on the way to becoming a clear narrative style. It would take another seventy years or so before the new theoretical conception reached the Netherlands; yet in the late fifteenth century there are already signs of change. This change, however, did not come from a theoretical concept. More likely, it was the consequence of the gradual rise of visual precision and circumstantial anecdote in Netherlandish painting during the fifteenth century.

Practice in painting had been influenced, quite logically, by the way in which an artist would read, interpret and imagine a text, as well as (I assume) by a human desire for clear anecdotes instead of abstract, conceptual statements or symbols. This fondness for anecdote and circumstantial fantasy is reflected, for instance, in the history and character of theological commentary. Already in the early age of Christendom, writers (possibly influenced by the Jewish tradition of anecdotal commentary) had started to enlarge upon the sparse biblical text, more or less inventing narrative details in order to *explain* the Gospels by making them easier to grasp for a public with only its own life and surroundings to refer to. The magnificent *summa* of this tradition is the thirteenth-century *Golden Legend*, a highly popular compilation of religious stories and lives of saints told with a wealth of narrative detail.

In relation to image-making, however, even the language of the *Golden Legend* was very sparse and uninformative. Details which a painter desperately needs are lacking. A writer need only say, for example, that Christ was present at the Marriage at Cana and miraculously turned water into wine – but a painter must figure out how the characters were dressed, in what space the marriage might have taken place, what food they had at the banquet, what kind of cutlery was used, and so on. A painter, therefore, looked around in his own world for examples: and that is, roughly, how realism inevitably slipped into painting. When in about 1455, in Haarlem, Albert Ouwater (active 1450–80) painted *The Raising of Lazarus*, his own 2 experience became the raw material for his imagination. The description of Lazarus' grave, in John 11:38, is that 'it was a cave, and a stone lay upon it'. Now it is known that in Judaea people were buried in caves cut out of the rock; but Ouwater lived before archaeology and did not have that

information. He could not visualize the biblical detail. He interpreted the story, in this respect, within the framework of the burial habits of his own time, when people were buried in the church floor. He knew that the incident had taken place a long time ago, so for the church he just used the oldest architecture known to him, Late Romanesque. To dress the group of unbelieving Jews on the right, he used richly embroidered Oriental clothing and strangely formed hats, which he may have seen in Dutch ports. For Christ's Apostles on the left, he chose garments that had a certain austere, monastic look.

1 Comparing the picture to a static, formalized image like the Rogier van der Weyden, it is immediately apparent that Ouwater conceived his *Raising of Lazarus* as a real narrative. There is a convincing indication of actual space. The main scene is laid out in the choir of the church; behind that is a clearly lit ambulatory. Through a barred window in the choir-screen an audience watches. This spatial organization is far removed from the flat field on which a medieval image is usually projected; its complexity, in design as well as lighting, makes it look all the more real and complete. Evidently, Ouwater found some difficulty in organizing the figures and in defining their proper · role in the story. Still, considering the limited choice of possibilities at the time, the painting is quite successful. There are three groups placed around the subtly vivid, nude figure of Lazarus rising from his grave. Closest to him are the three figures of his sister Martha, Christ, and an Apostle, presumably Peter. They *act* the story, which is a demonstration of divine power. Behind Christ stand other disciples, together with Mary, Lazarus' other sister. They are very quiet, for they *know* and don't have to be convinced. Opposite them is an agitated group of Jews. They twist and turn, and two of them press their clothes to their noses, for, as the Bible says, 'by this time he stinketh: for he hath been dead four days'. The actual story is enacted through gestures, subtly varied among the three figures. Christ makes the sign of blessing: he raises Lazarus. Martha, kneeling in prayer, expresses deep devotion; and Peter makes a gesture of exposition ('now you see') towards the Jews.

The story is told entirely within a context of descriptive realism. No abstract symbols are introduced, not even a nimbus for Christ. But certain accents are employed. The central figure of Lazarus, for instance, is more brightly lit than the other figures; and he is framed by the central arch and the bright window of the ambulatory. Christ's hand raised in blessing is subtly emphasized by the only column catching light. Features like these make the painting a good example of Early Netherlandish realism, and of the problems a painter, working within a realist framework, had to cope with. For the abstract symbols, freely used by medieval artists, he had to find fitting equivalents.

2 ALBERT OUWATER
*The Raising of
Lazarus c.* 1455

Early Netherlandish artists like Ouwater came to a more or less convincing form of narrative realism, but without the theoretical understanding of perspective or of human movement recommended and described in humanist theory; nor did they hold a philosophical conception about history painting. They stuck to what they had discovered for themselves. Real innovation in structure is rare; what did increase, of course, was their immense skill in refined illusionism.

This skill was praised as far away as Italy, where many Early Netherlandish paintings were sold. In his *Book of Famous Men*, composed in 1455–56, the humanist Bartolommeo Fazio, employed at the Court of Naples, incorporated paragraphs on four contemporary painters, two of whom were Netherlandish: Rogier van der Weyden and Jan van Eyck, 'the leading painter of our time'. One painting by Van Eyck was apparently considered a *tour de force* of illusionism and praised accordingly. It showed women emerging from their bath, 'and of one of them he has shown only the face and breast but has then presented the hind part of her body in a

13

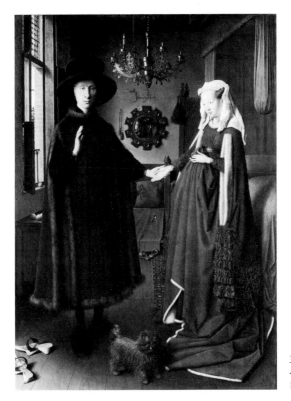

3 VAN EYCK *Giovanni Arnolfini and his Wife* 1434

mirror painted on the wall opposite'. Then there was 'a lantern in the bath chamber, just like one lit, and an old woman seemingly sweating, a puppy lapping up water, and also horses, minute figures of men, mountains, groves, hamlets, and castles carried out with such skill you would believe one was fifty miles distant from another'. Unfortunately the painting is now lost, but the mirror and other striking details in Jan van Eyck's bridal portrait of
3 *Giovanni Arnolfini and his Wife* (1434) may show what Fazio, and others, marvelled at.

Ouwater was the earliest artist now known to us who carried the new painting, introduced by Jan van Eyck in Flanders, to the north. He may have been a pupil of Petrus Christus, who was himself the pupil of Van Eyck. *The*
2 *Raising of Lazarus* was painted in Haarlem around 1455, where Ouwater was presumably the teacher of the best-known and the best Dutch painter of the fifteenth century, Geertgen tot Sint Jans (1460/65–1490/95). One of
4 Geertgen's earlier paintings, *The Holy Kindred*, probably dating from around 1485, shows his dependence upon Ouwater quite clearly. The composition is

14

more complex, however, especially in the size of the figures. The differentiation of figure size was facilitated, of course, by the presence of children in the scene, but also because Geertgen was able to design a deeper space and to have figures, properly diminished in size, in the background. The architectural design, too, is more complex and daring; the nave of the church is not, as in Ouwater's picture, placed at right angles to the picture-plane. Instead, the placing is slightly oblique; on the left, through the columns, can be seen open doors; beyond that are houses and greenery. This makes Geertgen's composition less centralized, more lively and informal.

Geertgen was also, I believe, freer in the grouping of figures, in this painting at least, since the subject had no narrative content that could force him into certain arrangements. Taken, in fact, from the *Golden Legend*, the subject is one of those domestic, sentimental ensembles for which there is no real scriptural basis. Apocryphal sources relate that Anna, the mother of the Virgin Mary by Joachim the priest, had been married twice before, to a certain Cleophas and to a certain Salomas. So Mary had two half-sisters: Mary Cleophae, who married one Alpheus and became (legend has it) the mother of the apostles James the Lesser, Simon Zelotes and Judas Thaddeus; and Mary Salomae who married Zebedee and became the mother of James the Greater and John the Evangelist. Associated with this family is also John the Baptist's mother, Elizabeth, whom Luke calls Mary's 'cousin', and her husband Zacharias. Together with Joseph, Mary and Christ, that makes a group of nineteen persons. They are all represented – in a church, symbolizing the sacredness of the genealogical convention.

While Geertgen was free to arrange this group any way he wanted, provided the most important figures were in the foreground, he did face a quite different problem: how to identify someone who is outside a narrative – that is, not acting a particular part in a story by which he could be identified. The medieval artist could introduce abstract symbols and attributes as he wished; but Geertgen and his contemporaries had to find equivalents that would fit smoothly into a realistic context so as not to disrupt the logical coherence of that realism.

Certainly they could not do without heavy symbolic implications, in paintings that were still meant to adorn churches and other religious institutions, whether they were commissioned by the church itself or by private persons who wanted to secure their place in Paradise. The artist or the designer of a picture's iconographical programme (often an ecclesiastic) had, therefore, to adapt to theological and liturgical requirements; and the church wanted religious imagery to imply or to express moral notions as they could be related to biblical stories or figures. For instance, a painting representing Mary almost always contains several references to her virginity and purity: a

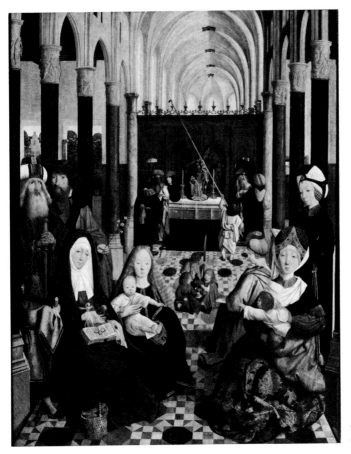

4 GEERTGEN *The Holy Kindred c.* 1485

ewer of water, a fire, strong light coming in through a window, or a vase of lilies. In Geertgen's *Holy Kindred*, Joseph, on the left, is holding a lily over Mary's head.

A strikingly subtle example of identification in *The Holy Kindred* is the group of three children playing. One of them is pouring water from a pilgrim's flask into the chalice held by another; the third is watching them, leaning on a small saw. They are: Judas Thaddaeus, identified by his usual attribute, the pilgrim's flask; John the Evangelist, with the chalice; and Simon, with the saw. The symbolic function of the architecture is another interesting example. The nave of the church, which has coloured columns with figurative capitals and small windows, is Romanesque in style; the choir, beyond the altar, is Gothic and brightly lit through high, narrow windows. This stylistic difference demonstrates the juxtaposition of the Old

Covenant and the New Covenant, the time after Christ's coming. In this context, which is an iconographic commonplace in Early Netherlandish art, Christ and Mary were considered the new Adam and Eve. To make that reference clear, the altar is decorated with scenes from the life of Adam and Eve: the Tree of the Knowledge of Good and Evil on the left, and the Expulsion from Paradise which is, of course, the exact opposite of the Coming of Christ – the subject celebrated (through the complex genealogy) in Geertgen's painting.

Visually, Early Netherlandish painting is very rich. Since it offers an analogy with the real world, this visual variety is an important function of realism: it shows the *fullness* of the real world. It is, however, very much a variety of details and not, as in later painting influenced by Italian art, a variety of action, movement, gesture and facial expression. The figures in the pictures by Ouwater and Geertgen look rather stiff. Their faces are much the same, and their gestures are not eloquent. Usually groups are closely knit together, and spatial intervals between figures are there mainly by implication. Take, for example, *The Madonna Surrounded by Four Female Saints*, done in the 1490s by an unnamed but important artist, who was called, after this picture, the Master of the Virgin among Virgins. A contemporary of Geertgen, he was active between 1475 and 1500 in Delft. The five main figures are awkwardly crowded together in an enclosure

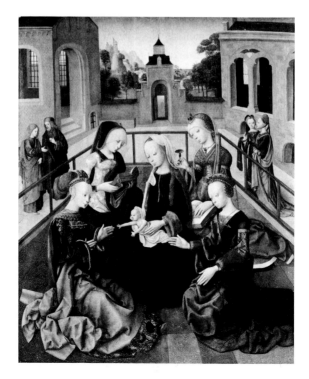

5 MASTER OF THE VIRGIN AMONG VIRGINS *The Madonna Surrounded by Four Female Saints* c. 1495

within a courtyard; they are set apart, again, by orthodox overlapping and by very strong contrast in colour: bright red, dark purple, green and blue. The real suggestion of space in the picture does not come from the figures, but from the surrounding architecture which provides a wide, deep stage. The same applies, more or less, to Geertgen's *Holy Kindred*. In one respect, however, the Virgin Master seems more advanced than Geertgen: notice how the movement and position of the hands seem to dramatize the space within the group of virgins.

4

Towards the very end of the fifteenth century, signs of a new approach to narrative style became stronger and stronger – yet they remained largely outside the orbit of Italian style. And if there was some knowledge of the new Italian theoretical concepts, it was not yet strong enough to allow painters to move away from their local manner.

I will quote two examples: *The Marriage at Cana*, an early painting by Jheronimus Bosch (1450–1516), active in 's Hertogenbosch; and *Joseph Expounding the Dreams of the Butler and the Baker*, by Jan Mostaert (*c.* 1475–1555), who was the leading painter in Haarlem after Geertgen's death.

6

7

To appreciate the change towards a more pronounced kind of narrative, compare Ouwater's *Raising of Lazarus* with Mostaert's *Joseph*. The gestures made by Ouwater's main characters (Christ, Lazarus, Peter, Martha) seem rather isolated; or, to put it another way, they are not really related in a dynamism of action and reaction. The narrative is built on a sum of gestures, each of them expressive in its own, private way. Ultimately this applies to all narrative art, but that does not exclude a relative difference, in this respect, between Ouwater and Mostaert. In Mostaert's small picture Joseph's left hand is raised in a conventional expository gesture; in his right hand he is holding the tankard signifying his position as a servant (Genesis 40). The location, Pharaoh's prison, is indicated by the two prisoners, put in the stocks in an alcove, as well as by the barred window. The content of the dreams is illustrated in balloons above the heads of the baker, in the middle, and the butler, on the right. Now the baker and the butler are, however awkwardly, *reacting* to Joseph's explanation. The butler is bending slightly forward: he is listening. The baker too is listening but, in a gesture of astonishment, presses his hand to his breast – for Joseph is telling him that he will be hanged. (Perhaps for that reason, he is dressed in black.) Similar characteristics occur in Bosch's painting, especially on the left, where one finds quite complex narrative groupings of people talking to each other. Noticeable too is the free distribution of figures in space – already quite remote from Ouwater or Geertgen.

2

The figure style itself is rather formalized. The faces of the three figures in Mostaert's picture, for instance, are all given in the three-quarter view so

6 BOSCH *The Marriage at Cana*

7 MOSTAERT *Joseph Expounding the Dreams of the Butler and the Baker*
c. 1495

characteristic of Early Netherlandish portraiture – from which context they might be adapted. They are not developed within a conscious conception of narrative; and a real understanding of the dynamics of human movement is still lacking. As long as Early Netherlandish painting was iconographically oriented towards devotional subjects, this had not been a relevant problem. But when awareness of narrative became stronger, artists may have felt inadequacies in their traditional native style. That, at least, is the impression conveyed by the rather bizarre twists and turns of some of the figures in Bosch's *Marriage at Cana*. Here one senses how the painter was trying to force a native style into new uses.

Bosch's evident difficulty in letting his 'actors' move freely makes it understandable that Italian examples were, finally, welcomed. So, at least, it appeared to the theorist and biographer Karel van Mander who, writing in Haarlem shortly after 1600, noted approvingly that the painter Jan van Scorel (1495–1562) was called 'the lantern-bearer and road-paver of the Arts in the Netherlands'. To the humanist writer, this could only mean that it was Scorel who, more than anyone else, had been responsible for the establishment of Italian humanist aesthetics as a powerful influence in northern painting; by combining his northern sense of acute observation with an Italian formal model, he founded a style which in art history is known as 'Romanism'. One picture explicitly mentioned by Van Mander (praising the fine proportions of the figures, the Raphaelesque grace of the women, and the wide and flowing landscape) is *The Baptism of Christ*, painted in Haarlem in 1528.

8

The picture is a superior example of the assimilation of the new Italian conception in Netherlandish painting. In it several motives, functionally quite distinct, are brought together, and they are brought together as they should be: within a clear, realistic space, and answering to aesthetic requirements developed in Renaissance art theory, such as grace and visual variety.

As far as realism is concerned, the picture seems quite convincing. Everybody moves around naturally; and with their size, the figures fit very well into the space. The same goes for the relationship between foreground and background. The transition, by way of the bending river, is smooth, giving a sense of continuous space. The mountains, with their differentiated lighting which produces many different shades of green, are beautiful and totally convincing. However, the background is purely background; it has to be there because realism requires a complete description of the location. The real action takes place among the foreground figures. There are three main groups: Christ and John the Baptist (functionally, the Holy Ghost, descending from Heaven as a white dove, belongs to this section too); the

8 SCOREL *The Baptism of Christ* 1528

two ladies on the left, gazing upwards into the sky; and the three almost nude bathers on the right. (The woman combing her hair, seen from the back just left of John, is a functional part of this third group, though compositionally she has been set apart.)

These three groups subtly reinforce each other on different levels. In its essence, the biblical story is told by the first group: John baptizing Christ with the Holy Ghost descending in a beam of golden light. But then, a story not only must be told, it should also be qualified and adorned with the proper emotions. Moreover, it should be presented in an artistically graceful manner. It should *teach*, *move* and *please* the audience.

Because he is the centre of the narrative, Christ's presence had to be emphasized, and so did the gesture of baptism made by John. In medieval art, not restricted by the laws of realism, Christ would have been identified by a golden nimbus. Also, he would have been larger than the other characters. In realism, based on coherent space and unified proportions, this of course was out of the question. To make Christ *appear* larger, Scorel moved him to the front; and to retain a nimbus of some kind he took care to let the beam of light, in which the Holy Ghost is descending, strike the tree-trunk directly

above Christ's head. Moreover Christ is set off as a major figure by the slightly stooping posture of the Baptist bending over him – a suggestion taken over by the curved tree-trunk. The momentous emotional significance of the scene is expressed mainly through Christ's own expression: his hands together in prayer, his eyes cast down in humble acceptance.

The descent of the Holy Ghost, the other highly important element in the biblical story, is a supernatural event and is bound to raise problems for the realist painter. Scorel chose to be very discreet: there is a small dove and a narrow beam of light. But the descent (as well as the invisible voice of the Lord, calling Christ his son) are strongly emphasized by the two women on the left: they look upwards and witness the event. One of the three bathers seems to look upwards, too. The other two are busy drying themselves.

The humanist writers on art theory had borrowed a term, 'invention', from classical rhetoric. There it referred to the choice of a fitting and usually anecdotal example by which the orator might make his point more forcefully. In early fifteenth-century Italian theory this meaning of the word was retained; as in classical rhetoric, it referred primarily to an artist's intellectual capacity and his knowledge of ancient history and literature. As all history painting should, by references implied in its subject, express a lofty moral, the artist had to be able to select a morally proper subject that would suit a painting's function. He should also take care that the rules of decorum were observed – that the picture should not contain elements that were improper within the context of the story, or impaired its dignity. The decorations in the ante-chamber to a royal audience-hall, for instance, should exalt the king's benevolence – to be contemplated with due respect by those subjects waiting to be admitted. Here a proper story would be Alexander's benevolence towards the wives of Darius – he did not have them executed, as was customary with direct relatives of defeated enemies. The selection of this story was called 'invention'.

During the sixteenth century, however, the term took on a different and somewhat metaphysical meaning. It began to refer to artistic virtuosity – more specifically to virtuosity in composing an historical narrative. But still the earlier meaning of 'invention' remained part of the new, expanded definition. That was important: as it implied a wide knowledge of literary sources, it seconded the painter's claim to be an intellectual like a poet – a *pictor doctus* or 'learned painter'. Like the poet he did not work with his hands as much as with his mind, as Michelangelo once remarked: *si pinge col cervello, non colla mano*. Invention, then, was conceived of as an act of imaginative intelligence: it would find its first expression in drawing; final execution in

painting was almost secondary, at least in terms of theory. (Quite logically, the first collections of drawings, as independent works of art, were brought together in the sixteenth century.)

What direction should invention take? It should go from Nature towards Art. These two concepts, virtually opposed, began to play an important part in the criticism and discussion of art; and they apparently influenced the judgment of artists as well. Realism as a system of pictorial representation had led artists to study Nature; realism worked by analogy to the real world; and it was the common knowledge of the world which enabled the public to see what was going on in a picture. But did Nature not impede the free articulation of Art? Was not the artist, following Nature, a slavish copyist instead of a free, imaginative agent? This juxtaposition too was part of the change in the meaning of invention.

The emphasis on invention as the expression of Art in the sixteenth century forced the painter towards originality in design and composition. Admittedly he was not completely free in letting his fancy go, for other conditions had to be taken into account; he had to observe decorum as well as the requirements of the story he was illustrating. Still, the history of composition and figure style during the sixteenth century is bizarre.

First consider an Early Netherlandish masterpiece like Geertgen's *The Bones of John the Baptist*, the right wing of a triptych painted between 1490 9 and 1495. The *Golden Legend* tells how the Emperor Julian the Apostate ordered the remains of the Baptist to be destroyed. Monks, however, managed to salvage one or two bones which they brought to a castle of the Knights of St John. Set in a mountainous landscape, Geertgen used the different levels as separate stages for different episodes. The main action, the burning of the bones, is presented in front; behind the open grave we see the monks. (This group includes some portraits of the Haarlem Knights of St John, identified by the Maltese Cross, who commissioned the altarpiece.) Behind them, two previous episodes are illustrated: the burial of the beheaded Baptist, and Queen Herodias hiding the Baptist's head in a cave.

The story is told in a marvellously economical and concise way. All action is functional within the context of the narrative; there is no fanciful digression for Art's sake. How different this picture is from later works like *John the Baptist Preaching* by the Utrecht painter Abraham Bloemaert 10 (1564–1651), painted in about 1600, shortly before Bloemaert turned to a more sober style; or *The Marriage of Peleus and Thetis* (1593) by Cornelis 11 Cornelisz. van Haarlem (1562–1638)! In both these paintings the central subject is almost hidden, to make room for complex groups of figures showing off the artist's power of invention. But the requirements of the story are served, too; and the laws of decorum are duly observed. In the

shadows among the trees in Bloemaert's painting, John the Baptist is actually preaching, just as Peleus and Thetis are sitting at the wedding-banquet within a circle of decorated trees. The real interest, from a visual point of view, has shifted to secondary figures, however, and that shift is justified by the story. Present at Peleus and Thetis' marriage were the Olympian Gods – whom, conveniently, decorum permitted to portray in the nude. John the Baptist preached to large congregations 'in the wilderness of Judaea' – which allowed for the utterly fantastic landscape. Both painters, then, interpreted the story to accommodate inventive Art, as opposed to Nature. Their paintings are Nature embellished, elevated and dramatized by Art. In doing so Bloemaert and Cornelis Cornelisz. associated themselves, consciously no doubt, with the International High Mannerism of which the theoretical doctrine was formulated for Holland by Van Mander, a friend of Cornelis Cornelisz. in Haarlem. Certain of his theoretical passages read almost as a description of Bloemaert's or Cornelisz.'s pictures:

Nature is beautiful in its variety. One may observe this when the earth displays its thousand colours in full bloom, in competition with the starry expanse of the sky. In many other things too an agreeable delightfulness can be discovered: at a table well spread with food and drink, people take pleasure in many and various ways. The figure-piece, too, so important, needs the figures to be varied as to position, movement, activity, design, character and expression. We mentioned the seven directions of movement;

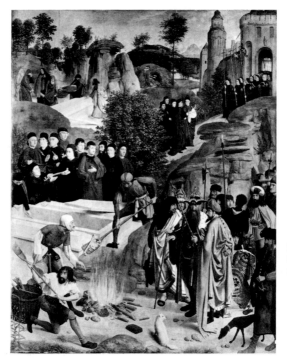

9 GEERTGEN *The Bones of John the Baptist* 1490–95

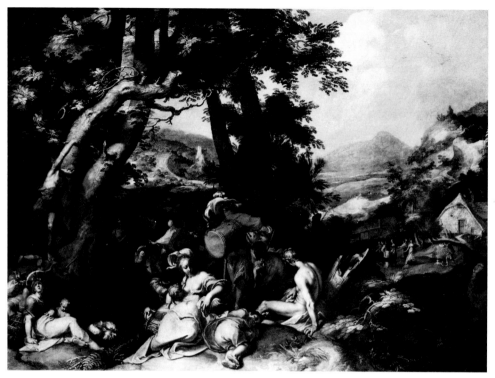

10 BLOEMAERT *John the Baptist Preaching c.* 1600

11 CORNELIS CORNELISZ. *The Marriage of Peleus and Thetis* 1593

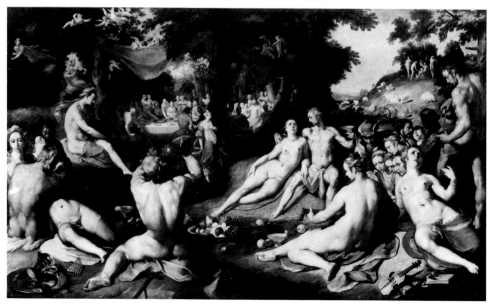

so some figures will have to be frontal, or taking a forward step, while others will show face and body in profile. Some will be seen from the back; some will sit or lie down or crawl or ascend or descend or stand up or kneel. If there is occasion, some figures will be in a position as if they were falling, or they will sneak furtively; some will look upward, or lean on something, or writhe with pain. It is necessary also to mix fully dressed figures with partly dressed and nude ones.

This is a quotation from the versified didactic preface to Van Mander's *Schilder-Boeck*, the book on painting on which he had been working for some time before publishing it in 1604. Already the design of this important book, the first full-scale art theory to appear in Holland, illustrates the aesthetic concerns and the theoretical reasoning of the period. It is in three parts which have a particular relation to each other. The first is the didactic preface, which deals systematically with theoretical issues such as design of figures, composition, landscape and colour. The second is a collection of biographies of individual artists from classical antiquity (based, by way of secondary sources, on the fragmentary information contained in Pliny's *Natural History*) and from the Italian Renaissance (based on Giorgio Vasari's *Lives of the Most Excellent Italian Architects, Painters and Sculptors*, 1550, which was Van Mander's direct model), and of Netherlandish and German painters from Jan van Eyck to Van Mander's contemporaries. The information for these northern biographies was collected by the author himself. Finally, the third part is concerned with the symbolic and moral interpretation of Ovid's *Metamorphoses*, and with the proper construction of allegory. The bulk of the book thus consists of biographies; they function as the exemplary Grand Tradition of Art on which theory is founded, while the theory, expounded in the didactic preface, aids the reader to pass qualitative judgment on the painters discussed in the lives. The third part, being concerned with humanistic subject matter, serves the intellectual ambitions of the 'learned painter'.

As a style, Mannerism was oriented towards Art. In consequence it was really a variation of High Renaissance style – of the work of Michelangelo and Raphael – which was widely considered the epitome of perfect Art. (In Dutch terms it is, of course, a direct development from the Romanism practised by Scorel and others, which was the northern variant of Italian High Renaissance style.) It was an extremely *style-conscious* style, in which artists sought to express their personality through invention. This is not to say that Mannerism was an artistic aberration, though there were some weird moments. Its great achievement was that it destroyed the last vestiges of medieval staticness in design and composition. Furthermore, the shift of interest to secondary aspects of a subject, in order to gain more freedom for

12 CONINXLOO *Landscape with Elijah c.* 1600

imaginative invention, eventually led to the complete autonomy of new pictorial categories like still-life, landscape and genre (the painting of scenes from everyday life). In fact, to us Bloemaert's *John the Baptist Preaching* is first 10 and foremost a great landscape. The biblical subject seems almost an alibi, in a period in which history painting was judged to be the supreme expression of pictorial art. This is even more apparent in the brilliantly Mannerist *Landscape with Elijah*, painted around 1600 by Gillis van Coninxloo 12 (1544–1607). Sometimes, too, the shift of interest would function as an intriguing moral pointer, as in most of the paintings by the Amsterdam artist Pieter Aertsen (1509–75). His *Christ in the House of Martha and Mary*, a 13 painting which in its spatial design certainly satisfies the love of virtuosity, provides a view through a kitchen into a sunlit courtyard. There Christ admonishes Martha that devotion to God should always take precedence over worldly pursuits (Luke 10:38–42). The latter are vividly portrayed in the kitchen, with an extremely sumptuous still-life of food, and genre-like details such as a man trying to seduce a young girl. The point of the picture was that contemplation of the dissolute kitchen scene, in relation to the biblical *exemplum* in the background, would remind people to lead a

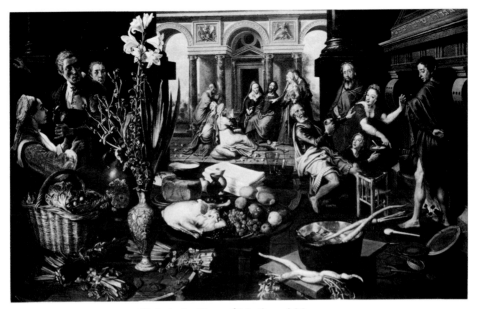

13 AERTSEN *Christ in the House of Martha and Mary*

virtuous life. Another key to this reading is very likely the lilies (symbolizing purity) that are so conspicuously visible, as an introduction almost, in the foreground. Yet the image of pleasure and indulgence remains, notwithstanding the several moralistic pointers – and one cannot but conclude that this was part of the picture's ambiguous content.

The history of Mannerism in the Netherlands combines powerful Italian influences with equally strong native traditions. The last phase of Early Netherlandish painting, in the first two or three decades of the sixteenth century, developed on its own a certain stylishness somewhat reminiscent of contemporary Italian Mannerism. For want of a better term, this style is sometimes called Late Gothic Mannerism. However, stylishness is only one aspect, and only a minor one, of Mannerism in Italy and elsewhere. Above, I suggested that Mannerism, by destroying medieval staticness, arrived at a much more *flexible* type of composition; and indeed, how extremely fluent is Bloemaert's picture compared to those by Ouwater, Geertgen or even Scorel. Geertgen's *Bones of John the Baptist* is largely dominated by vertical and horizontal directions; blocks of figures are firmly fixed and immobile in their place. The colours are similarly fixed; each colour is sharply contoured and restricted to its own area. Light tonalities are set off against dark ones, marking spatial contrasts, as in the group of the Emperor and his retinue. But

10, 2, 9
8

28

in Bloemaert's painting the landscape slopes in all directions, almost continually unsettling the eye as it goes through the picture's wide, fluent space; soft half-tones guarantee smooth transitions from one area to another.

This new flexibility clearly works in the interest of a more freely moving, more dramatic narrative – and this may well have been the major incentive behind Italian Mannerism. The same may be true of so-called Late Gothic Mannerism in the north – only there it worked out slightly differently. In terms of Early Netherlandish style, a painting like Jheronimus Bosch's *Mocking of Christ* is certainly curious. But the narrative is pointed and 14 dramatic. The drama is not enacted, though, by wildly moving figures as it would be in an Italian Mannerist painting – and could be, given the Italian tradition in figure design which was lacking in the north. Bosch had to work within the context of a native skill, that of meticulous portraiture. His narrative is built upon the juxtaposition of faces, and to make that juxtaposition more eloquent, he cuts out all further detail.

Another and even more curious aspect of Late Gothic Mannerism, not only on the level of form but on that of content, is the strange iconography for which Bosch is famous: scenes of human debauchery, images of Hell, vignettes of folly. These pictures, such as his exquisite *Ship of Fools*, show the 15 formal *bizarrerie* of which Gothic artists of this period were capable; in addition they testify to flights of imagination in interpreting their popular

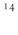

14 BOSCH *The Mocking of Christ*

lore – from which Bosch drew most of his subject matter – that are truly marvels of invention.

The Leiden painter Cornelis Engebrechtsz. (*c.* 1468–1533) fell back on another northern skill to dramatize his *Lamentation*, in about 1510: the rendering of surface texture and drapery. And like Bosch, though rather more diffusely, he too expressed the narrative by juxtaposition. The richly dressed group of mourners (broken by the posture of John the Evangelist holding and comforting the swooning Mary) provides an extremely strong contrast to the seemingly floating, emaciated figure of the dead Christ – making him look all the more sorrowful. More than fifty years later, in 1566, Maerten van Heemskerck (1498–1574), who was a rather pedestrian follower of Scorel, active in Haarlem, did the same subject, but now very much *all'italiana*. The structure is basically the same, however: the dead Christ, with rather Apollonian features, surrounded by mourners who now express their quiet sorrow through gesture and facial expression.

Invention primarily referred to composition: to the organization of all elements involved (figures, animals, trees, buildings) so as to express the

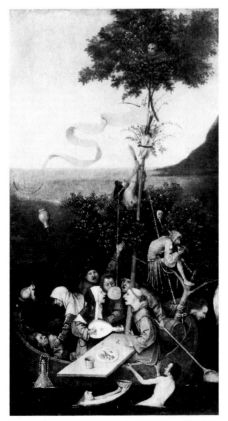

16 ENGEBRECHTSZ. *The Lamentation of Christ c.* 1510

15 BOSCH *The Ship of Fools*

narrative clearly but also with a satisfactory and pleasing variety. The most central element was, of course, the human figure. And as variety was the aesthetic concept underlying composition, so the concept of grace (*gratia*) functioned in relation to the design of the human figure – grace and well-balanced proportions.

Logically it was easier to design one figure according to Italian taste than it was to organize a complex composition with many figures – and it is in single figures (as well as in the borrowings of architectural details) that we encounter the first clear examples of direct Italian influence upon northern painting. It was the German, Albrecht Dürer (1471–1528), who, crossing the Alps in the early 1490s, was the first to fall under the spell of Italian art, and was able to adapt it to northern style. (Rogier van der Weyden, who was in Rome about 1450, came back as if nothing had happened.) Possibly the first Netherlandish painter to be influenced by Dürer was Jan Gossaert, known as Mabuse (1478–*c.* 1533). He was only slightly younger than the German

master, and, like him, was to travel extensively in Italy. He worked mainly in the southern Netherlands, but apparently crucial contacts with artists like Jan van Scorel and Lucas van Leyden made him an important link in the transmission of Italian style to the north. Like Dürer in some of his engravings, for instance the famous *Adam and Eve*, Gossaert often seemed to choose a subject which allowed him to make an essay in figure design. His *Venus and Amor* of 1521 is a fine example. The subtly mobile, gently curving figure of Venus, leading a somewhat chubby Amor by the hand, is an epitome of grace. Brilliant too is the spatial structure holding Venus and Amor; the beautiful congruency of the size of the figures and the dimensions of the space had never been achieved before in Northern painting.

It was the generation coming after Gossaert, and starting from his and Dürer's achievements, which seriously began to tackle the problems of large-scale, narrative figure-pieces. One representative of this generation, Jan van Scorel, has already been discussed; but more brilliant than Scorel was Cornelis Engebrechtsz.'s pupil Lucas van Leyden (*c.* 1490–1533). The great Dürer himself was much impressed by his work when they met in Antwerp in 1521 (Dürer noted in his diary: 'He is a small man but a good painter'). Van Mander put Scorel above Lucas; but then Scorel could be associated with Haarlem, Van Mander's home town which he tried to exalt

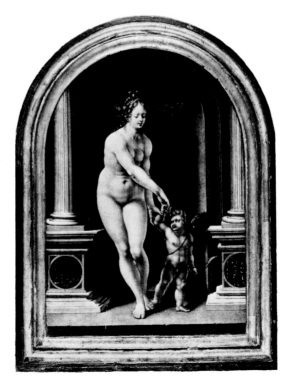

17 GOSSAERT *Venus and Amor* 1521

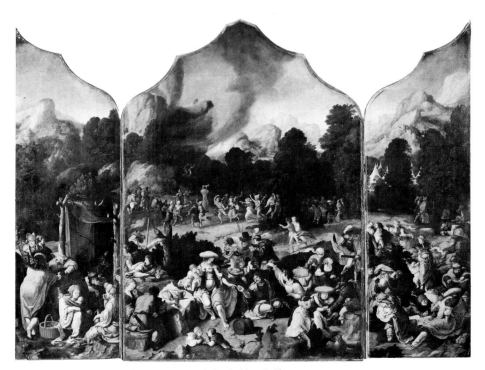

18 LUCAS VAN LEYDEN *The Dance Around the Golden Calf c.* 1530

above other cities as the cradle of Dutch art, as Vasari with more justification had done with Florence.

In Scorel's pictures, such as *The Baptism of Christ*, one always feels a certain orthodoxy; but Lucas's *Dance Around the Golden Calf*, a triptych painted around 1530, has a sparkling fluency Scorel never achieved. It is brilliant in all respects: in the liveliness of the movements, in the observation of narrative detail, the distribution of bright colours, the transition from foreground to background.

In Lucas's time the concept of invention evidently was not yet a powerful enough incentive to search for Art that went beyond the natural implications of a story. It is true that in *The Golden Calf* the actual subject has moved to the background, while the foreground is occupied by a merry company of people eating and drinking. But their gestures and movements all have a certain natural logic: the picture is trying to narrate the story rather straightforwardly (and the dissoluteness of the people *is* an important part of it); it is completely different from the High Mannerism practised in Haarlem towards the end of the century by Cornelis Cornelisz. and the elegant Jacob de Gheyn II (1565–1629).

8
18

Strangely enough, Haarlem was also the town where modern realism originated. De Gheyn's curious *Poseidon and Amphitrite*, with Amor erotically pointing into a shell, seems to combine both tendencies. The grouping of the figures as well as the composition of the shells in the foreground (marine symbols for Poseidon) is heavily Mannerist. The shells themselves, however, are marvels of realistic observation; they are more meticulously rendered than almost anything else in sixteenth-century art. De Gheyn owned a collection of such shells, and this again is typical of Mannerist taste: bizarre shells were cherished as Art produced by Nature. This kind of realism of detail, which enhances the artfulness and *bizarrerie* of a picture, is a logical component of Mannerist taste.

All the more striking, therefore, is the return of a more logical approach in narrative composition, which occurs in Haarlem, too, more specifically in the later work of Hendrick Goltzius (1558–1616). At first it is only a change in degree. When Goltzius' friend Cornelis Cornelisz. painted his strangely beautiful *Bathsheba* in 1594, he was still very much a Mannerist. His concern is less with a succinct presentation of the story than with the design of three mysterious nudes in a mysterious garden. The picture suggests very strong *aesthetic* preoccupations, as Goltzius' *Juno Receiving the Eyes of Argus*, painted in 1615, does not. Certainly there is in Goltzius' painting a concern with gracefully designed nudes and with elegant invention, and its Mannerist provenance is clear. But at the same time Goltzius is attempting to present the story in a clearly legible way – direct and undisguised by Art.

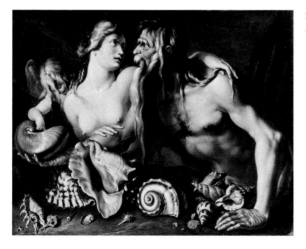

19 DE GHEYN *Poseidon and Amphitrite* 1592

20 CORNELIS CORNELISZ. *Bathsheba* 1594

21 GOLTZIUS *Juno Receiving the Eyes of Argus* 1615

34

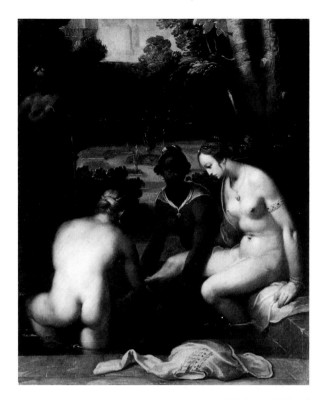

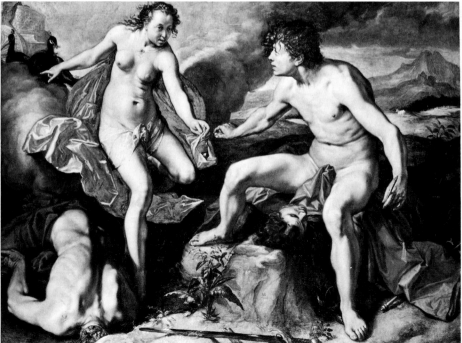

Virtue explained

Genre painting in the seventeenth century

A new realism established itself as a mainstream style in landscape, still-life and genre during the second decade of the seventeenth century. A prime example of this new approach is found in a brilliant picture, *The Ferry*, painted in 1622 by the Haarlem master Esaias van de Velde (1591–1632). *The Ferry* has a closeness to the reality of the Dutch countryside which had not existed before in painting. Mannerism, as exemplified by Bloemaert or Coninxloo, led landscape painting into the context of rhetoric; it became an integral and often eloquent part of the lofty rhetoric of history painting. Also before the advent of Mannerism, landscape had already had to function in accordance with a narrative subject; and since painting a narrative picture is an act of invention and imagination (however much the imagination is the result of the visual experience of the artist), the landscape, its character and its structure, came from imagination too.

In *The Ferry* Esaias van de Velde could remain close to his own experience of actual landscape because there is no overt narrative in the painting to adapt to or to sustain. That landscapes such as this exist, devoid of narrative drama, cannot but mean that Dutch culture had come to accept paintings without historical incident as complete works of art. Evidently alibis like the Elijah story in Coninxloo's picture were no longer required.

Does this mean that Dutch culture rejected the classic theory of art that proclaimed history painting the highest form of visual art, or even the only relevant category? This conclusion would not be correct. Classic theory had two aspects. One was the philosophical aspect, one might say, which dealt with art's moral quality to *teach* people; and what subjects could be more eminent and didactic than those taken from such canonical sources as the Bible, the Lives of the Saints or various classical authors? The other aspect was an analytical concept, advising the painter that a picture would be realistically more *complete* if it showed more varied motifs. Van Mander, for instance, writing about landscape, advised:

Do not forget to put small figures under tall trees. There should also be tiny figures ploughing here, and there mowing. Let them lead their wagons, and let them fish somewhere else, or go in boats or catch birds or hunt. . . . Make

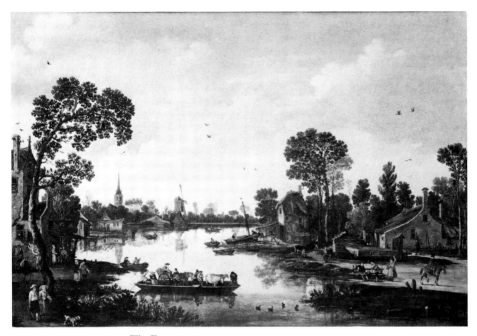

22 ESAIAS VAN DE VELDE *The Ferry* 1622

the countryside or the town or the water full of activity; people should be doing things in their houses, and others should stroll on the roads.

The Ferry seems to reflect advice like that quite directly; Esaias's picture even has a structure of variety which is quite traditional. There is even an attempt at a narrative; or could a narrative not be avoided? Maybe it comes by implication, and it makes the picture much more than something once seen and duly recorded as in a photograph.

The picture shows a bend in a river. There are people going about, there are houses – and they are not casual. Each building and almost each human figure suggests a specific social function; when read together these motifs portray, by their variety, something like quiet village life. The high building on the left is an inn; opposite, on the right, is a farmhouse with a fenced yard. Beyond the farm, on the river, is a boatyard; on the horizon we see a mill and a small church. And then the people: they are fishing, building a ship, talking (in the front porch of the inn or while waiting for the ferry to arrive), travelling or walking in couples with their dogs. Some are clearly resident, others are passing through. On the left, a pedlar is entering the scene; on the

37

right a gentleman on horseback is leaving. The sun is setting; it is late afternoon, and all is quiet.

This reading of the painting is not, I believe, just romantic fancy. The selection and distribution of the motifs seems far too precise and calculated to be arbitrary. There is, however, no written text to which this, admittedly weak, narrative structure can refer. The picture refers directly to reality, without the intervention of literary subject matter; it evokes reality in a controlled way and cannot be dissociated from it – simply *because* the painting is realistic. But, though this reading looks fairly logical in this case, with a picture which does not contain explicit symbols, it is certainly not a general model.

A seventeenth-century Dutchman would look at Nature in a moralistic way, within a framework of moral values: contemporary poetry shows this quite clearly. He would look at a realistic picture in much the same way, the picture being a mirror of nature. It is natural to think about decay when flowers are in full bloom, and this is, for instance, the primary meaning of early seventeenth-century flower-pieces like those by Ambrosius Bosschaert. But natural symbolism seems to express itself clearly only in broad oppositions; and, wherever there is no textual basis for it, it is always ambiguous. There are, of course, many poems about flowers in bloom and impending decay – but to relate them directly to Bosschaert's still-life is conjectural. Somewhat the same problem has been observed above, while discussing Early Netherlandish painting, where a realist aesthetic forced painters to adopt a subtle system of disguised symbolism. There is, however, a major difference here. Early Netherlandish painting always referred to a written text: the Bible, commentaries, church hymns and the like. The language used in these texts is often heavy with metaphor; Mary's virginity was always compared to the pure white of a lily or the clarity of water, and these traditional metaphors provided suitable symbols. For the new subject matter of seventeenth-century realism – landscape, still-life and genre – such an established metaphorical tradition was lacking. To make up for it, artists started to make use of the popular emblematical literature.

The first emblems were published in Italy in the early sixteenth century. Their composition was a literary genre among humanists; by finding apt combinations of image and text they could show off their metaphorical inventiveness and wit. The genre spread quickly and became immensely popular. In Holland it was soon employed by Calvinistic moralists like Johan de Brune who realized the didactic value of a concrete image explained by a concise text.

In its classical form, an emblem (like the example illustrated here, from Johan de Brune) consists of three parts: a motto, an image and an address.

85

23

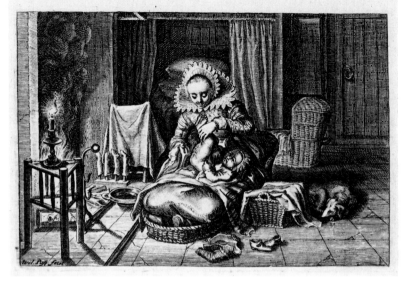

Dit lijf, wat ift, als ftanck en mift ?

23 DE BRUNE *Emblem* 1624

The image, in De Brune's emblem, shows a domestic scene, a mother wiping the buttocks of her child. If we encountered it outside this context, what else could it be than a realistic anecdote? Here, the image is moralized, in a general way, by the motto which reads: 'This body, what else is it but stench and shit?' The significance of this moral is further explained in the address, directed at a lover, saying that his beloved, even if she were a princess and extremely beautiful, is but a body, 'conceived in shame . . . and delivered in unclean blood'.

This emblematic image figures in a picture, dated 1652, by the Leiden painter Gerrit Dou (1613–75), usually entitled *The Quack*. At face value, this picture seems just a lively anecdote from everyday life. Underneath its realistic appearance there is, however, a subtle structure of emblematic signs which turn the painting into a metaphor of human deception. Certain emblematic signs in Dou's painting make this general meaning more precise; other signs turn it into a grand metaphor of Good versus Evil, of the Spiritual versus the Sensuous Life. The obscure potions the quack tries to peddle may help physical ailments but do not help the soul. His authority is false, and accepted only by those who believe the mock diploma on his table – which, incidentally, reflects a contemporary emblem with the motto: 'The seal gives confidence.' The woman wiping her child's buttocks is cooking pancakes at

28

the same time. This is another emblem, using the underdone pancake as a metaphor of the half-baked bragging of the quack. On the ground, behind the man carrying a hare on a stick, is a boy trying to catch a bird – an emblematic reference to greed, and of course related to the quack. People, when offered a choice between Good and Evil, often make the wrong choice; this is expressed by the dead tree in front and the tree in bloom next to the quack.

The realism of Dou's picture is a metaphorical realism – or better, a realism of visual detail in support of a symbolic and moralistic content. To take this, or indeed most realism in the seventeenth century, in an anecdotal sense would be a mistake. *The Quack* does not reflect a street scene in Leiden, witnessed by Dou as he casually passes by, though the elements that constitute the picture are no doubt realistic *fragments*. They have an extraordinary sharpness of definition and do reveal that Dou was a careful observer of what went on around him. Quacks were certainly regular visitors in any town. For anyone seeing the picture, the quack must have looked normal enough – and precisely this familiarity gave the moralistic point a special urgency. The scene could be *recognized*; but it is not a direct recording of an actual scene, as is confirmed by its compositional structure. The focal centre is of course the quack on his platform under an Oriental parasol. In direct opposition to this focal point, Dou placed a gnarled dead tree. In relation to the tree in bloom, rising up behind the quack, this trunk signifies the credulous acceptance by ordinary people of quacks or any other form of charming deceit. The dead tree is placed directly and very conspicuously in the foreground; and, moreover, it is placed there for the viewer only; structurally it is not part of the group round the quack's platform. It is a strong key symbol, setting the tone of the picture; one's glance has to pass it before coming to the central group. Close inspection reveals that this group is made up of highly disparate figures: the pancake woman, the hunter with the hare, the woman with the basket, the painter looking out of the window, the boy trying to catch a bird – it is really very unlikely that one would find such a mixed party watching a performance of a quack. And, of course, they are not a real audience; each of these characters is a vehicle of a precise symbolic meaning relative to the quack's activity and the audience's credulity. They are presented as an audience to assure for the symbols a *natural* presence within the realistic texture of the picture. This shows then that the composition was controlled more by the conditions of its content than by realistic concerns, being a moral *exemplum*.

What makes the realism that emerged in the early seventeenth century in Holland special is its use of motives which derive from direct visual

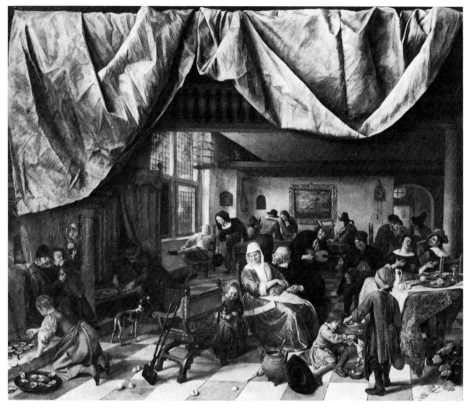

24 STEEN *The Life of Man* 1665

experience of the painter's own surroundings, the real world. A painting like *The Life of Man*, painted around 1665 by that master of genre, Jan Steen (1625–79), may clarify this further – especially in comparison with sixteenth-century pictures like those by Pieter Aertsen, which might be called predecessors of later genre painting. Indeed, Aertsen's *Christ in the House of Martha and Mary* is full of realistic detail, but it is a very stylized realism – a realism kept at a distance by strong aesthetic concerns, in the composition as well as in the design of the individual figures. This intervention of style in realism no doubt served to elevate the scene to a higher level than actual daily life – to the level of high Art and noble content. This was precisely what Jan Steen omitted. His painting shows an ordinary interior with ordinary people, in a straightforward way, not particularly

24

13

embellished. Yet, in this deceptively natural painting, too, a moral is hiding. This is not a scene casually glimpsed but the *presentation* of a scene; it is presented, literally, by drawing up a curtain. This drawn-up curtain has much the same function as the dead tree in the foreground of *The Quack*, though as a device it is less precise: it calls the scene to the viewer's special attention: 'now look at this'. What he sees are people, young and old, male and female, drinking and playing and, above all, eating a lot of oysters. As oysters were a conventional aphrodisiac, they became a common sexual symbol – and their abundance gives this picture an unambiguous erotic meaning. But then, almost exactly where in the middle the curtain is drawn up highest, a young boy is hiding in the attic, blowing bubbles; a skull is next to him. The connotation of the skull is clear enough – and so, to a contemporary audience, was the boy. He is the illustration of a classic adage: *homo bulla* – 'man is a bubble'. The inclusion of this symbol of the insignificance of worldly pursuits unavoidably changes the meaning of this painting. Maybe paintings like this are an indication of how people in the seventeenth century experienced reality. 'The Lord's benevolence shines from every dune,' wrote the poet and humanist Constantijn Huijgens – one of the many instances in literature which give an intimation of how metaphorical seventeenth-century thought was. It seems that experience of reality was controlled by a conceptual framework that subordinated perception of the world to a formal system of knowledge. For this reason, neutral representation had no place in seventeenth-century culture; it was too straightforward. Had not Christ himself spoken in parables?

28, 24 The paintings just quoted, by Gerrit Dou and Jan Steen, belong to a category of art which in seventeenth-century Holland became specially prominent, and which is known by a later name: 'genre'. Contemporary writers, who must have witnessed the spectacular rise of genre, did not bother to find a name for it – which testifies to the curious inability of classical theory to deal with a new phenomenon when it does not fit into the High Tradition. Only later, when thought was no longer dominated by classical theory, did the word genre come into use; it was probably the eighteenth-century French writer and critic Denis Diderot who introduced the word – to designate the paintings of his contemporaries Chardin and Greuze. Earlier writers just called the pictures after what they saw represented: a merry company, a brothel, a peasant dance, or whatever – and invariably classified them as second-rate art. Even though an artist could excel as a painter of 'drolleries', as they were sometimes called by English visitors, what was a brothel scene compared to a lofty subject like *The*
50 *Banquet of Antony and Cleopatra*? And the eminent Sir Joshua Reynolds, R.A., whose expert judgment could not deny Jan Steen a certain quality,

argued that he 'would have ranged with the great pillars and supporters of our Art' had 'this extraordinary man' been living in Rome instead of Leiden. He would then have had Raphael and Michelangelo for his masters, and instead of painting vulgar subjects he would have excelled in 'the selection and imitation of what was great and elevated in Nature'.

But the culture to which Reynolds belonged was very different from the one in which Steen worked. In fact the Dutch Republic, especially in the first half of the seventeenth century, was a society with a sociological structure all its own, the product of a war of liberation with Spain which lasted for eighty years and ended only in 1648 with the official recognition of the Republic. One of the results of the long struggle was a fundamental change in the balance of power within the Republic: as the war had been fought by the cities, the greater part of the nobility either taking sides with Spain or being more or less neutral, the power finally passed into the hands of a bourgeois middle class. This meant that the traditional support-structure of art was destroyed, for, unlike the aristocracy, middle-class people were not used to acting as patrons – nor did they have the intention of doing so. In general, then, artists could no longer work on commission – portraitists, of course, excepted. Now they had to work for a free market, first painting the pictures and afterwards trying to sell them – and sell them to a different class, with a different culture. This new orientation in Dutch culture also effected changes in artistic practice. In the sixteenth century every self-respecting painter had to travel to Italy and especially to Rome. There Raphael and Michelangelo had executed the immortal works in which they had demonstrated the rules that the art of painting should follow. None of the great masters responsible for the rise of Dutch painting, however, felt the need to go to Italy. Esaias van de Velde, Jacob van Ruisdael, Frans Hals, Jan Vermeer, Jan Steen, Rembrandt – they stayed in Holland, close to their own culture. They painted basically for a local public.

There is little contemporary information as to the distribution of pictures; but what information there is testifies that many houses contained them: 'butchers and bakers not much inferiour in their shoppes, which are Fairely sett Forth', wrote an English observer in 1640, 'yea many tymes, blacksmithes, cobblers etts., will have some picture or other by their Forge and in their stalle. Such is the generall Notion, enclination and delight that these Countrie Native[s] have to Painting.' This middle-class culture, of people who did not speak French or Latin and who were not educated with the humanist reverence for classical antiquity, consisted of simple religion and popular lore – expressed in farce, proverbs, jokes, popular theatre – which, as far as can be judged from literary remains, usually had a rather crude, realistic quality.

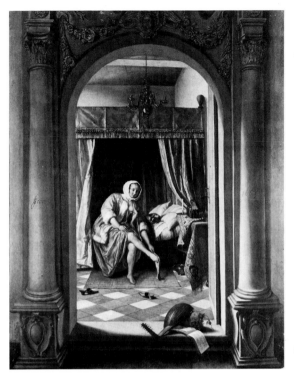

25 STEEN *The Morning Toilet* 1663

It was within this context of an indigenous culture, crude maybe, but one that in the war against Spain (which was also a war against another class) had emancipated itself, that painters now had to be meaningful. When, for 25 instance, Jan Steen painted *The Morning Toilet*, it was precisely popular language which he took for a semantic basis. The painting is a warning against venal love. Its moral content is introduced by the still-life in the doorway, which consists of conventional symbols of Vanity – but the erotic content in the picture is defined in reference to linguistic usage. The candle and open jewel-box, on the table next to the bed, refer to a popular saying: 'Neither does one buy pearls in the dark, nor does one look for love at night.' The girl, then, is a prostitute; she is putting on a stocking, conspicuously enough. The Dutch word for stocking, *kous*, had in slang another meaning: vagina.

A similar reference to language is found in a painting by Gabriel Metsu (1629–67), another prolific practitioner of genre; it is now called *The* 26 *Sleeping Sportsman*, a title of typical Victorian sentimentality. Modern titles for genre paintings were in fact coined in the nineteenth century, when a

44

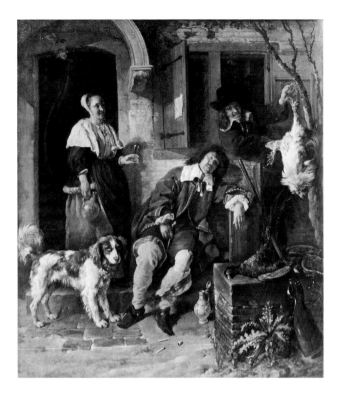

26 METSU *The Sleeping
Sportsman*

contemporary interest in anecdotal realism led to a reappraisal of Dutch
genre; at that time the popular lore, from which their subject matter was
drawn, was lost, and those critics and curators who thought up the titles had
only the seemingly realist image to go on. With the prudishness of their age a
picture of a whore putting on a stocking became *The Morning Toilet*, and
this painting by Metsu *The Sleeping Sportsman*. Its real subject, however, is as
erotic as that of *The Morning Toilet* – and equally moralistic. The hunter is
incapable, because he drank too much while passing time with the girl. The
key to this reading is the dead birds on the right, whose presence in the
picture seems so natural, but as the Dutch word for bird is quite close to a
vernacular term for copulation, *vogelen*, the general meaning of the picture
was clear to a contemporary audience.

Unlike a history painting, a genre picture does not generally refer to a
written text. Its relation, as we have seen, is to a very different area – to the
popular, often crude and simplistic, metaphorical interpretation of the
world. Genre pictures, therefore, have a different structure from history
painting, and that structure is one of their major characteristics. A history

45

painting usually illustrates the decisive moment of the historical narrative to which it refers – with the story of Lazarus, the exact moment when Lazarus is resurrected, and not, for instance, Christ on his way to Lazarus' grave. For a genre painting, however, there never could be such a crucial moment: there was no story. A genre painting always presents a *situation*, which, through the introduction of key symbols, is reversed into a moral example. The

31 *Brothel Scene*, for instance, done in 1658 by the fashionable Leiden painter Frans van Mieris the Elder (1635–81), shows an interior with a rather coy lady pouring a smartly dressed young man a glass of wine. An elegant scene – until one perceives, farther back in the room, two dogs copulating. This crude and explicit detail associates the picture with a popular expression of Italian origin: 'As is the lady, so is her dog.' And another proverb, saying that beautiful women and sweet wine are full of dangers, may also apply here. So what at first seems a harmless, attractive scene, is suddenly reversed when the viewer encounters an explicit symbol, often hidden in the background.

This semantic structure of sudden reversal is, in a way, an aesthetic component of genre, and it reflects the seventeenth-century attitude towards the aesthetics of disguised symbolism in general. The poet and moralist Jacob Cats (whose extremely popular works almost read like an index to genre symbolism), writing about the hidden meaning in proverbs, which like genre paintings rely on the device of reversal, and which are 'particularly attractive because of their pleasing obscurity', noted that one discovers those meanings only after some reflection. This he compared to finding a 'beautiful bunch of grapes underneath a thick bed of barren leaves'. And in the same vein Samuel van Hoogstraeten, in a theoretical book on painting (1678), praised the subtle introduction of 'accessories that covertly explain'. This aesthetic element had survived from the humanist tradition of emblematic literature, in which difficulty was considered a quality because, as some writers noted, the decoding was then a real exercise of the mind, while at the same time the emblem would not be accessible to everyone. The mainstream of Dutch emblems in the seventeenth century, however, was much less difficult and obscure than in the sixteenth century – and it tended to make use of a descriptive realism quite similar to the realism employed in genre painting. Quite often, too, it was established genre artists who engraved the images in emblem books.

The new genre painting emerged in Haarlem. There the tone was set by two artists, both highly inventive: Esaias van de Velde and Willem Buytewech

27 (1591–1624). In Buytewech's *Banquet in the Open Air*, probably painted around 1615, all the typical elements of genre are already manifest, even though the painting clearly reflects a transitional style. Transitional it is, not

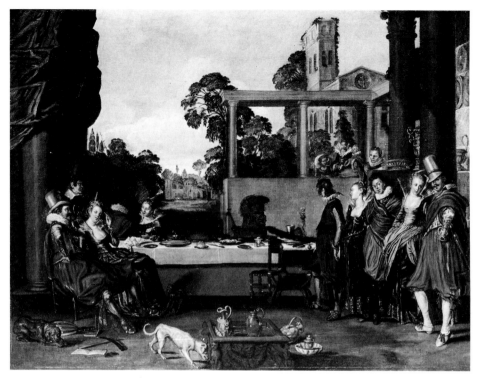

27 BUYTEWECH *Banquet in the Open Air c.* 1615

only in the general setting, which is curiously theatrical, but also in its stiff
composition. This stiffness may be the result of a very conscious anti-
Mannerist stance – the result, too, of a desire to avoid any misunderstanding
as to the actual meaning. The presentation of the different motives which
together constitute the scene is therefore painfully precise and orthodox. On
a stage-like floor, marked off from a garden by theatrical architecture, are
two groups of people, both consisting of richly dressed ladies and flashy men.
In the middle of the floor a table is set. One group is still seated next to the
table; the other is standing on the right, displaying themselves and also, one
has the impression, the table. Within this setting, two types of symbol have
been introduced: symbols of Luxury (among others: the golden vases and
decanters, the peacock on the table, the not quite contemporary fancy
dress) and symbols of Vanity (the musical instruments on the floor).
Among contemporary prints one finds representations of equally richly
dressed couples, sitting at a dinner-table with Death behind them in the form

47

of a skeleton; the meaning is explained in a legend: 'When we are at leisure, surrounded by Luxury, Death may be nearer than we know.' In a realistic picture like Buytewech's it was of course difficult to introduce a wandering skeleton among the company; yet the meaning of *The Banquet in the Open Air* is obviously the same. And the church, rising up behind the architectural décor, may be there to frame the moral point in a Christian ethic.

After this and other first essays by Buytewech (brilliant in their total commitment to a new style), the Haarlem manner of genre painting quickly gained influence. No doubt an important and decisive point in the development was the short stay of only a couple of years of the Flemish painter Adriaen Brouwer (1605–38) in Haarlem and Amsterdam, during the second half of the 1620s. For 'actors' in the scenes he painted, such as 30 *Cardplayers Brawling*, he used peasants, usually presented as rather unsavoury types – as his compatriot Pieter Bruegel the Elder (1525–69) had done, and before him, in some cases, Jheronimus Bosch. The paintings of this original artist acquired a high renown, especially among other painters; both Rubens and Rembrandt were eager collectors of his work. His immediate influence on the young Haarlem painter Adriaen van Ostade (1610–85) is clearly 29 evident in Van Ostade's early *Carousing Peasants* of about 1638. With the influence of Brouwer, consciously developed into an independent manner by Adriaen van Ostade, who was to become the leading master of the mature phase of Haarlem genre, a sense of the grotesque entered into Dutch painting – a certain cruelty, even, in the characterization of people, which had not been there since Bosch. The strong Mannerist emphasis on noble elegance had banished it (and in this respect the pointed elegance of Buytewech's 27 *Banquet in the Open Air* must be considered a Mannerist remnant). No doubt these peasant-pieces, too, have a moral significance, but exactly what it is is not quite clear. Sometimes they contain veiled references to conventional topics such as the Five Senses, but as often they do not. Maybe, then, they must be seen as general representations of what may happen to man if he is unaware of the Christian virtues and, losing all constraint, surrenders himself to drinking and tobacco-smoking. That would explain the grotesque and hideous atmosphere of these pieces, the mean ugliness of the faces, the squalor of the surroundings; the stylistic quality then would serve as interpretational key.

Meanwhile, in Leiden, a rather different approach to genre had been initiated 28 by Gerrit Dou. *The Quack* shows the characteristic qualities of his style and of the Leiden School he was to start: meticulously careful drawing, high finish or slickness even, and darkly shining colour – hence the name of the school: the Leiden *Fijnschilders* ('fine painters'). From Rembrandt, with whom he studied here, came a sense of chiaroscuro which in the hands of Dou and his

48

28 DOU *The Quack* 1652

immediate followers became a method of elegant lighting. His most gifted
31 pupil was Frans van Mieris the Elder, painter of the *Brothel Scene* discussed
26 above. Gabriel Metsu was born in Leiden in 1629; he stayed in his native
town until 1657 when he went to the big city, Amsterdam. He, too, seems to
have been a pupil of Dou – though from the start his style was more
independent.

A special characteristic of the Leiden School, whose subject matter
consisted mainly of quiet scenes in middle-class interiors, was the frequent
recourse to abtruse emblematic literature as a repertory for symbolic signs, as
28 we saw in *The Quack* – a characteristic which is not restricted to genre only,
but which is noticeable, too, in the allegorical still-lifes that were produced in
91 Leiden such as Steenwijck's *Vanitas*. That Leiden was a university town
might be the reason for this; one can easily imagine an intellectual class here
with a special interest in 'difficult' paintings. Meanwhile, in the remote city
of Deventer, Gerard Terborch (1617–81) developed a basically independent
form of genre which in the meticulousness of its execution, at least, seems
closest to the Leiden variant. In connection, maybe, with his remarkable
talent for sensitive rendering of the texture of different fabrics, which in all of
his mature paintings constitutes a major pictorial motive, Terborch showed
a preference for subjects associated with Vanity or Luxury. This preference
must have a partially aesthetic background, for these subjects allowed him to
32 paint elegant interiors and richly dressed ladies, as in *Brothel Scene* – ladies like
frail mannequins, standing there to be admired, in a painting that pleases
while it also teaches.

The fact that Jan Steen, too, tended towards a dense symbolism, may also be
due to his Leiden background. In stylistic respects, however, he was strongly
independent – fusing all influences he received (from his teacher Jan van
Goyen, from Adriaen van Ostade and, possibly through the latter, from
Adriaen Brouwer) into a manner completely his own. In subject matter the
oeuvre of this restless artist, who moved often and stayed in many places, is
very diverse; it contains quiet interior pieces, reminiscent of the Leiden
25, 36 tradition, like *The Morning Toilet*, as well as pictures like *The Skittle Players*
(1660–62) which seems purely idyllic, an evocation of gentle life, devoid of
the usual sinister reversal. Steen also tried his hand at history painting and at
portraiture; but the paintings he is most famous for are crowded, gay,
24 agitated scenes like *The Life of Man*. Paintings like this mark the
extraordinary development of Dutch genre since the early essays of Willem
Buytewech – which was, more than anything else, a development in
compositional technique and in syntactical organization of large groups of
figures. What is shown in this development, most of all, is how crucial the
relation was between genre and pictorial realism – and also that pictorial

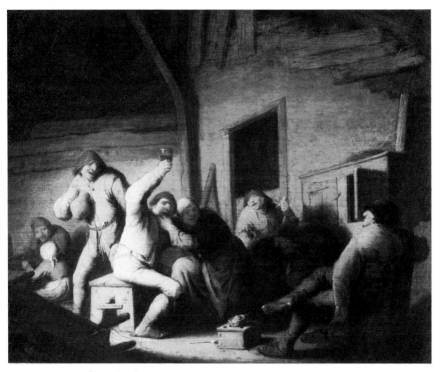

29 VAN OSTADE *Carousing Peasants c. 1638*

30 BROUWER *Cardplayers Brawling c. 1625*

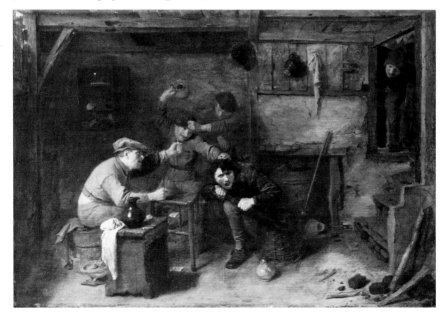

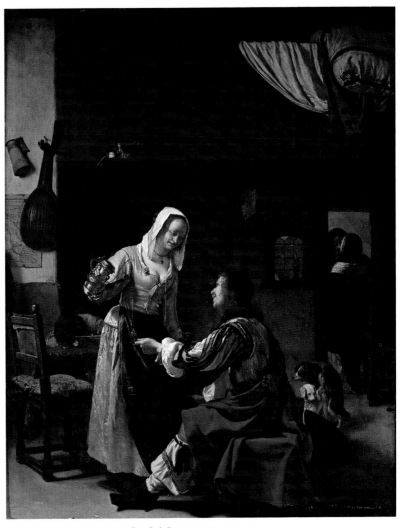

31 VAN MIERIS THE ELDER *Brothel Scene* 1658

realism was greatly furthered by the attention towards realistic detail necessitated by genre. It was, as we have seen, the point of genre to present a moral example – but as it had to be readable by ordinary people, it consequently had to be presented within a context which the public could recognize. This gave the realism in genre a quality of closeness and sharpness fundamentally different from the realism in history painting. In order to

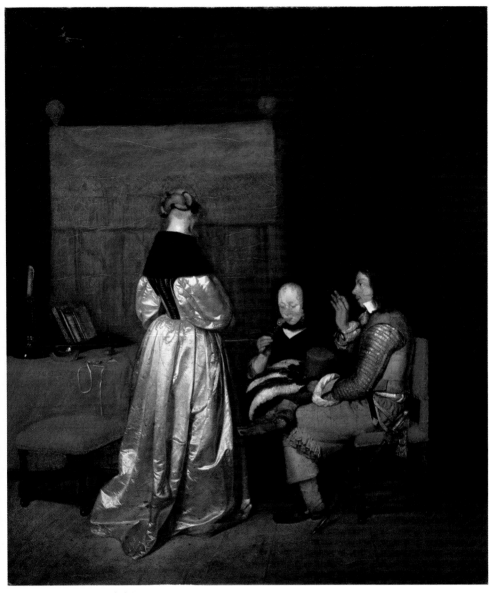

32　TERBORCH *Brothel Scene c.* 1654–55

convey the subject's loftiness, the realism employed in history painting had to be toned down – in a way which would subtly keep the narrative scene depicted in the painting at a certain distance from the real world.

Early in the century, while in Haarlem the foundations were laid that would eventually lead to the 'high genre' of Jan Steen, genre painting in Utrecht went in another direction. The two painters who were mainly responsible for this alternative development, Hendrick Terbrugghen (1588–1629) and Gerard van Honthorst (1590–1656), had a very different background from their colleagues in Haarlem and Leiden. Unlike them, Terbrugghen and Honthorst spent many years in Rome; and though they would manifest themselves primarily as history painters, they too produced genre pictures (Honthorst more than Terbrugghen) in a style adopted from the genre painting of Caravaggio and his circle. Instead of using small figures in a spacious setting, as their contemporary Buytewech did, Terbrugghen and Honthorst concentrated (following the style of Caravaggio) on one or only a few figures, mostly life-size, seen close to and strongly outlined against a plain background. What these pictures shared, however, with those of their contemporaries, was the moral content.

35 The actual meaning of Terbrugghen's beautifully serene *Flute Player* of 1621 is difficult to establish (it might be an illustration of Hearing, as one of
34 the Five Senses) – but the erotic content of Honthorst's *Procuress* (1625) is as explicit as in any painting by Steen or Van Mieris. Happily the procuress points to the smart young man, a possible customer who quite visibly holds his purse in his left hand. With his other hand he gestures towards the girl's lute, while the girl, too, her *décolletage* roguishly displayed in the candlelight, points towards her instrument. 'Learn on the lute, learn on the virginals to play. For strings have the power to steal the heart away', runs a contemporary poem – but surely the strong emphasis laid on the lute suggests that the instrument here has the more vulgar, and very common, significance of vagina. The Dutch word *luit* can mean either. Under an elegant veil, the painting thus illustrates – and by implication condemns – illicit love.

Utrecht genre (unlike its pendant in history painting) remained at first relatively isolated within Dutch art. Its reticent, detached realism was apparently too far removed from the form of realism with which Van Ostade or Steen were dealing. Only later did its serene quality affect the early development of the art of the great Jan Vermeer of Delft (1632–75).

33 In fact, an early picture by Vermeer, *Officer and Laughing Girl*, done around 1657, shows a striking similarity to Honthorst's *Procuress* – and not only in the composition and the disposition of the light, which in Vermeer's painting comes through a window. Some relation with Honthorst is

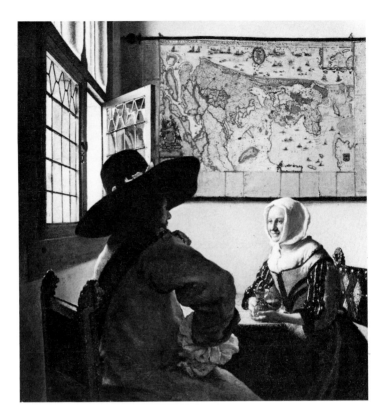

33 VERMEER *Officer and Laughing Girl*
c. 1657

34 HONTHORST
The Procuress 1625

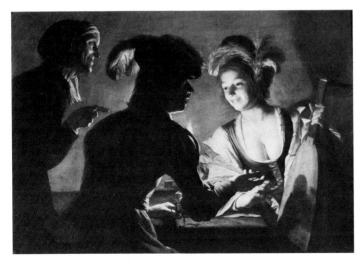

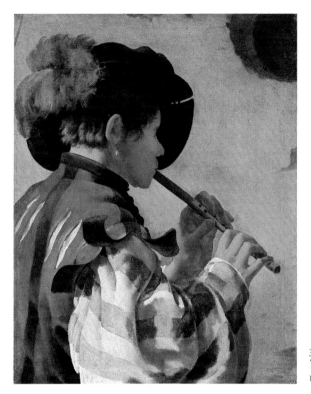

35 TERBRUGGHEN
The Flute Player
1621

noticeable, too, in the subtly anecdotal opposition of the alert figure of the soldier, with his dashing hat, looming darkly in the foreground, and the surprisingly small girl, caught in the mellow light, gently smiling. This opposition, which looks almost forced, introduces a tension into the picture, an expectation of things about to happen, which in Vermeer's later work was to disappear completely.

Even though it has a transitional quality, this early painting already presents most of the characteristic elements of Vermeer's serene, reticent art; the typical spatial setting is there, the corner of a whitewashed room with a window on the left, and hence the soft velvet light. In the treatment of light, Vermeer no doubt received decisive impulses from Carel Fabritius (1622–54), a mysterious artist who settled in Delft in 1650 and died in a powder-magazine explosion which destroyed a large part of the city. On that occasion the best part of his work was lost too; only about twelve paintings can now be attributed to him. They show an idiosyncratic artist of exceptional power who, among other things, experimented (as Vermeer did after him) with the camera obscura and other optical devices in

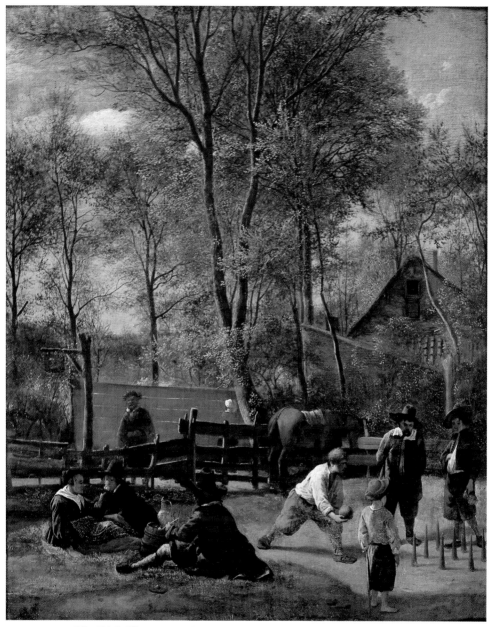

36 STEEN *The Skittle Players* 1660–62

order to gain a better insight into the construction of pictorial space. In the early 1640s Fabritius had been the pupil of Rembrandt; and it must have been the master's chiaroscuro, employed as a subtle method of defining form through the inflection of light which impressed him most deeply. But while most other pupils of Rembrandt slavishly applied chiaroscuro, making it pretty and charming like Dou, Fabritius went in another direction altogether. Rembrandt's chiaroscuro was basically tonal, using intensities of light on a scale varying from very dark to very bright. The

37 paintings of Fabritius, however, of which *The Goldfinch* of 1654 is a brilliant example, maintain an overall brightness, a golden glow; yet within the strong light, light is still more inflected – not by toning it down or intensifying it but by tingeing it with subtle hues of colour. It was this method that Vermeer learned from Fabritius.

Another artist then active in Delft also came under Fabritius' influence: Pieter de Hooch (1629–after 1684), a painter whose aspirations and concerns were close to those of Vermeer. De Hooch even might have been the 'inventor' of the tranquil, domestic interior. If so, he lacked the artistic intelligence to develop the theme, and finally needed the influence in the late 1650s and early 1660s of the more powerful and pure art of Vermeer to arrive at a satisfactory form for his interiors. They are not slavish imitations,

38 though – as is clearly shown by *The Mother*, painted around 1660. The picture undeniably has a stronger anecdotal, or even sentimental quality –

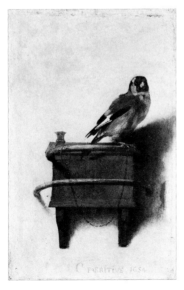

37 FABRITIUS *The Goldfinch* 1654

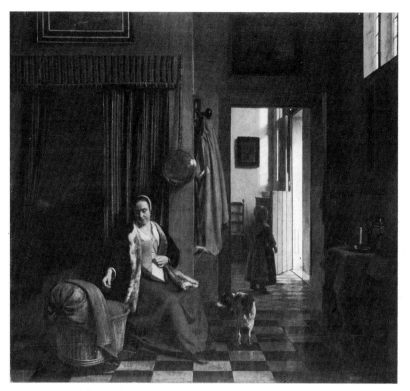

38 DE HOOCH *The Mother c. 1660*

which is also emphasized by the elaborate perspectival construction of the spatial setting and the elegant and charming inflections in the light. After 1660 De Hooch moved to Amsterdam, into more competitive surroundings, which led to a fashionable compromise in his art.

In Vermeer's development towards tranquillity, one is tempted to suppose a relation between his particular treatment of light, as a stylistic concern, and his choice of subject matter. Indeed, to express and control movement in space (as is necessary for instance in Rembrandt's *The 'Night* 71 *Watch'*) the light imbued with colour, as employed by Vermeer, is too delicate; instead it seems eminently suited to the serene stillness of the figures and objects in Vermeer's mature paintings, such as the *Woman with a Water* 40 *Jug* of 1660–65, or *The Lace Maker* of 1665–68 – both pictures of which the 39 subject, characteristically, is tranquillity itself, while in that subdued atmosphere the symbolism (giving the pictures their moral justification) is subdued and discreet, too. Meaning is never expressed, as often is the case

with Dou or Steen, through a chain of symbolic signs naturally reinforcing each other. The paintings of Vermeer generally acquire their meaning in association with only one symbolic sign, which then becomes the actual subject of the picture, and which allows the artist to keep his painting very subdued. In *The Lace Maker*, for instance, the needlework with which the woman is so intently occupying herself was a conventional symbol of modest homeliness, a virtue of women, which is thus the content of the picture. These paintings have a very different mood from the genre produced at the same time in Leiden or Haarlem. Compared to a contemporary painting by Steen or Van Ostade, the paintings by Vermeer seem curiously remote, detached from the world, subjects transmogrified by Art. This must be the visual effect of their balanced, static composition, in which horizontal and vertical accents strongly dominate. (One senses a

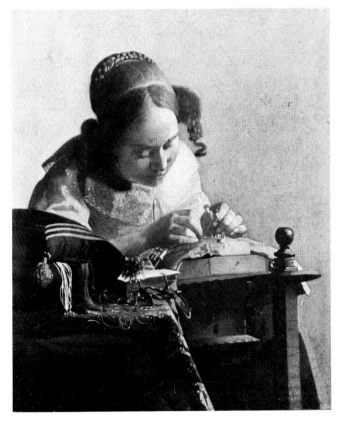

39 VERMEER *The Lacemaker* 1665–68

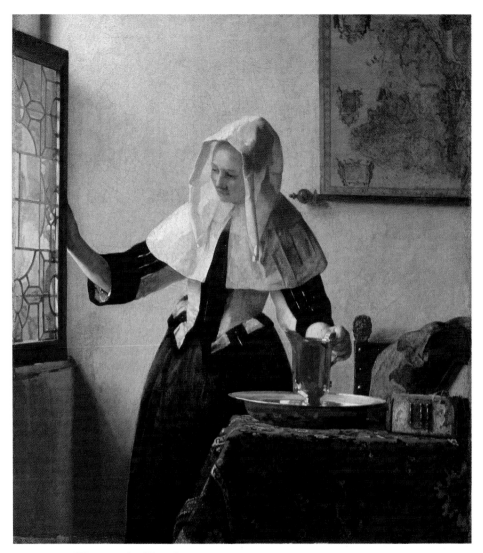

40 VERMEER *Woman with a Water Jug* 1660–65

deliberation in the organization of these compositions, and a slowness in decision and execution.) Another factor is the sparseness of the setting, with only a few, carefully chosen and carefully placed objects. But ultimately the atmosphere is created by the light as it spreads through the space and caresses the colours, giving them lustre while itself being modified by them.

Classic histories

History painting in the seventeenth century

In the context of optimistic contemplation of one's own world which originated with the early realism discussed in the preceding chapter, there was but little place for history painting as it had developed in sixteenth-century Mannerism. The elegant parties painted by artists like Buytewech might not reflect everyday life, far from it; but still they did have a certain logic. Such parties could be, and on occasion certainly were, organized; in the end they were a recognizable dream. But what about those naked gods and goddesses who were present at *The Marriage of Peleus and Thetis*, in the mythological painting by Cornelis Cornelisz. van Haarlem? They belonged to a kind of imagination which no longer seemed to be part of the spirit of the 1620s in the Dutch republic. The old-fashioned painters lived on, of course, and continued to paint, Cornelis Cornelisz. until 1638 and Bloemaert until 1651; but their work became more and more isolated from the new realist approach.

So history painting, once the pinnacle of pictorial art, gradually became a minority art. Most young painters opted for a specialist career in one of the categories of painting that were emancipated by realism. This was also, of course, a result of the economic situation within which they had to find a living as professional painters.

The war with Spain, which had started primarily as a reaction to economic repression, also involved religious repression; the Spanish regime refused the Protestants, of which there were a considerable and fast-growing number, freedom of worship. When in the course of the war the Dutch gained control over their own provinces, they began to regard themselves as a Protestant nation; the remaining Catholics were tolerated as long as they refrained from open worship. Their churches were dismantled and converted into Protestant ones. 'The best careers, that is the churches, no longer exist,' noted Samuel van Hoogstraeten in his book on painting of 1678, explaining and, of course, deploring the disappearance of history painting as a major genre in seventeenth-century Dutch art.

Still, that was not the whole reason. In realism itself, in what may be called its aesthetic spirit, resided something which did not encourage history

painting: it was a certain distrust of too fanciful an imagination, and a desire to stay close to home, to stick to what one could actually see and know. And then, any moral or spiritual edification, which one might want from painting, could be provided by genre pictures, too, or else by still-lifes or landscapes. Also, artistically, genre pictures could fully replace history paintings, for in composition and design they posed the same set of problems: they were equally difficult.

Yet history paintings continued to be produced; the transition from one set of cultural values to another is, of course, never complete and sudden. There seems to have been a public, too, though possibly a different one from before (which in itself is an indication of the cultural change that had taken place). In the sixteenth century there was hardly a specific public for religious history painting; everyone who came into a church to worship belonged to that public. The public for mythological painting was, of course, more restricted, since it was usually produced for the houses of the upper class and the aristocracy. A large number of these mythological pictures were, however, widely distributed through the newly invented means of graphic reproduction – which suggests an interest on the part of a much larger audience. In seventeenth-century Holland, it seems to have been an intellectual upper class, of humanist origins and with humanist interests, that remained concerned with history painting and continued to patronize it. The history paintings painted by artists of a younger generation have a markedly different flavour from the grand compositions of someone like Cornelis Cornelisz. – and here, too, one senses the influence of realism.

The fundamental difference between the old and the new approach to history painting was the development of a remarkable clarity of narration. In a picture like *Odysseus and Nausicaa* by the Amsterdam painter Pieter Lastman (1583–1633), the composition is carefully designed to present the clearest possible account of events – and the solution found is as simple as it is effective. The scene may be generally characterized as one of interruption and surprise: Nausicaa and her friends are having a picnic on the beach, when a stranger materializes from his hiding-place, asking for hospitality. The sudden appearance of the stranger Odysseus, constitutes an interruption; they are frightened, except for Nausicaa who, standing apart, accepts the stranger and bids him welcome. Such is the basic structure of the story, and Lastman has followed it closely. The suddenness of Odysseus' appearance is clearly demonstrated by placing him, rather isolated, in the right-hand corner; he is further isolated by the picnic laid out on the ground. Opposite and confronting him, stands Nausicaa. She answers Odysseus, who kneels in supplication, by extending her arms – a gesture of mild surprise as well as of welcome. Her friends act in a much more frightened way, making the

41

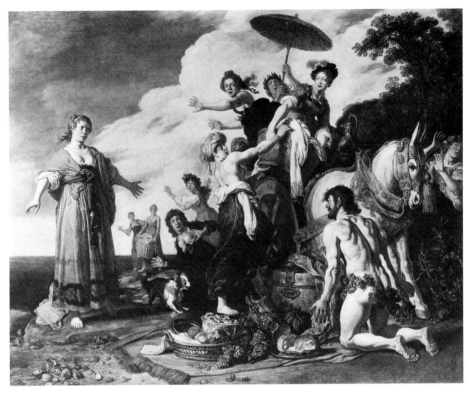

41 LASTMAN *Odysseus and Nausicaa* 1619

appropriate conventional gestures. A little dog barks at Odysseus. This
tightly organized, very agitated group seems to be rather apart from
Nausicaa and Odysseus; it acts, one could say, as a kind of chorus, expressing
the emotional content of the scene, while the central Nausicaa/Odysseus
encounter is characterized by a strange stillness.

It is this strong concentration on the basic narrative structure of the subject
that makes Lastman's picture so profoundly different from the history
paintings of the preceding generation. This difference is more fundamental
than certain differences in design – for instance in the design of human
bodies. Lastman's drawing, in this respect, is more realist and matter-of-fact
than the stylized, idealist design of the nudes in, for example, Cornelis
Cornelisz.'s *Marriage of Peleus and Thetis*. In other aspects, too, Lastman has
adopted a more realistic attitude. It looks as though he really thought about

11

64

the clothing of the women, about how the horse should be harnessed, and he thought about it *historically*.

He realized that the story took place in ancient times, and he tried to evoke those times in the details of his painting. Whether he was actually right about those details hardly matters now; he assumed he was right, and so in all probability did his audience. All this is part of a new conception of narrative history painting, in which a clear narration, following the structure of a story, was more important than presenting yet another brilliant invention. For the new generation of history painters such as Lastman an arrangement like Cornelis Cornelisz.'s *Marriage of Peleus and Thetis*, in which the subject only provides a motive for a highly inventive arrangement of elegant male and female nudes, was almost too arbitrary. On what grounds, and with what justification, could one paint such a group of nudes – however pleasing they might be to look at? Was not the fundamental task of history painting in jeopardy: to teach, to please, to move? Was not the pleasing stressed too much? The new history painting was, at least in part, a recourse to the original, orthodox conception: the presenting of a clear narrative. Mannerism had changed this conception by emphasizing visual elegance. And elegance is the last quality one would assign to Lastman's painting.

The new approach to history painting, manifesting itself in the painting of Lastman, his contemporary Jas Pynas (1583–1631), and others, is closely related to the emergence of realism in Holland. The new realism implied an orientation towards the familiar world, towards what the eye could grasp directly; and the new history painting of Lastman and Pynas is based on a new orientation towards what is tangible in an historical subject: the text. For Cornelis Cornelisz., an historical text was an occasion for a Mannerist fantasy, a virtuoso performance in high Art, but for Lastman the text (its structure and its emotional content) was the beginning and the end. He took the text seriously, much as Esaias van de Velde took the Dutch countryside seriously.

The choice of a text and its reading also had a more crucial meaning for Lastman or Pynas than for Cornelis Cornelisz. or any other Mannerist artist. From the way Cornelis Cornelisz. handled the story in the *Marriage of Peleus and Thetis*, one can deduce that he was primarily interested in a *setting*. That was what a story should provide – a general context in which an artist retained a certain freedom to organize his painting in the most imaginative way possible. He left out, for instance, one very conspicuous moment in the story: the intervention of Eris, Goddess of Envy, which caused the party to end in discord – and it was the ending which gave the story its historical weight, as this very quarrel among the Gods eventually led to the Trojan War. Cornelis Cornelisz., however, chose to ignore this; his banquet is still

quiet and peaceful, with absolutely no sign of trouble. Lastman and Pynas, however, had different needs. Their object was to present a story as an account of historical events, in the clearest, concisest possible way. Consequently, they preferred texts with a strong narrative content and a clear structure. Such a story as Odysseus and Nausicaa, a sudden appearance provoking strong reactions, answered this requirement.

The strongly modelled body of Odysseus, as well as the realistic design of the other figures in the painting, suggest that Lastman must have been aware of the dramatic art of Caravaggio (1573–1610). This is hardly surprising; for a young artist in Rome (Lastman stayed there probably from 1603 until early 1606) the example of Caravaggio's naturalistic conception of history painting (amid all the ambiguous elegance of Late Mannerism) must certainly have been impressive. Still, it was only in this insistence upon direct observation of nature, and this turning away from the artificial formulae of Mannerist style, that Lastman followed Caravaggio. This type of composition, with many small figures in a small-sized picture, seems much more to derive from the example of another painter then in Rome, the German Adam Elsheimer (1579–1610) – who was also influenced by Caravaggio's naturalism; looking at it, however, with a miniaturist mentality. Why exactly this small-scale version of Caravaggio appealed to Lastman and Pynas, is difficult to guess. Maybe they found it difficult to survey the grand scale of Caravaggio's work, and felt that a smaller scale was more suitable to their manner of narration.

It was actually the so-called Utrecht 'Caravaggists', notably Terbrugghen and Honthorst, who brought Caravaggio's art, in direct imitation, to the northern Netherlands. Their deeper involvement with Caravaggio might well be the result of a much longer stay in Rome than experienced by either Lastman or Pynas. Lastman and Pynas were in Rome immediately after Caravaggio created his masterpieces, at a time when his style was still the subject of fierce debate among artists and critics. That they chose to accept a toned-down influence from Caravaggio, is quite understandable, for they lacked a revolutionary temperament. Neither were Terbrugghen and Honthorst revolutionaries; but by the time they were in Italy (Terbrugghen, c. 1604–14; Honthorst, c. 1610–20) the implications of Caravaggio's art had been much more widely accepted by artists of different character and nationality (among them Peter Paul Rubens); and in the hands of his immediate followers Caravaggio's art had clearly become an important tendency.

Though Honthorst became the most famous Dutch Caravaggist, Terbrugghen was undoubtedly the most interesting. (Travelling in Holland in 1627, Rubens commented, or so tradition has it, that 'looking for a painter

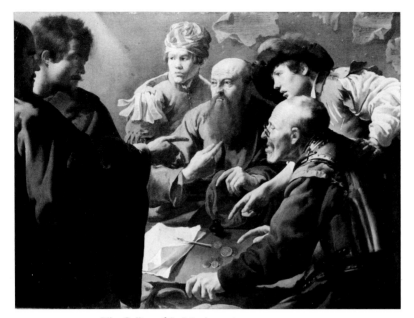

42 TERBRUGGHEN *The Calling of St Matthew* 1621

he had found but one, namely Henricus ter Brugghen.') One of the best and
most typical paintings by this master is *The Calling of St Matthew* of 1621. In 42
its strong, dramatic composition the Caravaggesque heritage is clear, while a
certain high-keyed realism, for instance in the treatment of facial
physiognomy, shows that Terbrugghen at the same time remained within
his native Dutch tradition. The narrative structure of *The Calling of St
Matthew* is not dissimilar to that employed in Lastman's *Odysseus and* 41
Nausicaa. Here too, sudden intervention is the content. Only, in
Terbrugghen's hands, this intervention is even more dramatically
concentrated. The figures, seen from the waist up, are actually life-size,
which in itself gives them a more immediate presence than Nausicaa or
Odysseus. But more importantly, there is nothing in the picture which
distracts from the crucial moment. The picture is almost completely filled
with figures, against a greyish wall. On the left, darkly silhouetted, is Christ,
pointing to Matthew, the tax-collector. His hand cuts very conspicuously
across the open space in the middle, over the table with the money and the
papers. Matthew shows his awareness of Christ's presence by pointing to
himself and, more discreetly, by having taken off his hat. In this dialogue of

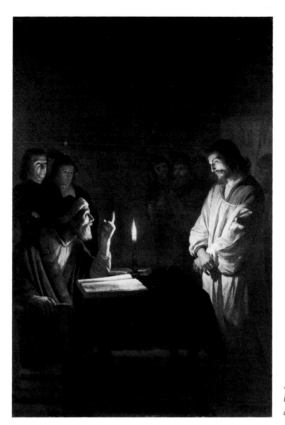

43 HONTHORST *Christ before the High Priest* c. 1617

two hands the essence of the story is clearly portrayed. The strong bond between Christ and Matthew is also very private; it escapes the attention of the others present. The two boys might have a slight intimation of what is going on, but the rather miserly-looking old man only has eyes for money.

Compared to Terbrugghen, whose boldness and compositional ingenuity he could never match, the paintings of Honthorst look almost timid; and certainly they are less inspired. He did, however, develop a speciality which made him famous. He became the master of artificial light and of mysteriously illuminated night scenes which, in Italy where he enjoyed high patronage, earned him the nickname 'Gherardo delle Notti'. The use of deep and strongly contrasted shadows had been picked up by Caravaggio as a means to heighten dramatic impact, and it was this device which Honthorst carried on. In his hands, however, it became a pictorial trick. An example is

43 *Christ before the High Priest*, a painting typical of Honthorst's historical manner, painted around 1617 when he was still in Italy. The narrative

structure of this picture is in fact singularly simple. In a dark space, two main figures emerge, dimly lit by a candle. To the left is the High Priest, in stern profile, admonishing Christ who stands before him in resignation. The narration, regulated by the way the light falls on the two protagonists, is based upon a dialectic between these two figures – upon their different physiognomy, their different postures and gestures. The burning candle, then, occupying almost exactly the visual centre, disturbs the delicate emotional relationship between the High Priest and Christ. It is too conspicuous, as if Honthorst were trying to prove his pictorial adroitness.

Rembrandt Harmensz. van Rijn (1606–69) was a painter who consciously tried to uphold the classic hierarchy of values in art. In a period when most of his colleagues (for example Steen, Ruisdael, Vermeer, Hals and Van Goyen), found themselves forced to become specialists in portraiture, landscape, still-life or genre, Rembrandt persisted in the grand old ambition to be a history painter. Certainly, other painters did history paintings occasionally, and sometimes a landscape painter would slip an historical subject as a narrative incident into his landscape; but none of them can really be called a history painter in the sense in which Rembrandt was one. History painting was for him still the highest form of pictorial art, and for that reason in 1624 he went to Amsterdam for six months to study with Lastman. To choose him as a teacher already implied a clear decision; it meant, too, that Rembrandt had no desire to associate himself with the *modern* movement of realism. The earliest pictures we know of his (the first is dated 1625) are all histories; landscapes, for instance, emerged only ten years later and then they had little to do with the current realist mode. One of those early history paintings, *Simeon in the Temple* (1628), shows the impact of Lastman's 44
narrative style. It is a tight construction of four different 'actors', each one clearly defined by strongly contrasted lighting. Not much of the surrounding space is shown; the location is indicated only by the heavy column, and all attention is directed towards the crucial, narrative moment. For pictures like these, clear and simple and yet highly intelligent in conception, Rembrandt was already at an early age admired and praised by contemporary connoisseurs of art. One of his admirers was the scholarly poet and civil servant Constantijn Huijgens, who, in 1633, was instrumental in securing Rembrandt one of his very rare commissions for a history: a series, for the Stadtholder, of five paintings illustrating the Lord's Passion. There is a correspondence about this commission between Huijgens, who was Secretary to the Stadtholder, and Rembrandt. In one of these letters, which mostly deal with problems of delivery, the artist apologizes for the late delivery of two pictures, *The Entombment* and *The Resurrection*, where 45
Christ rises from the dead to the great alarm of the guards; he says that the

work took so long because he 'concentrated on expressing the greatest and most natural movement [*beweechgelickheyt*]'; it is important to note that both physical motion and emotion are meant. This text, the only utterance on a painting we have from Rembrandt, make it clear, especially in connection with the little picture of *The Resurrection*, what Rembrandt's concerns in history painting were. They were essentially those of Lastman: painting a history meant reading the text scrupulously, but with imagination, providing the moment with the richest significance, and constructing the picture round that moment.

Visually, Rembrandt soon departed from Lastman's style. The narrative structure of *The Resurrection* is rather similar to that of Lastman's *Odysseus and Nausicaa* – but how very different is the treatment of space and light. The spatial setting in both pictures is defined only by implication, by flashes of light that are arranged in accordance with narrative interests: they pick up (like spotlights in a modern theatre) the highlights of the action, emphasizing them and drawing them to the beholder's attention.

In Rembrandt's earlier work this lighting (the famous chiaroscuro) is very Baroque, very diversely distributed through a vague space. In the later paintings, notably *The Conspiracy of Claudius Civilis* (1662) or the great *Jacob Blessing the Sons of Joseph* (1656), the light appears more concentrated: less bizarre, one is tempted to say. This development goes with a slow progression towards a shallower space – a space which no longer has secret, distant corners. The space in *Jacob Blessing the Sons of Joseph* is almost a non-space; there is only a foreground holding an extremely concentrated

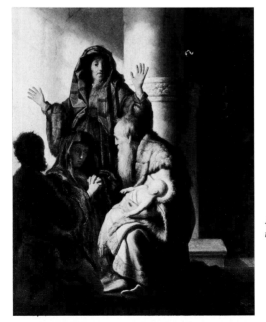

44 REMBRANDT *Simeon in the Temple* 1628

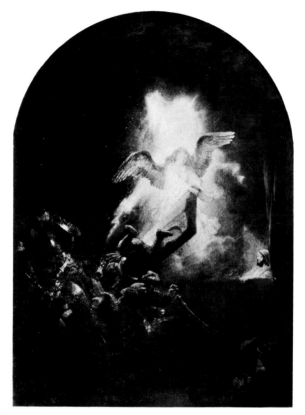

45 REMBRANDT *The Resurrection* 1633

composition very close to the beholder – without any virtuoso artistry but still deeply moving. The distance between this painting, so devoid of composition and so personal, and an earlier work like *The Wedding Banquet of Samson* marks Rembrandt's unique, and, within the context of what was going on around him, lonely development. This magnificent body of work, comprising history painting, portraits, group portraits and landscapes, was bound to be criticized by all those theorists who found it chaotic and missed a clear theoretical viewpoint – but at the same time they, too, were fascinated by its undeniable quality. Rembrandt was the 'first heretic in Art', as one contemporary writer, Andries Pels, called him; but he was the greatest heretic.

 On St Luke's Day 1641, in Leiden, the minor painter Philips Angel pronounced an address *In Praise of Painting*. He made special mention of Rembrandt's *The Wedding Banquet of Samson*. That Angel chose this painting to praise and set up as a commendable example, is not surprising. Any

47

supreme example had to be a history painting, of course; and by 1641 Rembrandt was undoubtedly the best history painter in Holland – while his work then did not show so clearly the idiosyncrasies for which he would later be criticized by classicist writers. What exactly Angel found laudable in Rembrandt's picture is more interesting, and provides an insight into what knowledgeable observers of painting around the middle of the seventeenth century expected from history painting. Before coming to Rembrandt, Angel proposed to his audience (which must largely have consisted of painters) that, before painting a subject, they should first carefully read and contemplate the relevant text so that artistic freedom would not be abused and the spirit of the story would not be violated. Here Angel seems to be criticizing the Mannerists' liberties – just as Lastman had done twenty years before, in his *Odysseus and Nausicaa*. And it is for this, for a careful reading of the relevant text (in Judges 14–16) that Angel praises Rembrandt, 'this bold mind'. Rembrandt's ability to grasp the deep spirit and significance of a subject, his highly independent, personal reading of a text, was one of the major reasons for his unique stature as a history painter.

46 REMBRANDT *The Conspiracy of Claudius Civilis* 1661–62

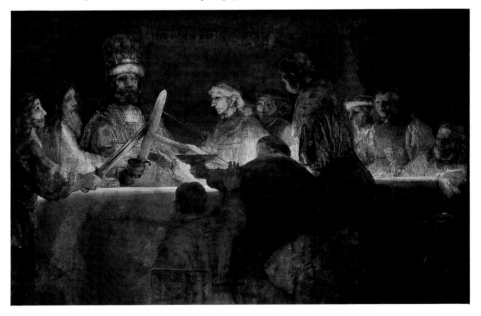

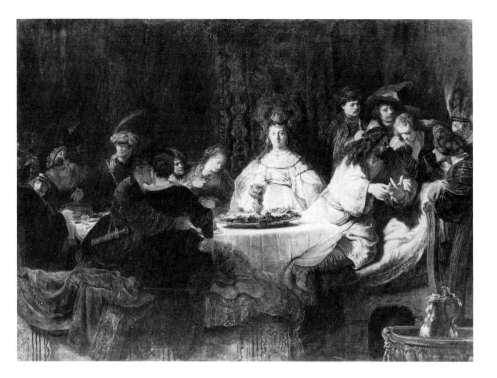

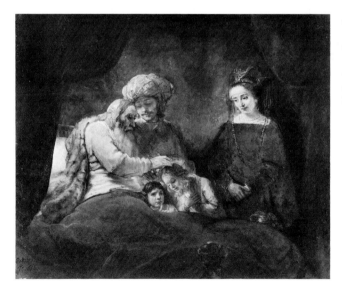

47 REMBRANDT *The Wedding Banquet of Samson* 1638

48 REMBRANDT *Jacob Blessing the Sons of Joseph* 1656

In this context, it is instructive to review the unfortunate history of the only commission for a public history-piece Rembrandt ever received – the commission to paint the conspiracy of Claudius Civilis and other Batavian leaders against the Romans. This was for a cycle, illustrating the Batavian Revolt, for the lunettes round the great hall of the new classicist Amsterdam town hall. For this commission Rembrandt was already second choice. At first Govert Flinck (1615–60), a one-time pupil of Rembrandt, was asked to provide sketches for a series of paintings illustrating important phases in the Batavian Revolt in AD 69 against Roman rule in the area which is now the Netherlands. In a typically humanist construction of historical parallels, the Batavian Revolt was regarded in the seventeenth century as the prefiguration of the insurrection against Spain, and thus a suitably symbolic and elegant subject in the public gallery of the new town hall – the largest, most impressive building in what was, by 1660, certainly one of the major cities in the known world. Flinck's designs were accepted, but the artist did not live to execute them. He died suddenly, early in 1660. After that, the commission was distributed among several painters, including Rembrandt. No doubt because Rembrandt had gained a certain fame as a painter of chiaroscuro scenes, he was commissioned to do the oath-taking which started the revolt and made Civilis its leader. Reportedly this oath was taken at night in a sacred grove. The picture which Rembrandt finished, early in 1662, was of brutal monumentality. Characteristically, too, he followed almost to the letter the written account of the event which is found in the *Histories* of the Roman author Tacitus. We are informed how Civilis, the mighty one-eyed chieftain, summoned the chief nobles of his tribe to a sacred grove. There, speaking vehemently, he enumerated for them all the evils of their slavery. His speech, wrote Tacitus, 'was received with great approval, and he at once bound them all to union, *using the barbarous ceremonies and strange oath of his country*'. It was this last sentence that was contemplated by Rembrandt, in the profound way praised twenty years before by Philips Angel, and which led him to give his picture its almost savage character. We see the Batavian noblemen round a table, from which emanates a strange burning light, illuminating the conspirators who are otherwise surrounded by darkness. Civilis is seen frontally; the spectator is literally confronted with this one-eyed and awesome hero clad in red and brown and gold, towering above the others who cross their swords with his over the table. All the others are looking intently at this sword-crossing, this 'barbarous ceremony', which marks the secret oath, accepting Civilis' leadership implicitly.

This staggering picture was not accepted by the authorities responsible for the decoration of the town hall. It was *in situ* only for a short time in 1662

49 REMBRANDT *The Conspiracy of Claudius Civilis* (drawing)

before it was removed; later, for reasons unknown, someone, presumably Rembrandt himself, cut the huge picture down to its present size (maybe to make it more saleable: as a drawing testifies, the scene was originally set in a 49 wide architectural frame, probably to match the architecture of the gallery where it was to be placed). It seems that it was precisely Rembrandt's attentive reading of Tacitus' text which led to the rejection of the painting. The depiction of this particular episode of early national history was for Rembrandt a specific artistic problem, which he approached in his usual straightforward manner. The city authorities, however, were less sensitive to artistic excellence; to them, history painting was the servant of a symbolic and ethical interpretation of history. The painting should not just illustrate the historical event which was its subject: it should, at the same time, be keyed to the lofty atmosphere with which the scene, through its symbolic significance in national history, inevitably came to be imbued. The painting, in short, had to be in accordance with the rules of decorum. But what, then, was decorous? What rules were there? Never before had the city of Amsterdam given such a grand commission. The authorities responsible were amateurs, and naturally they went by the book.

In 1612 a little book had been published about the Batavian Revolt which meant much to the young Republic. It contained thirty-six elegant etchings

by Antonio Tempesta after designs by the respectable, learned painter Otho Vaenius, each etching with a caption paraphrasing the relevant passages in Tacitus' account. This book became an immediate success and was reprinted many times. The illustrations in the Vaenius-Tempesta book were then so widely circulated that they, unavoidably, moulded the visual imagination; slowly, they had become canonical. Flinck, too, had in his design drawn heavily on those popular prints. Rembrandt did not, however, because he thought that the Vaenius interpretation of the text was wrong; and he could not perpetuate the error just because it had become a cherished tradition.

Consequently there are, in Rembrandt's version, two very conspicuous deviations from the usual pictorial interpretation. He had depicted Claudius Civilis as an almost savage character with only one eye – as Tacitus had reported. But in no way did the loftiness of that conspiracy (which led to national freedom) allow for a hero thus blemished. Vaenius, and after him Flinck, had realized this and had cleverly portrayed Civilis in profile – just as the Renaissance had done with that other one-eyed hero, Hannibal. And then the taking of the oath itself, also too savage. Vaenius and Flinck used the form they knew from classical sources, which of course was the Roman way of taking an oath: *iunctio dextrarum*, the clasping of the right hands. But Tacitus had explicitly spoken of 'barbarous ceremonies and strange oath', which Rembrandt visualized as the joining of swords. This as well as other aspects (such as the mostly crude physiognomy of the participants) gave Rembrandt's painting a brutal character incompatible with its sensitive function within a cycle exalting the fatherland's earliest history.

In a curious way this episode illustrates the *negative* freedom which in the Dutch Republic existed for history painters – or for all painters maybe, with the exception of portraitists. Interest in history painting was taken only by a relatively small group, mainly consisting of intellectuals, and it seems that many of them had no more than a very mild interest in the proper application of the rules of painting as expounded in theoretical treatises. The general public certainly had little or no knowledge of the rules; they took pictures as they came, be it genre or landscape or history. From this situation resulted a freedom in that the public, in general, did not lay down strong conditions in advance. But it is, once more, a negative freedom; a freedom resulting from lack of interest in the specific problems which confront a painter. And then, as soon as the public (in this case the city of Amsterdam) is forced to take a direct interest and make a judgment, they suddenly accept all the tenets of humanist art theory and for a model they fall back on etchings done forty years before!

To appreciate how far Rembrandt's *Conspiracy of Claudius Civilis* deviated from the classical, humanist notion of a well-designed *historia*, it might be

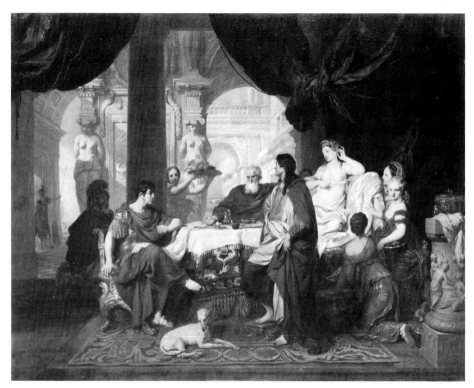

50 DE LAIRESSE *The Banquet of Antony and Cleopatra c.* 1680

compared with *The Banquet of Antony and Cleopatra*, painted around 1680 by 50
Gerard de Lairesse (1640–1711) a former student of Rembrandt's who
became the principal Dutch advocate of the classicist doctrine that was
spreading over Europe from the French Royal Academy. Of course, the
subject is fundamentally different. It is one of quiet repose, and that gives the
picture its general quality. But there is another, much more important
difference from Rembrandt's painting. Here every element is well defined,
in line and colour, and the entire space is elegantly lit. The dignity of the
scene is properly, decorously matched with the chic clothes and with the
nobility of the background architecture. Nowhere is there a dark or con-
fused passage. The carefully painted details suggest that De Lairesse was a
very learned painter indeed. Ten years after he finished this picture, which is
typical of the classicist, French-influenced phase in Dutch painting, De
Lairesse went blind. He then started to give lectures on the foundations and

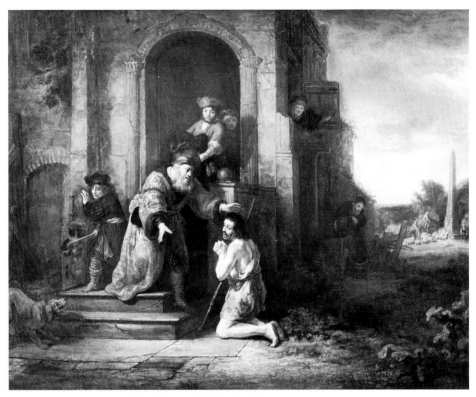

51 FLINCK *The Return of the Prodigal Son*

rules of art; these lectures were collected in two books, one on drawing
(*Grondlegginge der Teekenkunst*, 1701) and one on painting (*Het Groot
Schilderboek*, 1707). In these treatises, the same themes are reiterated as in
earlier theoretical writing (Van Mander or Hoogstraeten), but in a much
stricter fashion. In these two highly intelligent and systematic books, De
Lairesse describes the infallible rules of art. A painter, he wrote, should not
only trust his own observation or experience, should not just follow his
inspiration; his instinct must be checked by respectful study of the traditions
of ancient and modern masters. Only then can a true equilibrium be
achieved. And, although De Lairesse undoubtedly respected Rembrandt on
several points, he could not accept his position: Rembrandt always relied too
much on personal convictions – as indeed he found out when the
Amsterdam authorities rejected the *Claudius Civilis*, with less eloquence no
doubt than De Lairesse, but quite likely on similar grounds.

78

Then there was another important argument with which his critics reproached him; since he did not follow the rules of Art his style could not be taught. His manner was, by implication, based on private insight and visions uncontrolled by Reason. His pupils, such as Flinck, were unable to follow him; they only took the motives, types of composition or the arrangement of colours. In general, however, they borrowed these quite eclectically; and when eventually a lighter style became fashionable in Amsterdam, they followed that: witness Arnold Houbraken, the author of an early eighteenth-century anecdotal collection of artists' biographies, who wrote: 'Flinck left this manner of painting with much labour and difficulty since, before Rembrandt's death, the world had its eyes opened by true connoisseurs to imported Italian painting and bright, clear painting came into fashion again.' Only Aert de Gelder (1645–1727), who came to Rembrandt as late as 1661, tried to remain close to his master's example. His *Holy Family* shows these origins and also unavoidably reflects the different time in which it was painted, and the different aesthetic concerns. The dress of Mary, for instance, has a quite exaggerated Oriental quality, and the motive which is introduced to effect some movement in the composition (the orange which Joseph holds out for the baby to grasp) has a picturesque sentimentality. This motive, which Rembrandt would never have allowed himself, brings De

51

52

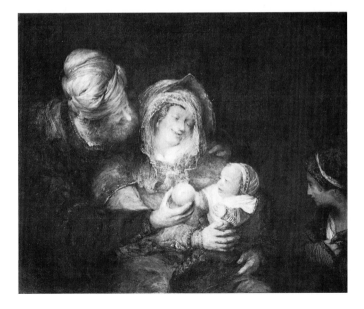

52 DE GELDER *Holy Family*

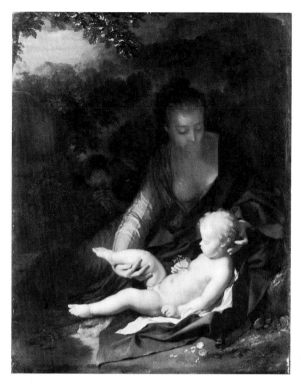

53 VAN DER WERFF
*The Rest on the
Flight into Egypt*
1706

53 Gelder's picture curiously close to *The Rest on the Flight into Egypt* (1706) by Adriaen van der Werff (1659–1722), who became the most famous and highly paid history painter of his generation – more famous, even, than De Lairesse. With this slick, ambiguous picture Dutch painting had finally moved away from the proud, native realism which had characterized it in the first half of the century. It had entered a new phase.

Images of pride

Types of portraiture

By 1610, the year that Frans Hals (1581–1666) joined the Haarlem Guild of St Luke, the art of portraiture, lacking real imaginative impulse, had become very orthodox. The leading master at the time – or at least the most popular – was Michiel van Miereveld (1567–1644). A real specialist with a steady output, Miereveld was in no mood for innovation. His portraits all show the same quiet formality. Their execution, the delicate drawing of the face as well as the rendering of texture is usually meticulous; it was this that made him well respected and famous. Hals showed a very different temperament; Haarlem, too, where he emerged as an artist, was very different from the quiet city of Delft where Miereveld worked. In Haarlem, Hals was no doubt in close contact with his younger contemporaries, Esaias van de Velde and Buytewech, who were discovering and formulating a new type of realism. And there can be little doubt that the development in Hals's art towards a greater vivacity and actuality in

54

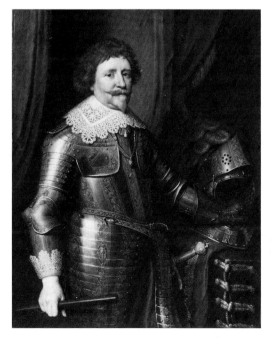

54 MIEREVELD *Frederick Hendrik*

81

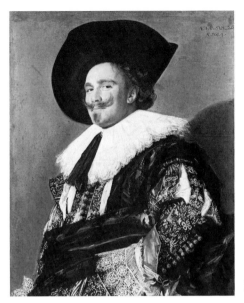

55 HALS *The Laughing Cavalier* 1624

portraiture, a closer approximation to the living person, reflects a similar realist attitude.

An exuberant male portrait, done in 1624, and traditionally named *The Laughing Cavalier*, shows how Hals, within the context of early realism in Haarlem, was able to move away from the formalism of Miereveld's portraiture. First, of course, there is the sheer brilliance in execution, the swiftness and vivacity of touch for which he became famous. Much more innovative, however – and more daring – is the composition of the portrait. Compare it with Miereveld's. There the Stadtholder Frederick Hendrik is placed in such a way that he seems at rest. He stands there, dignified, to be portrayed in all his dignity. In Hals's picture, however, the subject has taken a more dynamic stance, which is an effect of certain tensions which the artist, very subtly, has introduced into the structure of the painting. The picture itself is rectangular, but in the position of the subject nothing conforms to that rectangularity. The figure is placed obliquely, and this position is strongly accentuated by the dashingly protruding arm and by certain elements in the sitter's dress – notably the collar and the sash. At the same time he is seen slightly from below; our glance, therefore, goes upwards to his face, which then seems to look downwards and takes on an arrogant air which is emphasized by the dashing hat.

So subtle is the system of conflicting tensions in the work's structure that it is difficult to describe it more accurately. But the result is very clear; this

82

portrait breathes a vivacity which had not been achieved before. At the same time, however, it retains in essence the classic and very tenacious formula which had existed for the portrait since the middle of the sixteenth century. From this formula, Hals could only deviate in detail; he could imbue it with a new stylistic impulse from contemporary realism, but he could not change it.

No category in pictorial art is as conservative as portraiture. The major reason for this is that portraiture, more than any other category, is subject to strict conditions, the most important of which springs from its social sensitivity. A portrait is not just a likeness of an individual to be preserved for posterity; it is also an image of pride, a projection of social position. A man who wants his portrait painted cannot but attach a certain importance to himself, in whatever sense, and he is not likely to take chances; he is concerned about his appearance. Normally, and the history of portraiture testifies to this fact, he opts for the classic formula – the formula which has proved its efficiency.

What might be called the classic type of the formal portrait was established around the middle of the sixteenth century, by artists who were in contact with advanced Italian painting. Until then, Early Netherlandish portraiture had been based, almost exclusively, upon almost neutral observation – as was logical within the tradition of the meticulous, descriptive realism then existing. Lucas van Leyden, for instance, painted the *Portrait of a Man Aged Thirty-eight* shortly after 1520, a hundred years after 56
Van Eyck had created his highly influential portrait-type in Bruges – and still Lucas's portrait, with its serene modesty and its complete lack of rhetorical

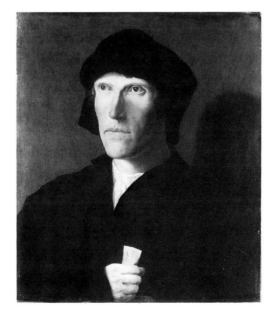

56 LUCAS VAN LEYDEN
*Portrait of a Man Aged
Thirty-eight c.* 1520

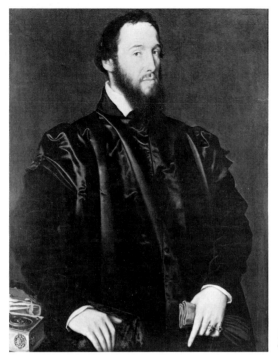

57 MORO *Cardinal Granvelle* 1549

flavour, is totally within that tradition. This is a clear proof of portraiture's inherent conservatism, the more so when one realizes that Lucas in his history painting belonged to the avant-garde of his day, and had left the static narrative style of the fifteenth century far behind him. A few years later, however, changes became noticeable. Maerten van Heemskerck's portrait of *Pieter Bicker*, Mint Master of Amsterdam, of 1529, not only presents a likeness of the man: it also seeks to convey his dignity. Heemskerck sought to enahance the sitter's presence by giving him a pose which is impressive (mainly because the head is so high up in the picture): it is no longer neutral, as in Lucas's portrait. No doubt Heemskerck's formula had its origins in Italy, where a rhetorical trend in portraiture had emerged as a consequence, it would seem, of the High Renaissance and Mannerist obsession with brilliant invention.

In closer contact with Italian aesthetics was Anthonie Mor (1519–74), a Dutch painter who, through his connections with the international Court of the Emperor Charles V, became (under his Italianized name Antonio Moro) one of the best-known portraitists of the century. It was he who brought to

58

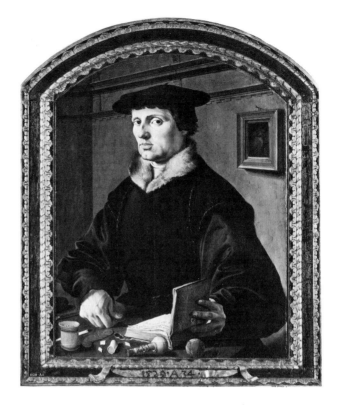

58 HEEMSKERCK *Pieter
Bicker* 1529

the Netherlands the classic type of the fashionable portrait – of which the
subtly formalist portrait of *Cardinal Granvelle*, counsellor to the Emperor, of 57
1549, is an example. The main characteristics of this type are the high
position of the head, giving an impression of austere dignity (and at times
even arrogance) and the fact that the head, if only slightly, is turned in a
different direction from the body. This suggestion of movement, then, of the
head in relation to the impressively broad body, gives a feeling of alertness
which is accentuated by the sideways glance. (Note, in retrospect, how in
Lucas's portrait the head does not turn in relation to the body, while the eyes
have a strangely fixed stare.)

Frans Hals's magnificent *Portrait of a Gentleman* from about 1650 leaves no 59
doubt as to the tenacity of the classic type. At the same time this portrait
makes it clear that Hals's innovations are innovations of degree; which,
however, still suffice to give it a totally different quality from Moro's
picture. For, in relation to Hals's gentleman, whose presence is very direct,
without inhibitions, Moro's Granvelle has something aloof about him, as if
he were intent on keeping his distance.

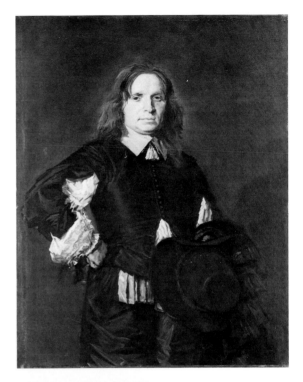

59 HALS *Portrait of
a Gentleman c.* 1650

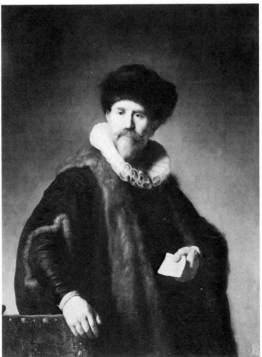

60 REMBRANDT
Nicholaes Ruts 1631

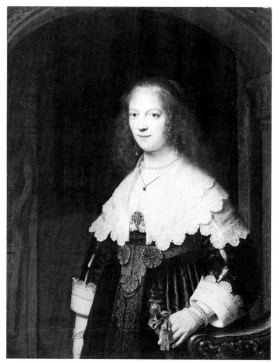

61 REMBRANDT *Maria
Trip* 1639

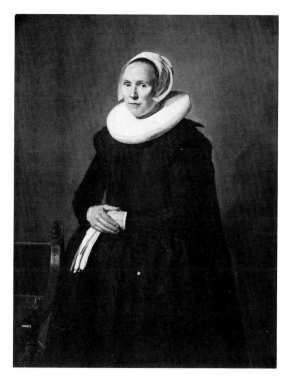

62 HALS *Freyntje van
Steenkiste* 1635

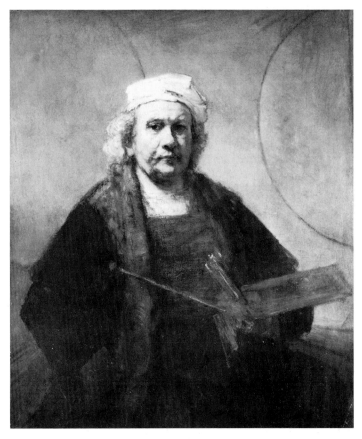

63 REMBRANDT *Self-Portrait*

A similar impression of immediacy and alertness is found in one of the
60 earliest commissioned portraits by Rembrandt, of the merchant Nicolaes
Ruts, which was painted just after the master had moved to Amsterdam in
1631, where he went (as an early biographer reported) because he could find
more profitable portrait commissions there than in his native Leiden.

In fact, Rembrandt had quite a profitable practice as a portrait-painter;
and even though he might have considered it primarily as a source of income,
he invariably applied all his artistic intelligence to the task. Many of the
portraits, especially those of the 1630s and early 1640s, are formal in nature,
61 and do not go beyond the established type – like the portrait of *Maria Trip*
(1639). In pictorial handling it differs from, for example, a typical female
62 portrait by Hals, *Freyntje van Steenkiste* (1635). In type there is no great
difference. Both portraits show the peculiar restraint which was then typical
of the female portrait. On other occasions, however, when no compliance

88

with official style was demanded, Rembrandt might depart from the normal portrait type. When he painted himself he was of course free to follow his own instinct; and if one reviews the self-portraits, of which there are a considerable number, one sees how here the point is not how a man *should* look but how, according to the different possibilities the art of painting offered, he *might* look. Instead of fixing a type, Rembrandt used the self-portraits to explore formal possibilities. Another category in which Rembrandt was free to do as he liked were portraits of his own family. The deeply sensitive, private portrait of his son Titus (1655) is obviously quite outside any formal tradition of portraiture. The boy is depicted at his writing-desk – at a moment when he is not writing but given to thought. This gives the portrait a quality of absent-mindedness which is basically foreign to official portraiture.

Not only single portraits were painted. There were also double portraits, often of couples and made in commemoration of the marriage. It might seem that here, where he had to relate two people within the coherent composition, the painter would have more liberty – but that is not borne out by the facts. Equally strict conditions were in force in this branch of portraiture as in the others. They might even have been more so; for here the culturally and sociologically delicate relationship between man and woman was involved. The expression of the more prominent position of the husband, in relation to the wife, was already the major compositional

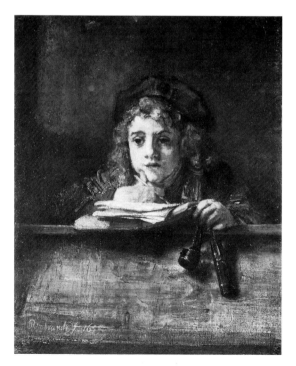

64 REMBRANDT *Titus at his Desk* 1655

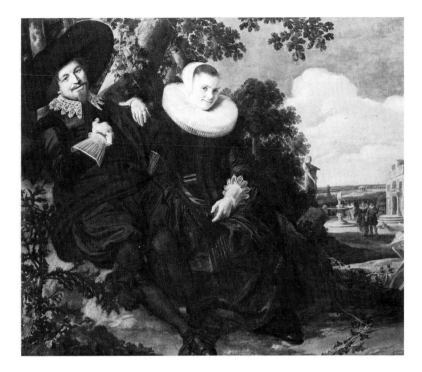

3 motive in *Giovanni Arnolfini and his Wife* (1434) by Jan van Eyck. In this
picture Arnolfini is presented almost frontally; he seems to be stepping
forward, asserting his presence, which is further underlined by the
authoritative gesture of his right hand. He holds his wife's hand, but is not
looking at her; he is gazing straight ahead, out into the world. She, however,
is looking at him, her head slightly bowed; in fact her attitude as a whole is
towards him, submissive and deferential.

65 In the marriage portraits of *Isaac Massa and his Wife* (*c.* 1621) by Hals and
66 of *Abraham del Court and his Wife* (1654) by the successful Amsterdam
portraitist Bartholomeus van der Helst (1613–70), so different in execution
and yet so similar in type, the wives seem only slightly less submissive than
Arnolfini's wife in the Van Eyck portrait; but that impression could be
deceptive. For just as the quiet submission of Arnolfini's wife ultimately
belongs to the aesthetic of Van Eyck's static style, the coquettish, almost
independent look of the wife of Massa may reflect a stylistic concern of Hals.
Hals treated the subject in his own resolute idiom, but clearly without
undermining its basic conditions. For it is abundantly clear that the husband
is the more prominent; he spreads himself out, conscious of his power,

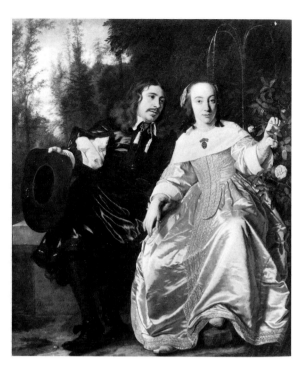

65 HALS *Isaac Massa and his Wife*
c. 1621

66 VAN DER HELST *Abraham del
Court and his Wife* 1654

leaning backwards a little so as to show off his pretty wife, whose pale
complexion identifies her as a 'careful housewife', and who is, literally,
leaning on him – true in her love, as expressed by such floral symbols as the
ivy twining round the tree.

In compositional terms, the relation between husband and wife in Van der
Helst's portrait is much the same as in Hals's picture. Yet the Van der Helst
has a very different mood. Of the directness in Hals's approach, only a
shadow is left. The genial gesture of Abraham del Court (as if saluting the
lady), at the same time leaning slightly backwards and towards her – these
elegant suggestions of movement ultimately derived from Hals. But Van der
Helst has changed them, subtly, almost imperceptibly. It seems that the
gesture of Abraham del Court, his hand poised in the air, is a movement
slowed down – that is, deliberately devoid of the resoluteness that charac-
terizes the pose of Isaac Massa. And Del Court's demure wife, dressed in rich,
shining satin, seems languorous; with a ceremonious gesture, she picks a rose,
the flower which, with its thorns, symbolizes the sweetness and pain of love.

This painting by Van der Helst, elegant and subtly flattering as it is, marks
a general stylistic change in portraiture around the middle of the century. It

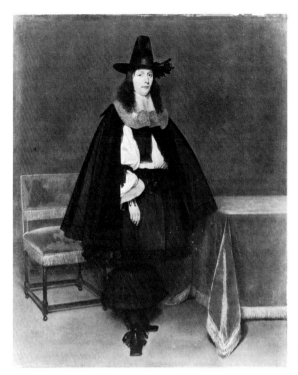

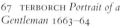

67 TERBORCH *Portrait of a Gentleman* 1663–64

seems likely that this change was occasioned by changes in the society as a whole. The generation of the 'founding fathers' of the Republic had passed away; now a second or even third generation was in power. Prosperity and power corrupted them and led them to acquire a taste for grandeur. It was in this period, for instance, that the city of Amsterdam embarked on the construction of a classicist town hall. This architectural venture, too, suggests a shift in taste similar to that manifested by portraiture. The portrait style of Hals or Rembrandt came to be considered as too simple, too unadorned. The new manner (of which Van der Helst was an important initiator) was very stylish, at times pompous. And, as is shown by Terborch's *Portrait of a Gentleman* (1663–64), or by *Lady with an Orange* (1681) by Caspar Netscher (1635–84), formally the same gestures and postures are employed; but, instead of being suggestive of immediacy and energy, they have now been formalized into rhetorical signs of the sitter's high social status.

At the exhumation and burning of the bones of St John the Baptist, as depicted by Geertgen tot Sint Jans between 1490 and 1495, prominent members of the Haarlem Knights of St John stood in attendance, solemnly

92

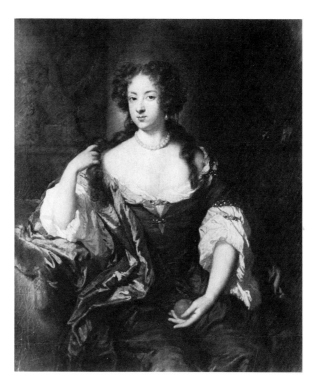

68 NETSCHER *Lady with an Orange* 1681

dressed in black, silently witnessing what was happening to the remains of their patron saint. No doubt these Knights (who paid for the altarpiece) were high-ranking citizens of Haarlem, and many of them must have held civic office. Yet they chose to have themselves painted in this honorary capacity, conscious of the humility expected of Christian Knights.

This formal group of witnesses constitutes one of the earliest examples of the group portrait, which early in the sixteenth century was to become an independent category. It was to gain special prominence, particularly in the seventeenth century – also from an artistic point of view, for with the virtual absence of grand history painting, it was almost the only large-scale type of painting to be executed. Its continued existence was no doubt supported by the ethical point of view (of Calvinist coinage) that it is idle to pride oneself on worldly power; it is much more discreet to have oneself portrayed in a private capacity, as member of a militia company or as governor of a charitable institution or a guild.

The basic problem in group portraiture was to organize a number of portraits of equal individual distinction into a coherent whole. In an early sixteenth-century example, painted in 1533, *The Banquet of the Archers' Guild* 69

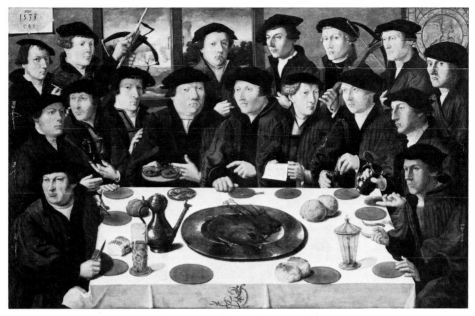

69　ANTHONISZ. *The Banquet of the Archers' Guild of St George* 1533

of St George, by the Amsterdam painter Cornelis Anthonisz. (*c.* 1500–53), the problem is present in all its apparent uneasiness. In a painting of a banquet it is, of course, particularly difficult; when people eat, they sit round a table – but portraying them in that position would mean that some of them would be seen from the back, which was obviously unacceptable. And the solution adopted by some artists, to depict some people in front of the table, seen from the back, who then look over their shoulder, was too awkward to be successful. The archers, all similarly attired in ceremonial dress, are presented in two rows of overlapping portraits more or less behind the table; the lower left- and right-hand corners of the picture are economically filled with two other members. Special attention is paid to the hands; the artist uses them to break up the monotony of the arrangement, to suggest also that the archers are not just sitting there but *together* engaged in something. But that they are having a banquet is not at all evident in the formal structure of the portraits. The banquet is present only in the form of the table, set squarely in the middle of the picture, visually almost totally separate from the portraits – and in a different perspective, too.

70　　The portrait of *The Militia Company of Captain Dirck Jacobsz. Roosecrans*, painted in Amsterdam in 1588 by Cornelis Ketel (1548–1616), presents a

94

different compositional problem. Here the militiamen are, so to speak, on duty: armed and in full dress, they stand before the Renaissance gate of their headquarters (the Doelen). (For unknown reasons, this picture was cut down on all sides; in its original form the Doelen gate was much more conspicuous, serving as the appropriate décor for the group.) Clearly Ketel, who was of Mannerist descent, was more advanced in compositional technique than Anthonisz. His problem was his unwillingness to sacrifice the individual distinctiveness of each single portrait to a conception of the group as a whole. To organize a lightly coherent group would have meant bringing the figures closer together, putting some in the foreground and others more towards the back, making more use of the space. Ketel, however, could not bring himself to do just that. His solution was that of a single row, unevenly spaced (which brings some vivacity into the grouping), and further differentiated by agitated gesticulation and a variety of different and occasionally rather weird poses. The picture looks like a compromise – as indeed do most portraits involving such large numbers of figures.

Only one artist was able to avoid such a compromise: Rembrandt, when he designed *The Militia Company of Captain Frans Banning Cocq* (1642), 71 which got its popular name, *The 'Nightwatch'*, in the nineteenth century after its varnish darkened; it has now been cleaned. The setting here is exactly the

70 KETEL *The Militia Company of Captain Dirck Jacobsz. Roosecrans c.* 1588

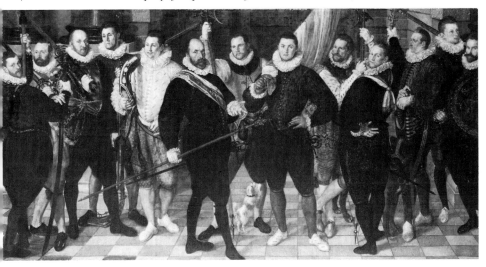

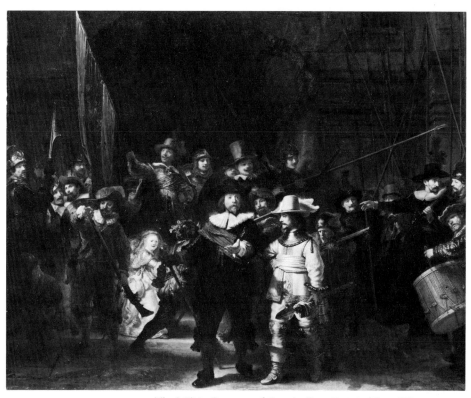

71 REMBRANDT *The Militia Company of Captain Frans Banning Cocq (The 'Nightwatch')* 1642

same as in Ketel's picture: a group of militiamen before a gate. Rembrandt, however, did what Ketel did not: he resolutely let the group take precedence over the individual portraits. He approached the pictorial problem with the instinct of a history painter. Making full use of the available space, he let the group be activated by a single movement, which was described in a caption to a watercolour copy of the painting in the Banning Cocq family album: 'the young Heer van Purmerlandt, as the captain [Banning Cocq], gives orders to his lieutenant, the Heer van Vlaerdingen [Ruytenburch], to have his company of burghers march out'. That is exactly what we see: the captain, making a commanding gesture, and his lieutenant are setting off. Their forward movement provides the motive for the disorder in the background, of militiamen getting into line – a disorder which is sustained and controlled by varied spots of bright light. As Samuel van Hoogstraeten wrote in 1678,

It is not enough that a painter should arrange his figures next to each other in rows, a method that can be seen all too frequently in Holland. True masters unify their work. Rembrandt has done this excellently in his piece [*The 'Night Watch'*] in the Kloveniersdoelen in Amsterdam. Indeed there are many who feel that he has done it all too well, for he has made more of the great unified composition of his own devising than of the individual portraits that were commissioned. Nevertheless this piece of work, no matter how much it can be censured, will, I feel sure, survive all its competitors, because it is so painterly in conception, so dashing in movement, and so powerful that, according to some, all the other pieces there look like playing-cards beside it.

Meanwhile, the banquet picture also underwent innovative changes when Hals tried his hand at the subject, first in 1616 and again in 1627, when he designed *The Banquet of the Officers of the Company of St Hadrian*. Hals, being a 72 professional portraitist with different options, approached the problem from a different angle from Rembrandt. As the painting shows, he made a clear, uncompromising choice to bring the individual portrait into prominence. The painting is actually an almost abstract arrangement of portraits. Cornelis Anthonisz., in his picture of 1533, had at least tried to convey the impression 69 that the company of archers were actually sitting round a table, but Hals did

72 HALS *The Banquet of the Officers of the Company of St Hadrian* 1616

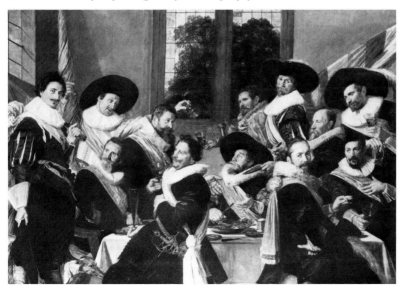

away with that fiction. Certainly, the table is there, but only as a discreet sign. Its function is to define the kind of gathering and, secondly, to allow for some figures to be seated. At both ends of the table (which in relation to the three foreground figures is too low), Hals constructed two groups, each with a seated figure in the centre. One figure, visible between the two seated figures in the foreground, is closest to the group on the right, but he is turned towards the group on the left, thus establishing a central contact between the two groups. A sense of coherence is also furthered by the strangely ambivalent approximate symmetry between the two halves. Finally, the liveliness of the gathering is secured through the great variety in movement and gesture, as well as through the distribution of strongly contrasted, bright colours. This vibrancy notwithstanding, the composition is predominantly formalist in nature – which, in the end, was eminently fitting for the ceremonial occasion.

When the vogue for large-scale militia portraits came to an end in the mid seventeenth century, the demand for portraits of smaller groups continued. It was either governors of a guild who wanted a record of their involvement in the affairs of the community – their sense of social responsibility – or governors of charitable institutions who had themselves painted in commemoration of their Christian neighbourly love. Because of their lofty significance, these pictures are invariably solemn. They show quiet and serious men bent on their task – and thus present a pictorial problem quite different from the one posed by the boisterous militia portraits. An example

74 of the classic seventeenth-century type is *The Governors of the Leper Hospital*, painted around 1649 by Ferdinand Bol (1616–80), an early pupil of Rembrandt. Four dignified gentlemen in black round a table, each of them slightly different in posture, receive a leprous boy who is presented by a servant. How formal this painting is; and yet, through slight shifts of position from one governor to another, it is subtly alive.

The greatest achievement in this category was another painting by

73 Rembrandt, *The Syndics*, of 1661. It is even more impressively solemn. 'They are just five gentlemen, all dressed in black, who just sit to have their portraits painted', as a government official dismissed it in 1801. Once more Rembrandt arrived at his solution by way of a subtle deviation from the norm. In Bol's painting the gentlemen sit round the table; and while they do not look at each other, they do not directly confront the beholder either. This puts a visual distance between sitters and audience (a sign of discretion maybe), which Rembrandt consciously tried to avoid. All five Syndics (inspectors for the Drapers' Guild) peer outward, with the servant in the background as a quiet witness. Their strangely attentive portraits are supported visually by the deep red table, which is placed obliquely, and

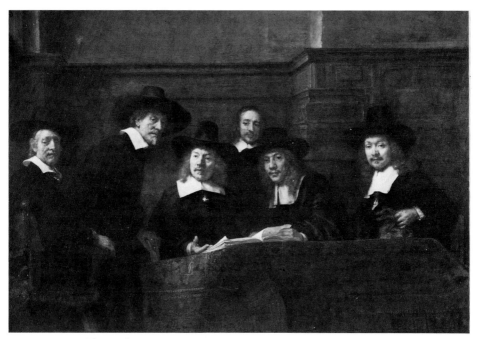

73 REMBRANDT *The Syndics* 1661

74 BOL *The Governors of the Leper Hospital c.* 1649

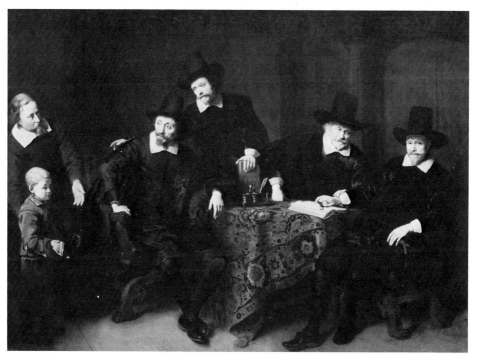

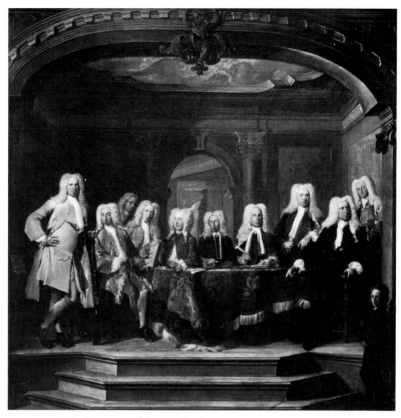

75 TROOST *The Governors of the City Orphanage* 1729

which we see from below so that the top is not visible. This provides
Rembrandt with the possibility of hiding most of the hands, which
otherwise (as in most portraits of this kind) could easily, by their
gesticulation, distract attention from the faces. The painting was meant to
hang rather high, possibly over a fireplace, and it testifies to Rembrandt's
genius how well he adjusted the picture's spatial construction to the angle of
vision of the viewer, while at the same time he used it in his composition.

The tradition of group portraiture continued well into the eighteenth
century – but the solemn formalism which for seventeenth-century art
looked so 'natural' became in the eighteenth century almost an impossibility.
When the Amsterdam artist Cornelis Troost (1697–1750), who at heart was
a master of comic genre, was commissioned in 1729 to portray *The*

Governors of the City Orphanage, the result was rather curious. From the composition it is evident that the conditions for this kind of official commission were still much the same as they had been in the previous century. But the culture had changed, and with it notions about painting; and what had changed above all was the artist's conception of the real. During the eighteenth century the formal systems that had governed seventeenth-century thought began to break down, to make way for a more empirical and anecdotal relation to reality. Clear signs of this process are manifest in painting. The weird, stagy quality in Troost's group portrait shows how difficult it was for the artist to find a satisfactory solution to his formal problem; somehow his culture prevented him from appreciating the inherent, solemn formalism of this kind of subject.

Single portraits, apparently still too sensitive in their social significance, in the eighteenth century and after retain, by and large, their formal nature. Yet it was a formalism of a different kind – a more informal formalism, one is tempted to say. In Troost's portrait known as *The Music Lover* (1736), the man takes on a pose of confidence which in its structure is rather conventional. But there the resemblance to the conventions of portraiture ends. For this man is sitting down. That, precisely, is an informality which is very unlike the seventeenth century. Confident men, in seventeenth-century portraiture, were most often standing; this was a sign of activity. But then, the man in Troost's portrait is not concerned with giving an impression of activity. He is – and this too is a new type of informality – at leisure; he does

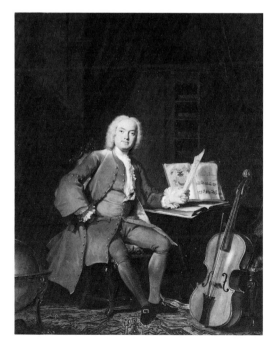

76 TROOST *The Music Lover* 1736

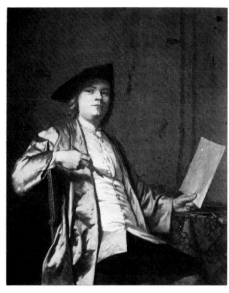

77 VAN DER MIJN *Cornelis Ploos van Amstel* 1748

78 KRUSEMAN *Adriaen van der Hoop c.* 1835

not show himself in his profession, but wants to be remembered as an amateur of music. To make this obvious he is not portrayed in a formal, almost abstract pose against a grey background, an isolated image of personal pride, but sitting in his study, surrounded by musical manuscripts and in the company of his cello. So, while the actual pose is a reiteration of a well-tested formula of portraiture, the mood and the content of the portrait are new.

Apart from the introduction of this formal informality, not much more would change in portraiture. Its classic masters, Hals and Rembrandt, referring back to inventive predecessors like Moro, had formulated its basic idiom – its repertory of poses and gestures – and Troost had added a leisurely type to that, slightly toning down the former high seriousness. From now on the idiom would be affected only by stylistic fluctuations. George van der Mijn's (1723–63) portrait of *Cornelis Ploos van Amstel* (1748), the collector and amateur artist, belongs to the leisurely type – while the portrait of *Adriaen van der Hoop*, painted in the 1830s by the fashionable specialist J. A. Kruseman (1804–62) is formal, in the manner of the *haute bourgeoisie*, but yet with the sentimental motive of the dog: man's best friend.

The world as image

Seventeenth-century landscape and still-life

One of the classic arguments in Renaissance criticism and theory was which of the two major illusionistic arts, painting or sculpture, was the more faithful to nature. In the seventeenth century this debate was still very much alive. One amateur of the arts, Sir Henry Wotton, formerly English Ambassador to Holland, decided (as most had done before him) in favour of painting: 'An excellent piece of painting, is to my judgment, the more admirable object, because neere an Artificiall Miracle.' The miracle, of course, was that a realistic picture could be so deceptively illusionistic that one thought oneself in the presence of the real object. Since the Early Renaissance, when this aspect of painting was brought up in Alberti's fundamental and unsurpassed book, *De pictura*, it had been one of the main criteria for a painting's artistic quality – as we have already seen with Bartolommeo Fazio's remarks on the art of Van Eyck (pp. 13–14). A respectable basis for this was found in the notes on painting which the Roman author Pliny had incorporated in his *Natural History*; he mentions several illusionistic *tours de force* by which famous ancient painters like Zeuxis and Apelles demonstrated their skill. They would paint a life-size mare, so brilliantly realistic that a real stallion would start to neigh at it; another anecdote tells how birds would crash into a wall on which a still-life was painted.

For pictorial realism the criterion of fidelity was of course logical. It had the advantage, too, that one could easily and objectively compare the real thing with its pictorial rendering. It was applied regardless of a picture's content or function. That too was logical, since moral meanings, for instance in Dutch genre painting, could not be part of a discussion of painting as an art. During the seventeenth century and before, painting had no choice but to be moralistic; there could have been a critical discussion about the elegance or discretion with which a symbol had been inserted into the realistic texture, but apart from general remarks by Samuel van Hoogstraeten, to the effect that agreeably veiled symbolism was highly commendable, there was no detailed discussion. Finally, morality had no bearing on the quality of painting as art – or, better, as a *skill*. After all, a

badly painted imitation of a Steen would have exactly the same moral significance, but the Steen was definitely a better picture: a more skilfully produced 'Artificiall Miracle'. Even qualities of composition were hardly taken into account; if they were mentioned at all, it was mostly in a very 71 general sense. Hoogstraeten praised Rembrandt's *The 'Nightwatch'* because it was *unified*. Other aspects like the naturalness of the movements, however, were more important to him. That he mentioned the quality at all might be due only to the fact that it was rare to have such a type of composition in a group portrait.

That the Renaissance took realistic fidelity for a major sign of quality must have been especially favourable to the emergence of categories of art that relied more than others on meticulous rendering of things observed: still-life, architectural painting and, in a sense, landscape. All these categories, which before had existed only as descriptive elements within history painting, became independent in the early sixteenth century, with little doubt in direct reference to the aesthetic appreciation of 'Artificiall Miracles'. Yet in Italy, where their emancipation started, they never became really important genres, at least not until the later seventeenth century; other aspects of classical theory, such as the exaltation of history painting, clearly impeded their rise. In seventeenth-century Holland the pressures of art theory were less heavy and less real – and it was here that landscape and still-life, as autonomous categories of painting, began to occupy a major place in art production. Even so, there was no serious theoretical discussion of them; Dutch theorists tended to regard the practitioners of still-life in particular as something of a joke (Samuel van Hoogstraeten, just after the middle of the seventeenth century, called them the 'common footmen in the Army of Art'). This relative lack of interest expressed itself in the absence of strict rules; painters of landscape and still-life thus enjoyed more artistic freedom than their colleagues practising history or genre. The most important innovation in Dutch painting, the realist approach, could therefore establish itself more easily in landscape than in any other category.

While early seventeenth-century genre, exemplified by Buytewech's 27 *Banquet in the Open Air*, still retained a strange artificiality in its organization and had yet to find its most appropriate style of realism, in Esaias van de 79 Velde's *View of Zierikzee* of 1618 a more natural effect is achieved. There is the outline of the town, occupying almost all the horizon, in a not too distant view, and painted almost exclusively in dark tones of brown, as one might see the silhouette of a town in the failing light of dusk, with only a few patches of very dark green in the river bank. The sky is a liquid blue, with stray clouds which by their diagonal sweep define and emphasize the sky's width. The sky and the town are reflected in the calm water. In the

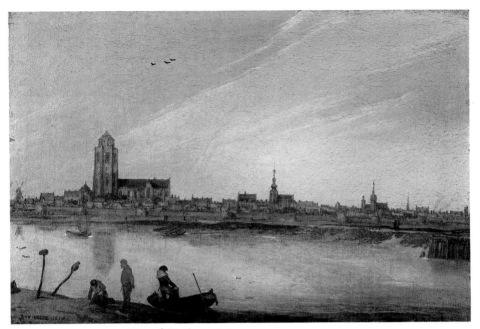

79 ESAIAS VAN DE VELDE *View of Zierikzee* 1618

foreground, as an introductory *repoussoir*, is the near bank with fishermen. Their silhouettes, and the strong red colour worn by the middle one, are points against which the vast space beyond may be measured. The surprise of this brilliant painting lies in Esaias's total matter-of-factness. All chances to embellish the picture, to make it more attractive to contemporary Late Mannerist taste, have been passed by. The painting is deliberately dry, almost to the point of fanaticism, and that is why it contains, already at this early date, the complete programme of realist landscape: the low viewpoint, the wide space, the horizon, the sky, the little figures as spatial points of reference.

The strength of Esaias's conviction is confirmed by *The Ferry* of 1622 and by *Dunes and Hunters* of 1629. This latter picture introduces another element which was to become part of the basic programme, and in an equally dry manner: the single tree in the middle ground, intersecting with the horizon and darkly drawn against a bleak sky. The uneven ground, which allows for differences in light, and which helps the spatial progression towards the horizon, is another programmatic point. The same device is used in *Landscape with Cottages*, also of 1629, painted by Pieter de Molijn

22
80

81

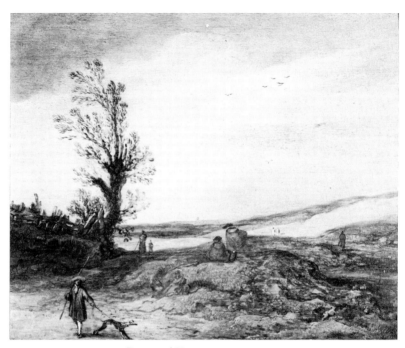

80 ESAIAS VAN DE VELDE *Dunes and Hunters* 1629

(1595–1661), who by 1616 had settled in Haarlem where he immediately came under Esaias's influence. De Molijn also added something of his own, though this is an innovation of degree. Compared to Esaias's *Dunes and Hunters*, his landscape is more unified and, at the same time, more contrasted. The contrast is between two movements: one, marked by the dense trees, goes slowly upwards; the second, along the sandy slope, gently descends to disappear on the right – in a diagonal direction which is the continuation of the path in the immediate foreground. The sandy side of the dune is caught in the low sunlight; the foreground is dark. Thus the two main movements, which generate a certain tension, are defined with structural precision.

Marine painting, stylistically a branch of landscape painting, was a relatively new speciality with, of course, a significance for a Dutch public since Holland's wealth and power largely depended on its sea-borne trade. Probably the first artist to establish himself as a specialist was Hendrick Cornelisz. Vroom (1566–1640), who was active in Haarlem around 1590. A characteristic painting by him is *The Arrival at Flushing of the Elector Palatine*

82

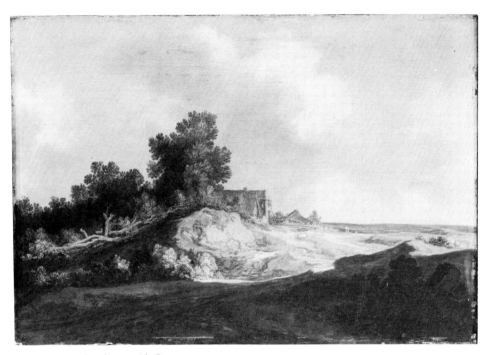

81 DE MOLIJN *Landscape with Cottages* 1629

Frederick V. It was commissioned in 1632 by the City of Haarlem to commemorate the Elector's visit to the Republic in 1613 upon his return from England, where he married Elizabeth, the daughter of James I. It is a painting full of detail, mainly portraits of ships as they are about to anchor in the roads off Flushing, which is shown on the horizon. Vroom has chosen a high viewpoint, to permit a broad and clear view; the little waves are painted with mechanical regularity. (An interesting point is that a *recent* historical event is shown. In official history painting this would have been impossible; it would have been too banal for the Noble Art. This again shows how free these new categories were of rigid conditions.) Something of Esaias's precision in the effective organization of detail is found in a beautifully sensitive painting of *Ships on a Stormy Sea* by another innovator, Jan Porcellis (1584–1632), which might date from as early as 1610. The ships painted by Porcellis are as precise as those of Vroom. Just as Esaias was not a painter of trees, Porcellis was not a painter of ships. He was a painter of the sea and the sky above, of, as a contemporary English writer put it, 'the beauties and terrors of the Element in Calmes and Tempests'. The ships are mainly

83

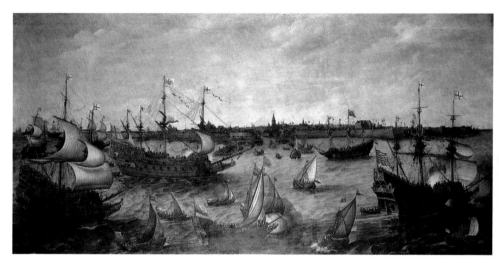

82 VROOM *The Arrival at Flushing of the Elector Palatine Frederick V c.* 1632

83 PORCELLIS *Ships on a Stormy Sea c.* 1610

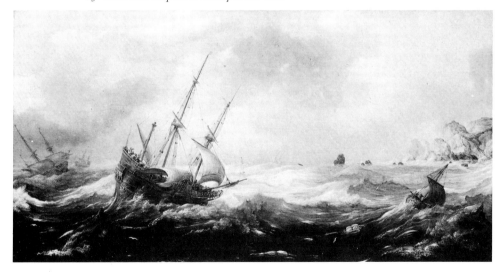

atmospheric signs: rolling on the waves, wheeling over under the lowering sky, they are the visible signs of the wind. The waves are swept up by the wind; the sea now becomes dangerous. It will unleash forces which will destroy the ships. They are hurrying along close to a rocky coast. This coast actually introduces an element of imminent doom into the picture, and one wonders whether this image of small ships on a storm-tossed sea is not another disguised symbol of human life, of 'life's uncertain voyage', as Shakespeare called it.

This reading of the content of Porcellis's painting is, I must admit, conjectural. It is based on the fact that its central image, boats on a stormy sea, has become conventional; it occurs in other paintings as well as in prints and, as a metaphor, in literature. In some cases an accompanying text makes its meaning quite clear. So I can only *assume* that this picture by Porcellis might have a similar meaning – partly because it is hard to accept a seventeenth-century painting without a particular moral content. Yet there are pictures, like for instance Esaias's *Dunes and Hunters* or De Molijn's *Landscape with* 80 *Cottages*, which are hard to place within any conventionalized tradition of 81 moralistic imagery; nor are there any clearly recognizable emblematic keys. What then is their point? Are they evocations of a Dutch countryside? It is hard to find a satisfactory answer; and it is not only with realist landscape that this problem arises. With still-lifes too, one often wonders whether the aesthetic element in the design is not much stronger than any conceivable moral content – whether the picture is not, first of all, an 'Artificiall Miracle'.

The new, realist type of still-life painting emerged together with the new landscape. Early signs of change towards realism are found in the flower-pieces of Ambrosius Bosschaert (1573–1631), a specialist active in Middelburg. His *Vase of Flowers* reflects, in certain aspects, a tendency 85 towards realism, in particular in its clear colour and in the bright, even light. As a type, however, it had by 1620 become old-fashioned. The near symmetry of the composition reveals a formalism which is Mannerist in feeling; and the subject, too, a collection of strangely coloured, strangely formed flowers, comes from the sixteenth century. To a Mannerist taste such mysterious artefacts of Nature, evidence of the Creator as artist, were of special interest. Actually one can also doubt the realist 'intent' of Bosschaert, if one examines the flowers closely: they bloom at different times. The bouquet, then, is an aesthetic construction, composed from illustrations in scientific flower-books rather than from actual observation – a thing of great beauty, painted with great skill; even the caterpillar and the dragonfly are rendered with great delicacy. All natural beauty, however, will eventually decay: this sentiment of transience is part of the picture's meaning.

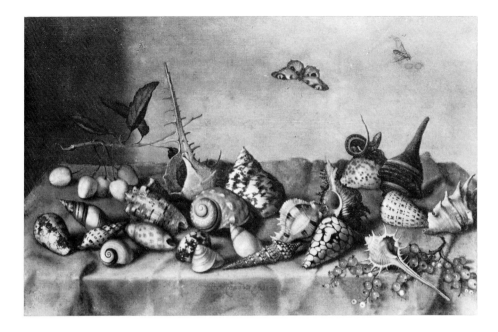

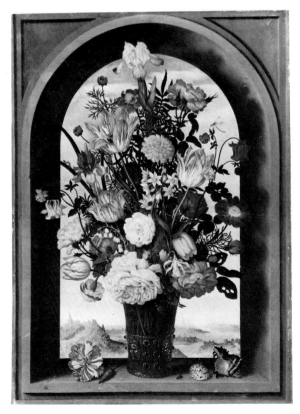

84 VAN DER AST *Still-life with Shells*

85 BOSSCHAERT *Vase of Flowers* 1620

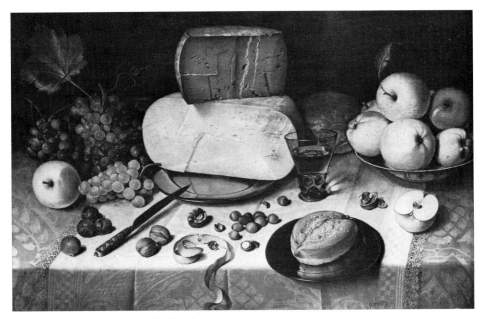

86　VAN DYCK *Ontbijtje (Breakfast Piece)* 1613

Like flowers, shells too were cherished for their bizarre beauty; it was Bosschaert's brother-in-law, Balthazar van der Ast (1593/94–1657) who specialized in these still-lifes. For good measure, he would add symbols of the transience of natural beauty or introduce butterflies and snails symbolizing the carefree life of the soul after it is free from all terrestrial desires. In their composition the paintings of Van der Ast conform to a newer type of still-life arrangement, in which the objects are displayed while laid out on a table which takes up more than half of the picture-space. The pictures themselves now have an oblong format. An early example of this new type of still-life is an *Ontbijtje* (Breakfast Piece) of 1613 by Floris van Dyck (1575–1661), who was active in Haarlem when Esaias and De Molijn painted their early landscapes. His picture gives the impression of having been constructed with great deliberation, slowly and with careful attention to the position of each specific object. All through the picture one finds discreet overlaps and shifts in direction, which have been introduced to convey a sense of actuality: as if someone really had been eating and left the table in slight disarray. This approach, designed for the realist effect, set Van Dyck's painting apart from the paintings by Bosschaert and Van der Ast which evidently bear much less relation to real life. Shells as depicted by Van der Ast were rare collector's

84

86

87 AVERCAMP *Winter Landscape*

items; and vases of flowers were certainly not common in Dutch houses. To pick flowers and put them in a vase in a room belongs to a sentimental naturalism that did not exist before the nineteenth century; before that time people had *pictures* of flowers in their houses.

The careful disposition of objects in space with which Floris van Dyck seems so concerned, producing an image which is clear in its visual detail and lively at the same time, is noticeable too in the winter landscapes by Hendrick Avercamp (1585–1634). Avercamp, another of the pioneers of realist landscape, was a mute. This kept him all his life in his native town of Kampen – at such a distance from the main artistic centres that his art had little influence on the development of landscape painting. The relation between Avercamp and Floris van Dyck, who certainly were not in contact with each other, is purely mental: both artists show (as do Esaias and De Molijn) an obsessive attention to a certain type of detailed *order* – which is a consequence, one feels, of a conscious desire to create a new art, and to formulate the programmatic language for that art.

It testifies too to the spiritual closeness of the two genres. Reflecting upon this it seems that they, within a conception of realism as the visual exploration of reality, are related by their total opposition as two different modes of visual experience. While still-life offers an extremely close view,

87

landscape presents a view as far as the horizon, which is the actual limit of human perception of the world.

The stylistic phases and fluctuations in aesthetics through which landscape passed had their direct counterpart in still-life. The silvery tone which dominates in a *Still-life* of 1636 by Pieter Claesz. (1597/98–1661), muting the colours and subtly adjusting the objects to each other, directly relates to the tonal direction landscape took after 1630. Possibly the first impulses came from marine painting, from Porcellis; of course, the sea itself, which turns a cold grey colour when the wind freshens under a grey sky, suggested to him the thin grey atmosphere of his late paintings. The visually highly sensitive Constantijn Huijgens probably sensed this change; he praised the new landscape school for its ability (another 'Artificiall Miracle') to evoke 'the warmth of the sun and the movement caused by a cool breeze'. In this connection he mentioned three young painters by name: Jan van Goyen (1596–1656), who worked in his native Leiden until he moved to The Hague

88

88 PIETER CLAESZ. *Still-life with Herring* 1636

in 1631; Salomon van Ruysdael (1600/03–70), who spent most of his life in Haarlem; and De Molijn.

22 Esaias's *The Ferry* is drawn – and the same is true of the work of Avercamp – with all the minute detail that was the marvel of early realism, and the colour was added later, so to speak. Ten years after *The Ferry*, in 1632,

89 Salomon van Ruysdael painted a *River Scene*, in which the formation of trees and bushes on the bank almost seems to rise as a mirage from the motionless water. The whole picture, which is without a sharply drawn line, is a modulation within an almost monochromatic scale; while staying in the same greyish key, this monochromaticism is only subtly adjusted towards the sky, where it acquires a bluish tinge, or towards the water with hints of blue and brown, while in the foliage on the bank a greenish grey predominates. In a distant haze the horizon is only vaguely discernible, which makes this calm picture into a harmony of air and water in which the shore, gently receding until it is lost to the eye, delineates a deep, wide space.

So refined and delicate is this painting that one feels that it must be something more than a sensitive approximation to a real view along the bank of a Dutch river or lake, early on a cool summer morning before the wind has blown the mist away. A conscious *aesthetic* element is involved.

Another indication of this aestheticism is the emergence of a similar tonality in still-life painting – where it must be purely artificial and deliberate, since the light that illuminates a still-life is naturally independent

88 of atmospheric conditions. There is the picture by Pieter Claesz.; other

90 examples are a *Still-life* from around 1636 by Willem Claesz. Heda (1599–1680/82), who like Pieter Claesz., was active in Haarlem, and a

91 *Vanitas*, done around 1640 by the Leiden specialist Harmen Steenwijck (1612–56). These pictures also show that tonality in still-life had its limits. Pieter Claesz. avoided the problem by choosing very simple objects in two main colours: pewter plates, a herring, a knife, a glass of beer, all with a dull grey sheen; the brownish colour matches the lighter brown of the piece of bread in which, too, there is some grey. Steenwijck was also able to adopt a tonal scale, departing from the ashen colour of the skull; the other objects mostly vary between sallow brown and greyish yellow. The still-life by Heda is somewhat more problematic; there is a much stronger differentiation between the objects he employs. This problem is peculiar to still-life, of which the 'Artificiall Miracle' of course resided in the faithful rendering of the different textures of materials. Thus Heda took care to give the pewter jug a duller gloss than the silver vessels, or to make the lemon peel a brighter yellow than the soft ochre pie. There is another aspect which brings these still-lifes close to contemporary tonal landscape (apart from the attempts to reduce the colours to a common denominator), and that is their

curiously indeterminate space. The objects are put on a table (or, in Steenwijck's case, one a marble console), but that table is placed against a plain background which is strangely transparent with dull light. Compared, then, to the still-lifes of Bosschaert, which are tightly held within a niche – or those of Floris van Dyck, held within the picture-frame – these still-lifes 86 almost seem to float, like the mirage of trees on the still, reflective water in the landscape of Salomon van Ruysdael. This mysterious illusionism is 89 especially strong in the pictures by Heda and Steenwijck, in which the back-edge of the still-life's support is obscured from view – making a measurement of space almost impossible.

The allegorical meaning of the flower-piece by Bosschaert was one of 85 Vanity and transience. That, in principle, is the meaning of every still-life painted in the seventeenth or the first part of the eighteenth century. It is very clearly the significance of Steenwijck's painting, which is an ensemble of 91 objects which all propound transience: pipes gone out, a tumbled glass, a flute (music fading away), a candle petering out, history-books – and in the middle of that, as a key symbol, the skull. Pictures of this type were an almost exclusive speciality of the Leiden School. The scholarly clientele in that university town apparently had a special preference for this type of dense symbolism; in Leiden genre painting the same trend can be noticed. (When books and other items of scholarship are included, the still-life may also contain a warning against the pride to which knowledge leads.) The other type of still-life, of food and drink, is equally metaphorical of transience, though more by natural association: all food eventually gets tainted, all drinks will become stale. But here, too, an occasional symbol might be slipped in – such as the peeled lemon in Heda's picture which symbolizes 90 Deceptive Appearance: beautiful to look at, a lemon yet tastes sour.

By 1640 the basic type of still-life, in content as well as form, was fixed, as in this painting by Heda; a table against a blank background, without clear spatial definition, and on the table objects with different types of texture. The composition would invariably develop in a upward diagonal direction; thus all the objects would be clearly visible. This classic formula could not be changed by the next, and greatest, master of still-life, Willem Kalf (1619–93) nor by his contemporary Abraham van Beyeren (1620/21–90). Yet the still-lifes by Kalf look very different from those of his predecessors. They are, in a 92 sense, much more theatrical; in their sonorous quality they bring to mind the landscapes of his contemporary Jacob van Ruisdael. In the paintings by Heda or Pieter Claesz., the objects are ordered in a simple way; they are just laid 88 out on the table. The light is even; shadows are used only to emphasize each object's plastic form. The still-life is generally set in a rather wide space (the painting itself being oblong). In Kalf's paintings, however, the space is

89 RUYSDAEL *River Scene* 1632

narrowed. The background is much darker; and in this narrow space, against this background, the still-life seems curiously isolated. A soft light picks out each different object, showing its unique quality and colour – as spotlights focus on actors on a dark stage. In the narrow space, the arrangement too is much tighter: it seems to be a more consciously aesthetic display than before.

For this rich, glowing kind of still-life the seventeenth century used an apt term, *pronkstilleven* (still-life of ostentation); and part of the content of this term is certainly the choice of objects itself. In Heda and Claesz. food and utensils appear that belong to normal life: bread, beer, fish, plates and jugs of pewter or ordinary glass. Kalf, and Van Beyeren too in his luxurious still-life

93 of 1654, use almost exclusively objects that are extraordinary: vessels of silver and gold, chalices of china, lobster, tropical fruit – displayed against rich Persian cloth.

The tonal style in landscape painting continued well into the 1640s, while still developing, especially in the hands of Jan van Goyen. The direction in which Van Goyen took landscape reveals a considered logic; as tonal painting was a realistic attempt to capture an atmosphere, its consequence

94 was, in the end, to paint the sky over the flat, low land. Thus, in his *Windmill*

116

90 HEDA *Still-life c.* 1636

91 STEENWIJCK *Vanitas c.* 1640

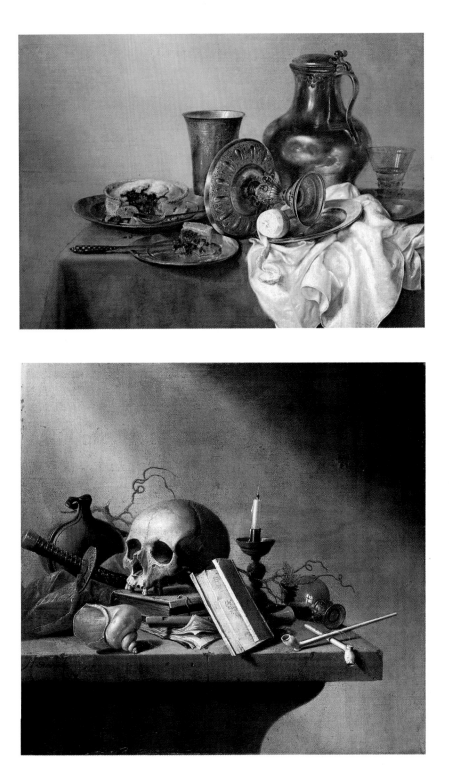

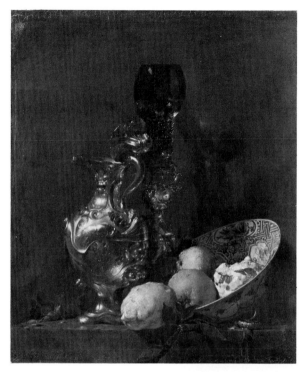

92 KALF *Still-life*

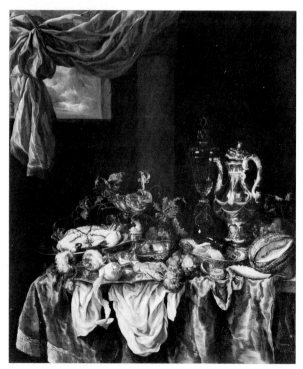

93 VAN BEYEREN
Still-life 1654

by a River of 1642, the real subject is the moving skies. Compared to this picture (incredible in its suggestive power considering how small it is), Salomon van Ruysdael's painting of 1632, and similar pictures from that time by Van Goyen himself, still look like merely interesting natural motives in the tradition of Esaias. In *The Windmill*, however, everything is subordinated to the high sky – a sky that seems to take on the colour of the vast land stretching to a low, distant horizon: a brownish green with tinges of blue. Only the sky contains more grey – the clouds – and is more transparent in its pictorial treatment. Dunes in the foreground, caught in a splash of sunlight, introduce the distance – suggesting a high viewpoint that gives the view naturalness. The windmill, painted in the greyish-brown colour of the sky, is a discreet spatial reference point. 89

 With subjects like this, Van Goyen had no peer, unless it was the marine painter Simon de Vliegher (1600–53), who had taken his style from Porcellis (who likewise influenced Van Goyen). In the 1630s De Vliegher, too, was caught up in the tonal style, so suited to marine painting, and he gradually departed from Porcellis's tendency to paint seas in stormy weather. As in *A Dutch Man-of-war and Various Vessels in a Breeze*, painted between 1640 and 1645, his sea is usually much calmer and less threatening to the ships, the vast sky more gentle. Rarely, too, is it the high sea; the shore-line is visible on the distant horizon, and in the lower left corner a stake is protruding as a discreet indication of the shore at this side. It is a wide estuary, then; ships are coming in from the sea; another ship, in the distance, is riding at anchor. 95

 It seems that this calmness is an aesthetic factor which, not surprisingly, goes together with tonality. Even when a painting shows an incident like a burning church in a typical nocturnal landscape by Aert van der Neer (1603/04–77), it is a strongly muted incident, lost in the night. Van der Neer, who belonged to the generation of De Vliegher and Salomon van Ruysdael, was a specialist in two genres: winter scenes and nocturnal landscapes. Both adapted well to the tonal style, of course, as shown in this painting; the night is subtly illuminated by the subdued light from the burning church – a fire which has an aesthetic meaning only, slightly unreal, with no apparent cause, no consequence. As calm as De Vliegher's and Van der Neer's pictures is Van Goyen's *View of Nijmegen* (1643); but here the calmness of the smooth water and of the ferry quietly setting off (*towards* the town), seems to have a very specific function. Comparing this picture with Esaias's early *View of Zierikzee*, in which the town is seen with a neutral, almost cold glance, it is evident that Van Goyen did more than just describe the town's appearance. He also tried to capture the visual effect the city has when seen from the other side of the river – that of an impregnable fortress; this strength is emphasized by contrast with the serene atmosphere of the land around it. 96 97 79

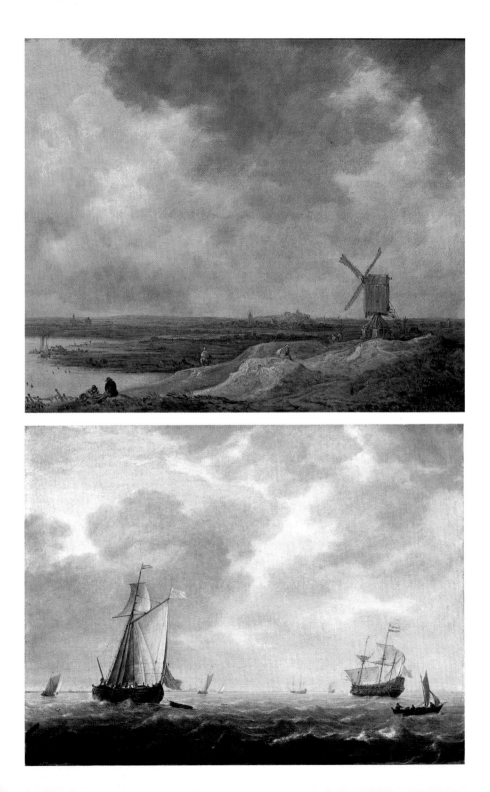

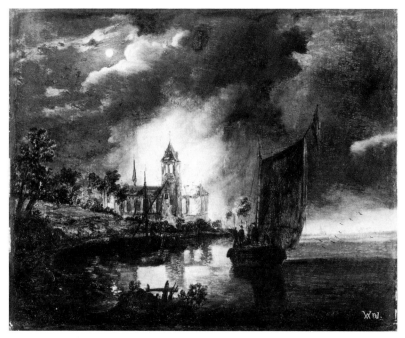

96 VAN DER NEER *Burning Church*

94 VAN GOYEN *Windmill by a River* 1642

95 DE VLIEGHER *A Dutch Man-of-war and Various Vessels in a Breeze c.* 1642

97 VAN GOYEN *View of Nijmegen* 1643

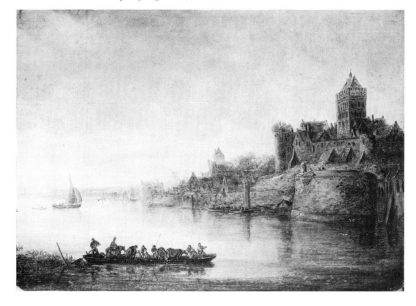

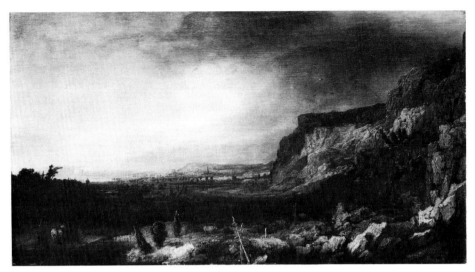

98 SEGHERS *Mountainous Landscape c.* 1633

Two major exceptions to tonal realism manifested themselves; and while they were against the general trend of the 1630s and 1640s, both had a decisive influence on developments in landscape painting during the 1650s. One was a mysterious artist, about whom not much is known, Hercules Seghers. He was born in Haarlem, in 1590 or 1598; he disappeared from the scene after 1633; the exact date of his death is not known. Only about fifteen paintings can now with some certainty be ascribed to him; more is extant of his powerful and original graphic work. The other exception was Rembrandt, who was not a specialist in landscape but produced, mainly in the late 1630s, some landscapes of great and independent originality. To mention Seghers and Rembrandt together is not strange. Rembrandt owned eight paintings by Seghers, which indicates how deeply the older master fascinated him. Seghers, in turn, might have been influenced by Rembrandt's chiaroscuro.

98 In some respects the landscapes by Seghers, of which *Mountainous Landscape* of around 1633 is a supreme example, continue the Mannerist tradition of his teacher Gillis van Coninxloo. There is a similar strong sense of the mysterious and bizarre grandeur of nature – Samuel van Hoogstraeten commented, very aptly, that these paintings by Seghers were 'as if pregnant with whole Provinces which he delivered into immense spaces'. The architecture of these landscapes, the clear logic of their organization and of the measured progression into a deep and ordered space, reveals a debt to

contemporary realism; but Seghers was not satisfied with rendering what his eye perceived; he had grander visions of a nature more forbidding, more awe-inspiring – and these he painted, with his Dutch sensitivity to changing light and atmospheric detail. The theorist Van Mander, writing early in the century, singled out for praise those landscapes which were painted 'from the Mind'. They were more important than realistically recorded views, for in them the mind had carefully selected the motifs. Now no seventeenth-century artist ever painted out of doors – that became a habit only in the nineteenth century – but Van Mander meant something else. He meant that in the mind the artist would reflect upon nature and then order the motifs into a landscape according to the proper rules of Art – embellishing Nature, leaving out its deficiencies. That Rembrandt, with his consciousness of high classical tradition (even though at times his interpretation was deeply personal), would almost literally follow Van Mander's advice, is not surprising; there is logic, then, in his high regard for Seghers. After all, Rembrandt came to landscape from history painting, where landscape functions as décor for a narrative subject. As a support for an emotional situation, landscape was itself an emotional vision – like the *Landscape with* 99 *Thunderstorm* of around 1637. This landscape is so beyond naturalism, in its structure as in its imaginary colour, that to look for a natural explanation (for instance, that the weird light is the realistic reproduction of lightning) is to deny its prime meaning, which is to be imagination: to be Art.

❊ ❊ ❊

99 REMBRANDT *Landscape with Thunderstorm c.* 1637

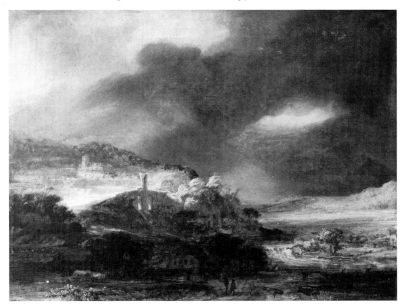

The art of Pieter Jansz. Saenredam (1597–1665), of the same generation as Van Goyen and working in Haarlem, is not, in certain aesthetic aspects, wholly unrelated to contemporary tonal landscape. In these architectural paintings an almost fanatical attention is paid to the tonalities of daylight, as it falls through the high windows of Saenredam's churches, defining surfaces, corners, divisions by subtle inflections. But Saenredam's background was very different from Van Goyen's. His tradition was that of the study of perspective, which since the Early Renaissance had been a major concern of artists and, of course, theorists. The reason for this obsession is clear enough, and was expounded by Alberti, who opened his book on painting (1435) with an ingenious method for spatial construction based on central perspective; without a precisely ordered space it was of course impossible to obtain a convincing illusion of reality. Later in the age a discussion started about the status of painting, previously considered to be just a manual skill. Painters aspired to the high status enjoyed by poets, philosophers and scientists; their use of perspective, which is a branch of mathematics, was then a point in their favour. (Leonardo da Vinci went even further: he claimed that painting was more important than poetry and philosophy because painting appealed to the eye, which according to Aristotle was the first human organ through which knowledge of reality enters into the soul.)

It was around this time, too, that artists and architects began to make perspective studies for their own sake – these were often engraved and published as model-books. In the sixteenth century perspective study turned into perspective fantasies in the form of imaginary architecture, often highly elaborate, sophisticated and Mannerist. This interest in perspective and architectural ornament also caused the emergence of painters who began to specialize in this field. One of the most famous inventors in this area was the Dutch painter Hans Vredeman de Vries, who shortly before he died in 1604 published a book with engraved perspective inventions. This book, which was extremely important in transmitting the extensive Italian knowledge about perspective and architectural ornament to the north, no doubt influenced Dirk van Delen (1604/05–71). His *Architectural Fantasy*, probably painted around 1635, reveals the dominant style in architectural painting which Saenredam found and in which Van Delen (though even younger than Saenredam) continued to his death.

Saenredam's *Interior of the Buurkerk, Utrecht*, of 1644, is utterly different. In line with contemporary realism, it is the meticulous recording of a corner in an actual church. Characteristic of Saenredam is the precision of the painting, which in this, as in other cases, can be checked against the existing building. If for any reason he made changes, he always took care to

100

101

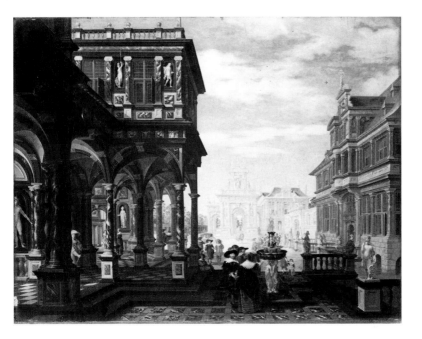

100 VAN DELEN
Architectural Fantasy
c. 1635

101 SAENREDAM *Interior of*
the Buurkerk, Utrecht 1644

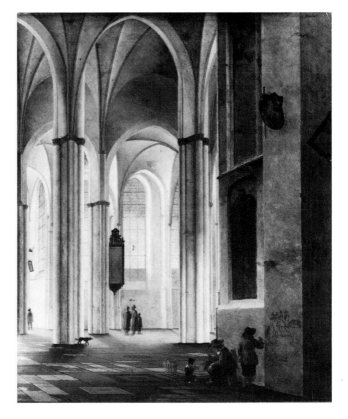

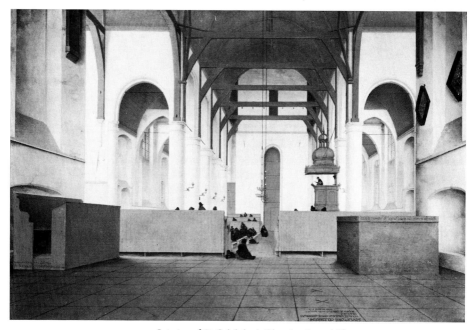

102 SAENREDAM *Interior of St Odolphus' Church, Assendelft* 1649

make a note on the drawing for the painting. These drawings were always
made on the spot, sometimes many years before (in 1636 for this painting);
when he did the painting, he would make a large construction drawing from
which the main outlines would be traced on to the panel. This picture, it
seems important to note, is not a fantasy at all. It does not present, as does
Van Delen's picture, imaginary architectural constructions, nor does it have
anything to do with contemporary architectural aesthetics, since almost all
the buildings portrayed by Saenredam are late Romanesque or Gothic in
style – old-fashioned; it is an interior of an existing building. The painting
thus becomes an image of a space already formed – an image of *spatial order*.
An even stronger impression of order in space is conveyed in a painting of
the *Interior of St Odolphus' Church, Assendelft*, 1649, with the grave of
Saenredam's father in the foreground. The view in this painting is less
'casual' than in the painting of the Buurkerk; it goes almost straight into the
nave, drawing with it the converging white walls, tightening the space into
an image of absolute clarity.

 Cool and yet vibrant in its almost transparent colouring, a colour reticent
so as not to compromise the clarity of the structure, this refined art stands

102

126

alone in Dutch painting. Saenredam had no real master (his teacher in Haarlem was a mediocre painter from whom he cannot have learnt more than the technique), nor had he followers of any significance. The next generation of architectural painters, led by Emanuel de Witte (c. 1617–92), went in a totally different direction. It is this isolation, more than anything else, which makes Saenredam so enigmatic; it is just an extremely personal variant within the well-established tradition of topographical painting, or does its meaning lie elsewhere? A painting by Saenredam occupied a place of honour above a mantelpiece in the house of Constantijn Huijgens. The humanist connoisseur must have found the painting (which did not even show modern, classicist architecture but the interior of an old Romanesque church) important – and not just for its sheer beauty, for that was not quite his style in connoisseurship. If my analysis is correct, in that Saenredam's pictures are primarily images of spatial order produced by architectural geometry, it could be that Huijgens appreciated them for that reason – as images of reasonable order, controlled reason. 'He who wishes to know reason must always measure,' wrote Samuel van Hoogstraeten. That the belief in mathematical order as a sign of supreme reason was expressed in a picture of a church, was moreover a discreet hint as to who controlled and inspired human reason.

Of all architectural painters Saenredam was the most fanatical – in his insistence on absolute clarity, on order totally visible, on order, one is tempted to say, outside human life. For even where human beings occur in Saenredam's paintings, they are small and not at all eloquent; they are just there to measure the spatial dimensions of the building, not to bring it to life as a building that is used.

The conception of the second great architectural painter, De Witte, was fundamentally different; his interiors are always in use, they have a human atmosphere. Their architectural quality also is less analytical and strict. If Saenredam invariably chose a point of view which allowed him a complete and coherent architectural description of the building, De Witte's interest was more 'scenic', so to speak. The views he painted (like *Interior of the Oude* 104 *Kerk, Amsterdam*) are vague, and hardly offer any clue to the architectural structure. Quite often they were put together with elements from different buildings, or even wholly imaginary; the church is a décor, a space filled with sunlight which changes the colours, and a meeting-place for people. In this sense the paintings of De Witte are, in spirit, closer to the townscapes of Jan van der Heyden (1637–1712) and Gerrit Berckheyde (1638–98) than to the subtle, detached visions of Saenredam.

In a sense these townscapes, which usually portray important points in a city, are the opposite of landscape; in landscape, most conspicuously during

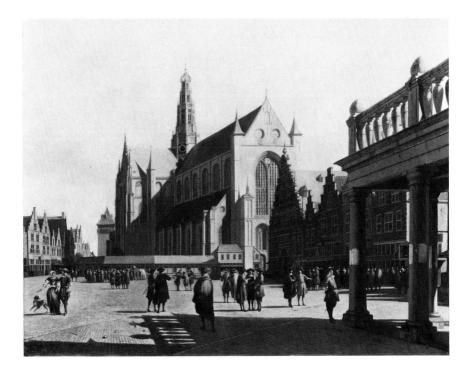

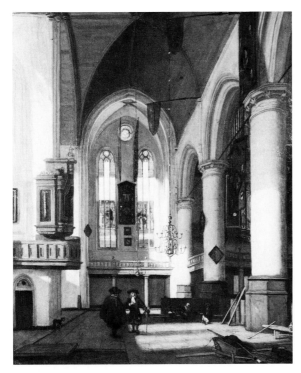

103 BERCKHEYDE *View of the Grote Markt and St Bavo, Haarlem* 1674

104 DE WITTE *Interior of the Oude Kerk, Amsterdam* c. 1680

105 JAN VAN DER
HEYDEN *The Dam,
Amsterdam c.* 1665

the second half of the century in the art of Jacob van Ruisdael, nature is experienced as capricious and mutable (as capricious as human fate), whereas townscapes show the glorious achievement of social organization. Their closest spiritual parallel is, in fact, the group portrait: townscapes too are images of civic pride, of good and benevolent government. In Berckheyde's 1674 *View of the Grote Markt and St Bavo, Haarlem* one sees, on 103 the right, the loggia of the town hall; the church is opposite (and one wonders whether this reference to secular and religious powers is symbolic); in the square dignified gentlemen are discussing the affairs of the day; they have reason to be satisfied, the houses are well kept, the city is quiet.

Van der Heyden's views of Amsterdam are usually less explicit in their exaltation of success, yet paintings like *The Dam, Amsterdam*, done in the 105 1660s, are basically not different from Berckheyde's picture. Just how special these paintings are, as a category, can be established when they are compared with similar subjects painted by relative outsiders to the genre – Vermeer's lucid, glittering *View of Delft* (1658), which presents the city floating on the 106 water, almost like a still-life, or Meindert Hobbema's *View of the Haarlem* 107 *Lock, Amsterdam* (*c.* 1665) in which a view in the city is interpreted with the

landscapist's sensitive eye for atmospheric incident. Such painterly liberties are hardly ever found in Van der Heyden or Berckheyde; they always take care to make a studied, balanced definition of a place, framed by buildings, which is a centre of those human activities that uphold the community.

Not surprisingly, for a merchant nation which relied heavily on its ships, similar attitudes of glorification and of civic pride are found in much of the marine painting of the later seventeenth century – particularly in the work of the genre's greatest, its classic representative, Willem van de Velde the Younger (1633–1707). Comparing his pictures, such as *The Cannon Shot* of around 1660, with earlier examples of marine painting, by De Vliegher, for instance, several important differences in approach can be noted. In this painting, as in most of his other works, Van de Velde focuses pointedly on the stately image of the ship; it sits there on the smooth surface of the water as a symbol of strength. The other boats, especially the two small barges, seem only to serve as an indication of scale: they emphasize the grandeur of the man-of-war. In earlier marine painting, ships were treated much more as natural elements in an atmospheric image of the sea. Even when Van de Velde presents a more dramatic view of a large ship, almost totally wrecked and lost, rolling heavily on high waves, the ship itself, proud even while approaching the end of her voyage, remains in command as the central image of the painting.

By 1650 the stylistic direction in landscape painting was changing. Two great masters were mainly responsible for this change: Albert Cuyp (1620–91) in Dordrecht, and Jacob van Ruisdael (1628/29–82) who first worked in his native Haarlem before settling in 1657 in Amsterdam. While they were quite independent from each other, the way in which Cuyp and Ruisdael reacted to Van Goyen's tonal monochromatic style shows fundamental similarities. It is evident that in paintings like Van Goyen's *Windmill by a River* the monochrome style had arrived at its limits; one step further and the image would dissolve in a light, transparent harmony of different shades of grey. Such a Turner-like development was of course impossible within the seventeenth-century conception of painting. Both Cuyp and Ruisdael introduced a new kind of structural clarity and coherence into landscape; at the same time, too, they departed from Van Goyen's almost neutral, matter-of-fact realism (which in Van Goyen's art was the legacy of the early Haarlem realists).

Cuyp's or Ruisdael's visions of landscape seem, as part of their content, to have emotional qualities; they are more than just observation. Ruisdael's famous *Mill at Wijk bij Duurstede*, painted around 1665, is as a typically balanced structure of strong tensions built round three major oppositions: water, land, sky. Instead of being fused into one diffuse, atmospheric image,

108
95

110

94

109

106 VERMEER *View of Delft* 1658

107 HOBBEMA *View of the Haarlem Lock, Amsterdam c.* 1665

108 VAN DE
VELDE THE
YOUNGER *The
Cannon Shot*
c. 1660

109 RUISDAEL
*The Mill at Wijk
bij Duurstede*
c. 1665

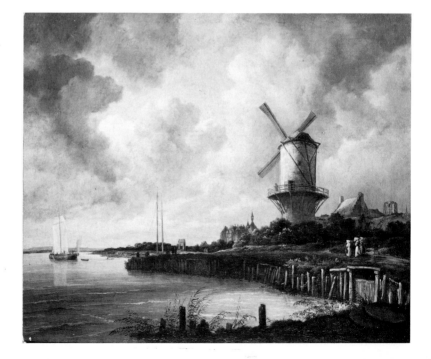

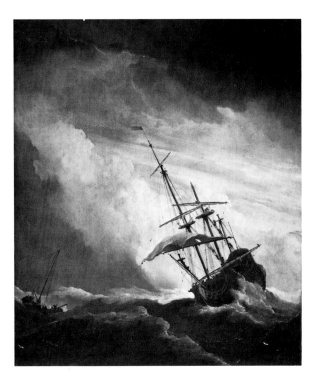

110 VAN DE
VELDE THE
YOUNGER *The
Gust of Wind*

each of these elements is clearly identified and differentiated in quality. The water is calm, with only a few gentle ripples; there is hardly any wind; the sails of the boat in the left background are hanging limply. The dark green land catches some stray splashes of sunlight. Three women quietly stroll along the road. But the sky is restless, moving; in the otherwise calm day this sky constitutes a disruptive element; the sky is *suggestive*. That is Ruisdael's typical way of introducing into the image a strong emotional accent – which can be read by anybody who looks at the painting and compares the situation depicted with what he knows about actual nature (which is, within realism, a logical comparison). The weather is about to change; grey clouds are gathering. Soon the sun will disappear completely; the women will hurry home as the wind freshens into a gale. Suddenly the strong mill which looks like a fortress as it towers over the land, the pride of man's ingenuity in using the forces of nature, looks curiously small against the sky. This beautiful effect introduces a subtle note of ambiguity into the painting – that what in human eyes seems strong and indestructible may yet be destroyed by natural forces unleashed by God.

Thus a painting like this, and many other realist images of the Dutch landscape, contained a *vanitas* as meaning – even though there is no direct emblematic reference. Such references do not seem necessary. From many literary sources it can be established that natural phenomena were experienced as reflections of Divine Power. Huijgens saw the Lord's benevolence shining from every dune; and here is a fragment from a poem by the great moralist Jacob Cats:

> Whatever may be said, from trees one learns;
> Whatever green is blooming is honour to the Creator.
> Wherever the eye may turn one finds occasion
> To laud His name, to sing His praises. . . .
> Who in the fields combines his vision with reason
> Will find many a thing to edify his morals.

If popular poetry like this is an indication of general modes of perception and experience (and what doubt can there be, especially if one reviews the problem of meaning in realistic landscape against the overwhelming evidence of the moralization of reality in genre painting) – then such a

111 RUISDAEL *Forest Scene c.* 1665

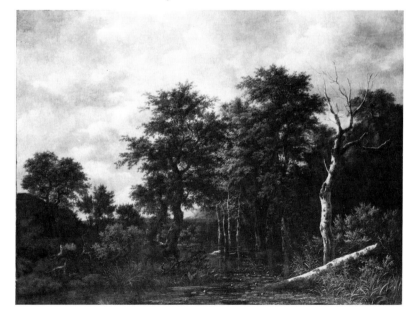

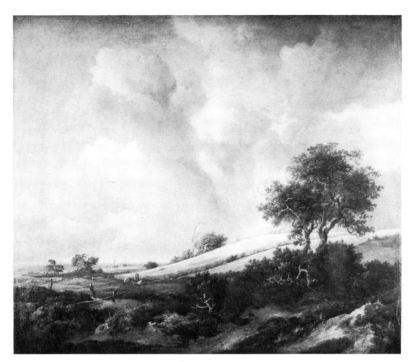

112 RUISDAEL *The Cornfield*

reading is the only logical solution. And there can be no doubt at all about such paintings as Ruisdael's *Forest Scene* of the 1660s; for here a natural 111 symbol is introduced, sharply set off against the dark forest and without any ambiguity: dead birch trees, which denote the decay of physical strength and beauty. A more subtle expression of this theme of transience is found in the tonal treatment of the forest, where the foliage of several trees is already turning brown. Similar effects, but (as is typical of Ruisdael) less explicit, and almost as ambiguous as in *The Mill*, are evident in *The Cornfield* – a painting 109, 112 which in its several aspects exemplifies the stylistic change that sets Ruisdael's art apart from that of his predecessors.

In the landscapes of Van Goyen or Salomon van Ruysdael the situation 97, 89 seems stable, calmly at rest; the colours fuse into each other, and there are no disruptive elements in the composition. How different then is *The Cornfield*! Here the straight horizon of the far sea is broken by a sloping hill, and then broken again by fantastic bushes and trees, green and brown – while above the capricious landscape storm-clouds are gathering. Nature here is

135

113 RUISDAEL *View of Haarlem*

114 HOBBEMA *Wooded Landscape* 1667

115 BOTH *Peasants with Mule and Oxen*

conceived in its fundamental instability; everything may change at any moment, and these landscapes are, through their particular formal properties, symbolic of human existence. So strong is Ruisdael's wish to let his landscapes be more than simple, direct views, that even in paintings like the
113 *View of Haarlem* the clouds project dark shadows over the land.

Ruisdael – and in his line pupils like the somewhat pedestrian and much less imaginative Meindert Hobbema (1638–1709), who in Amsterdam
114 specialized in woody landscapes mostly organized round a pool or a winding road – developed a type of landscape which later came to be admired by nineteenth-century Romantic artists in England and France; Albert Cuyp moved in a very different direction. His early work still reflects the monochromatic art of Van Goyen; later, during the 1640s he came under the influence of a type of 'Italianate' landscape that had, ever since the beginning of the century, occupied a position of its own, next to the typically Dutch landscape. (The word refers to the subject matter rather more than to the influence of Italian art.) It was Jan Both in particular (*c.* 1618–52), returning in 1641 to his native Utrecht after a three-year stay in Italy, who influenced

136

116 ASSELIJN *Italian Landscape*

Albert Cuyp – and led him to a stronger colouristic differentiation and the use of a soft, golden light which also was the prime quality in Both's own
115 gentle landscapes. Besides Both, several other painters gained prominence as outstanding practitioners of this nostalgic kind of landscape (which was very
116 popular with the Dutch public): Jan Asselijn (1615–52), Nicolaes Berchem
118 (1620–83) and Adam Pijnacker (1621–73). One of the earliest masters in this
119 development was the Utrecht painter Cornelis van Poelenburgh (1568–1667), who, with Honthorst and Terbrugghen, belonged to the first generation of Italianate painters. Van Poelenburgh was in Italy between 1617 and 1627 where he painted views around Rome, like the *Waterfalls at Tivoli* (*c.* 1620), that set a model for subsequent development. Typical is the markedly idyllic treatment, emphasized by the presence of leisurely shepherds. Van Poelenburgh's model returns almost literally in a painting by
117 the prolific Nicolaes Berchem. His landscape does not present a specific view; it is totally imaginary. With its beautiful shepherdesses, one of them pointing upwards to the ruins, seemingly, of an antique temple, it is meant to be a poetic image of 'Paradise lost'; and as such it runs parallel to the pastoral literature of the time, having a similar escapist function. And, as in pastoral

138

117 BERCHEM
*Landscape with
Rotunda*

118 PIJNACKER *Landscape
with Wooden Bridge*

119 VAN POELENBURGH *Waterfalls at Tivoli c.* 1620

literature, the same motifs return over and over again – so in the Italianate type of landscape the visual programme is generally the same: shepherds, antique ruins, imposing yet gentle nature, and always the warm, golden light. Sometimes biblical or mythological subject matter is used, though even then it usually remains within the same pastoral vein.

 How strongly Cuyp was affected by the Italianate idiom is clear in his
121 *View of Nijmegen*, painted around 1660 – and even more so if this painting is
97 compared with Van Goyen's treatment of the same subject. In Cuyp's picture all forms are defined by bright patches of colour, all colours modulated in a soft, yellowish light, coming from the left and filling the whole picture. Another painting which testifies to Cuyp's dependence upon
120 the Italianate painters is the *River Valley*, also from about 1660. At the same time, however, this fantastic landscape surpasses, in its painterly brilliance and even more in its broad, noble composition, everything ever painted by his Italianate contemporaries.

 With Cuyp and Ruisdael, and that solitary master of wide riverscapes,
122 Philips de Koninck (1619–88), the great age of Dutch landscape was over. To

120 CUYP *River Valley c.* 1660

121 CUYP *View of Nijmegen c.* 1660

122 DE KONINCK
*Landscape with
Hawking Party*

paint those grand images, a certain attitude had been necessary – an attitude
almost of awe. But in the eighteenth century another, lighter mentality
prevailed. In spirit, then, the eighteenth-century artists could not continue
123 the earlier tradition. Like Isaac Ouwater (1750–93), for instance, they
continued only to employ the classic types.

123 ISAAC
OUWATER *View of
the Westerkerk,
Amsterdam* 1773

Subject and style

The eighteenth and nineteenth centuries

In 1794 the Amsterdam collector Jan Gildemeester had himself and his friends painted among his treasures by the fashionable portraitist Adriaan de Lelie (1755–1820). The painting offers a charming and informal look into Gildemeester's salon, where his elegant, well-to-do friends meet on a Sunday afternoon to admire the collection, discuss art, or just gossip. This is essentially a portrait of one man, Gildemeester, who stands in the middle of the room talking to the gentleman with the eye-glasses. And, certainly, Gildemeester is portrayed as quite a respectable person – but that is not what gives the picture its dignity. The dignity comes from the social occasion: a gentleman, taking a personal pride in his possessions and in his astute connoisseurship, receives his social peers. This approach gives the painting the character of a genre picture, but a genre quite unlike that of the seventeenth century – without its moral tone and its formal realism. It is totally different, too, from the earlier tradition of group portraiture; there is nothing of the rhetorical flavour of Hals's militia banquets, nothing of their abstractness of design. In this 'conversation-piece' people are in their own comfortable surroundings, and there is nothing more to be added. No moral level will turn the reality into an illusion.

There is not one picture in Gildemeester's gallery which does not come from the seventeenth century. The anecdotal richness of Dutch art at this time continued to haunt eighteenth-century artists and collectors alike – and it is quite evident that eighteenth-century artists did not have the power or the will to introduce something really new. Their art is one of reflection on earlier achievements, within the context, however, of a new *mood*. Artistic innovations happen only when a culture has come to a point where it can no longer accept and maintain the existing values and attitudes. In the early eighteenth century, however, there was no question of a deep cultural change. It was a time of contentment, of different manners, of acceptance of French *courtoisie* as a life-style – but all this had already started in the late seventeenth century. The Republic was strong and prosperous; the emergence of aggressive powers such as France and England made further expansion unlikely; now was a time of quiet relaxation, and of adaptation to

124

124 DE LELIE *The Collection of Jan Gildemeester* 1794

the fact that Holland was a small country again. The art went with the times; it became light and relaxed, and shed the heavy, moralistic seriousness of the preceding century – while continuing to exploit the art of the earlier masters.

125 Evidence of this is a delightful painting, *Blindman's Buff*, from around 1735, by Cornelis Troost (1697–1750), by far the most original and versatile artist of his age, whom we have already met as a portraitist. 'He took on all that belongs to Art,' wrote a contemporary, 'painting Histories, antique and modern Companies in which one sees many human occupations portrayed: inside as well as outside; the backgrounds are beautiful landscapes or Views of Country Houses, furnished with the Portraits of their Owners, as they pass the time with their close Friends.'

The subject of *Blindman's Buff* is a game in the garden of a country home, played on a terrace next to a hedge; the background is vague and resembles the swiftly painted theatre décors of the time; it is light and gay, as indeed are many of Troost's subjects (which often come from comedy), and it shows an approach, typical of contemporary *goût*, towards French Rococo painting – in the light colour especially. The spatial setting, however, and the design and movement of the figures, also evoke the art of Steen – translated into a thoroughly contemporary idiom and differently oriented.

144

Blindman's Buff might be compared to Steen's *Skittle Players* – a 36 comparison which shows that the curiously fleeting quality of Troost's picture is the result of a carefully organized imbalance in the composition. But *The Skittle Players* has the strong internal order (the two halves of the picture balancing each other), which is typical of the classical seventeenth-century composition. It is from this formalism that Cornelis Troost deviates in a decisive way. His composition, instead of being organized round a central axis, gravitates towards the left in a beautiful fusion between the requirements of the object and compositional style; in this way, the composition appears to indicate the direction in which the lady in yellow will move to escape from the groping hands of the blindfolded gentleman. The fleeting quality of the painting, its extraordinary lightness, is the result of this suggestion of direction in the composition.

However, the realism of Troost, although different from the formalization of Steen, is still not completely direct; it is characterized by a very curious stylishness which reminds one of the ballet. This stylishness is a pervasive quality affecting all aspects of Troost's painting: figure, design,

125 TROOST *Blindman's Buff c.* 1735

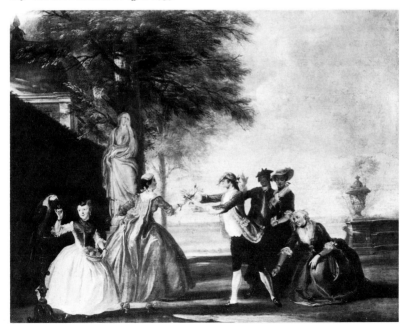

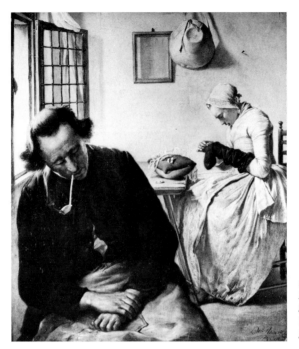

126 HENDRIKS
*Interior with a
Sleeping Man and a
Woman Mending
Stockings*

colour, landscape, movement (or perhaps, in the case of *Blindman's Buff*, choreography). It reflects the aesthetic attitude of his French contemporaries, Watteau, Boucher and Lancret; and there is ample evidence that Troost was a careful student of their work. Orientation on French art as model was to continue throughout the century, though always within the traditions set by the great native masters of the preceding age (in particular those of genre painting, of course). Later, when the aesthetic of Rococo had waned, one finds pictures under the influence of the contemporary French domestic
126 realism of Chardin – the *Interior with a Sleeping Man and a Woman Mending*
127 *Stockings* by Wybrand Hendriks (1744–1831) or the exquisite *Writer*, 1784, by the short-lived Jan Ekels (1759–93). The French influence is reflected primarily in the mood of the pictures, in the quiet sentimentality with which the subjects are treated. The compositions are strongly reminiscent of Vermeer, Metsu and Terborch – but again without the classical formalism. The sleeping man in Hendriks's painting is almost falling out of the frame. This gives the painting a strong momentary accent, in precise correspondence with the subject: in the silence of the room, with the woman quietly mending her stockings, the man is not exactly sleeping: he has just dozed off – smoke is still curling from his pipe. The atmosphere is more contemplative in *The Writer*. Seventeenth-century representations of a man

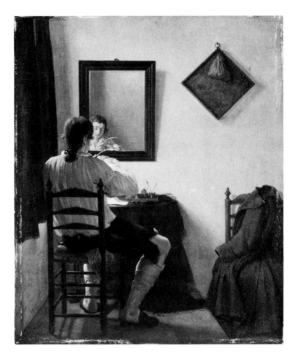

127 EKELS *The Writer* 1784

sharpening his pen (which is what this young man is doing) always carried a very specific meaning – study – and one wonders if there are traces of that in this picture. It is not likely: while in the seventeenth century representations of the sharpening of a pen would be a strongly emphasized, central motive, often carried out near a candle as an additional accent, here in Ekel's painting it seems a very minor incident, an occasion to lean back, a moment of rest and quiet. Other evidence, such as late eighteenth-century writing on seventeenth-century art, indicates quite unambiguously that the knowledge of that kind of veiled symbolism was lost. When, for instance, an eighteenth-century engraver made a print after a *Brothel Scene* by Gerard Terborch, 32 showing an officer who offers money to a beautiful girl, in the presence of a procuress, he left out the coin in the man's hand (or maybe the coin, which in the painting is almost invisible, had been erased by a previous owner of the painting who found the implications embarrassing), and gave the painting the title *'Paternal Admonition'*. Goethe, who wrote about the painting in his novel *Die Wahlverwandschaften (Elective Affinities)*, developed this title into a little novella. He notes how the father quietly and gently admonishes his daughter, while the mother sips from the glass of wine and lowers her eyes, so as not to witness her husband's sternness.

<div align="center">❊ ❊ ❊</div>

By the beginning of the nineteenth century the function of painting had altered, which meant that the content, too, had changed completely. In a culture which had an empirical and materialistic relation to reality, taking the world in its actual appearance and no longer as one grand metaphor for God's perfect creation, there was little use for the double meanings of seventeenth-century painting. That, too, is the significance of Goethe's interpretation of Terborch's picture: he could only accept what he saw; what he could not see was of no concern to him, because it was unknown. Grand pictorial allegory, which is a reference from the visible to the invisible (from a man sharpening his pen to the concept of study), became for the documentary, realist painting of the nineteenth century an impossible task. Spiritual content could be invoked in painting, but never with the formal precision of seventeenth-century symbolism; in Romantic painting, which made use of the same kind of realism as the other pictorial styles of the nineteenth century, and which can be read as a last attempt to continue a Grand Style, incorporating all emotions, it could only be vaguely alluded to.

128 A picture of 1896, by the very popular artist Josef Israëls (1824–1911), shows a girl staring into dark space, painted in the dark colours that reveal Israëls' admiration for the later Rembrandt. To a contemporary audience this painting may have conveyed a sense of doom, but in the end the title, *Sad Thoughts*, had to give a definition to the content. It can be argued that the young girl's pose does suggest, by the naturalness and closeness to actual life, that she is in a pensive mood, and that her physiognomy as well as the general

128 ISRAËLS *Sad Thoughts* 1896

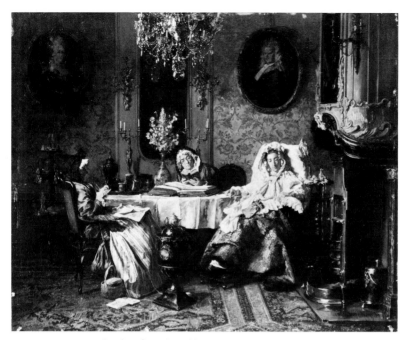

129 BAKKER KORFF *Reading from the Bible* 1879

dark atmosphere of the painting qualifies that mood, quite naturally too, as
sadness. But are states of mind so easily recognizable? If there is in the
painting more than an allusion, it is because the pose of the girl became the
culturally defined formula of an emotion. For Romantic painting, which
wanted to portray the *soul*, such formulae were, for obvious reasons, very
attractive. Israëls could use this formula with some emphasis because the
picture contains only that one figure. In more elaborate paintings, however,
like *Reading from the Bible* (1879) by A.H. Bakker Korff (1824–82), the 129
recognition of the Victorian sentimentality of the subject is wholly
dependent on the sub-title: *Song of Solomon 2:1 – I am the rose of Sharon, and
the lily of the valleys*. This quotation makes the scene, three spinsters in their
rich, bourgeois drawing-room, into a private moment of elegiac remem-
brance of their own youth, which is long past. Now they are in the twilight
of their lives, just as the twilight of the room suggests that the day is drawing
to its close.

The pictures of Israëls and Bakker Korff are typical of the quiet mood of
Dutch Romantic painting; violently erupting emotions, so characteristic of
the contemporary French Romanticism of Géricault or Delacroix, were

very rare. A sober realism had apparently anchored itself very deep within the culture. Within the context of this sobriety, that marvellous sense of rhetoric, that fascinating eloquence which are characteristic of seventeenth-century art, became meaningless. Painting's task now was to show reality as it really was.

That an empirical attitude towards reality (and a documentary attitude in painting) impedes the imagination, even if one actually wants to realize a grand design, is shown by one of the greatest pictorial undertakings of the nineteenth century: the immense painting of *The Battle of Waterloo* by Jan Willem Pieneman (1779–1853). For the Kingdom of the Netherlands, newly created at the Congress of Vienna, the Battle of Waterloo had a special, dynastic importance. Two days before the actual battle, on 18 June 1815, the Prince of Orange (later King William II) had greatly distinguished himself; against the orders of the Duke of Wellington, he had, with his Dutch troops, held a position near Quatre-Bras against Marshal Ney, thus securing passage for the English forces which arrived only later. The bravery of the Prince impressed the Dutch enormously; the fact that two days later, at Waterloo, he was wounded in battle naturally added to the national pride. The Dutch Parliament presented the Prince with a castle in the country, and commissioned the artist Pieneman to do a painting of Quatre-Bras, to be hung there. This painting became an instant success, and in 1818 Pieneman decided to paint a second picture on his own account, this time representing Waterloo itself.

The painting was finished in 1824; Pieneman spent almost two years on portrait studies of Wellington and his staff alone. Several moments are combined in the painting: on the left the brave Prince of Orange, who has just been wounded, is carried away. In the middle is the Duke of Wellington, caught in a sudden ray of sunshine, while from the right Lieutenant-Colonel Freemantle brings the message that the Prussians under Marshal Blücher have just arrived. This decided the battle in the nick of time in favour of the Allies. The captured French standards are raised in triumph.

Before the painting was bought by the King for a very large sum and installed in the Palace in Brussels, it went on an exhibition tour. For that occasion the artist wrote an explanatory leaflet, identifying the different characters and outlining the course of events. His text is more agitated than the painting. Pieneman wrote of Freemantle approaching 'at full gallop', of the staff officers of Wellington, 'full of enthusiasm to carry out the orders of the Duke', of cavalry 'charging down a hill', of a 'Dutch battery which by the intensity of its fire manages to silence the enemy guns'.

Little of that action, however, is visible in the painting; the battle which is presumably raging in the valley in the background is hidden from the eye by

130 PIENEMAN *The Battle of Waterloo* 1818–24

thick clouds of gunsmoke. The painting is little more than a formal group portrait with some slight hints of action. This cannot just be ascribed to incompetence, though Pieneman certainly was no superior artist: the painting was conceived within the context of a culture with little sense of high drama; the notions about the emotional attitudes acceptable in painting were such that this *Battle of Waterloo* must have seemed the most acceptable representation.

The very size of this painting indicated that the historical event was memorable indeed. That was its essential meaning and its *raison d'être*: to put on record the heroism and the military proficiency of actual persons. For this reason this historical painting consists of portraits against a background which is a faithful rendering of the actual landscape around Waterloo. It is not a grand evocation, as is for instance Rembrandt's *Conspiracy of Claudius* 46 *Civilis*, in which the composition, the colour and the light imbue the event with a sense of the supernatural. Here was an event which altered the course of national history; Rembrandt's painting brings this fact to one's consciousness. Pieneman's *Battle of Waterloo*, in the absence of all visual emotion, is a precise souvenir.

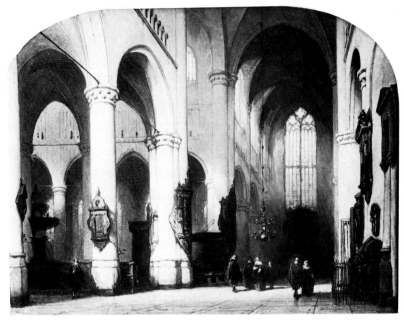

131　BOSBOOM *Interior of the Pieterskerk, Leiden* 1855

　　This momentous change in spiritual and mental attitude naturally had far-reaching consequences for painting – in particular in the choice of subjects and their treatment. With subject matter no longer controlled by moral categories, anything that was visible could be painted, however insignificant it might seem. The subject became the artist's personal choice; it was, in the end, his vision which might make the painting interesting. While Saenredam's church interiors had a significance independent of whatever the private feelings of the artist might have been – they were symbolic images of the geometric order on which, according to certain philosophers, the Creation was founded – the meaning of the interiors by Johannes Bosboom (1817–91) is precisely their personal vision. Saenredam's churches are painted in a harsh light (which is there to define the architectural structure more precisely); they are almost outside time. The churches of Bosboom, however, are mysterious: they are seen with a heavy, romantic feeling of nostalgia for times past, better times no doubt, Holland's Golden Age, as Bosboom subtly indicates through the seventeenth-century costumes of the tiny figures. His painting carries the private meaning of personal feelings. Such feelings were, for the seventeenth century, of no significance; they

131

were not recorded by biographers or by painters themselves. It was nineteenth-century art historians, embarking on the task of writing the national history of art and of composing biographies of its principal masters, who took the paintings for an index to character. After all, if Bosboom was expressing this feelings in his art, why should Rembrandt or Steen not have done so too? Seventeenth-century paintings, however, were made in a different way; instead of being constructed from private impressions, they were highly formalized; whatever meanings entered into them, entered through a network of conventions. So, even if a seventeenth-century painting might provide certain hints, it is certainly no basis for the reconstruction of historical characters.

Whatever letters of seventeenth-century painters have come down to us never speak about feelings *vis-à-vis* a subject. The nineteenth century, however, abounds in private journals and personal letters by artists in which they speak about what they felt and thought, what they dreamt of, what their desires were. From the journals of Delacroix or the letters of Vincent van Gogh, one has the impression of knowing these artists intimately; of Rembrandt's personal feelings or Steen's life next to nothing is known.

The growing emphasis on personal vision as the ultimate value in art could not but give art a very different status. Gradually it became more and more private; and the artist changed from someone with a precisely defined function in society into almost a solitary. But a solitary with an exceptional freedom: the freedom to make art exactly as he wanted to make it, to express any private vision of beauty he thought fit. It was the age of Art for Art's Sake; that comes to mind if one sees pictures like *Ducks*, painted around 1885 132

132 WILLEM MARIS
Ducks c. 1885

133 MAUVE *Donkeys
on the Beach*

133 by Willem Maris (1844–1910) or *Donkeys on the Beach* by Anton Mauve (1838–88). Their subjects are mere motives, insignificant in relation to their pictorial handling. In these paintings the emphasis has shifted from *what* is painted to *how* it is painted. It is the artistry with light and colour, the pictorial moment which makes these pictures interesting and, with reservations, modern. For in other aspects they are extremely traditional, or even provincial. In their Impressionistic appearance they are certainly approximations to what was being painted elsewhere, especially in France (*Ducks*, for instance, is exactly contemporary with the mature art of Cézanne); but structurally they are closer to, for instance, Bakker Korff, manifesting all the conventions of nineteenth-century realism. In Bakker

129 Korff's *Reading from the Bible*, the edge of the picture cuts abruptly across the chimney and the chandelier, while the carpet is at an angle to the lower edge. This gives the view of the room a curiously incidental quality reminiscent of photographic images, which heightens the realistic actuality of the scene. What one sees is a fragment of space – but in that fragment the main motive of the painting is still securely fixed. This ambivalence, or contradiction even, is also evident in the paintings by Maris and Mauve. While at first they give the impression of being the result of a brief glance, the concentration on the motive in the centre gives them at the same time a strange immobility.

 The strongest and most direct advocate of the new pictorial realism, which by the middle of the nineteenth century had become a major artistic ideology, was the French painter Gustave Courbet. 'The art of painting can

only consist of the representation of objects which are visible and tangible for the artist,' he said – and artists of one century were therefore 'basically incapable of reproducing the aspects of a past or future century'. The true artist found his subjects in his own time, and in his own surroundings; there he would paint what he saw, without employing stylistic devices (as earlier masters had done) to imbue his subject with moral qualities. Courbet was orthodox in his ideological conviction. His contemporaries were usually less passionate; but they too subscribed to the basic principles of realism. Reality should be depicted as it was: reality as significant in itself; everything else was of no real relevance. The true way to arrive at an understanding of the present – or of the past – was just to examine the evidence as it was found – without interpreting it within a framework of moral values. In this sense paintings like *Kenau Simons Hasselaer at the Siege of Haarlem* by the celebrated 134

134 ROCHUSSEN
*Kenau Simons
Hasselaer at the Siege
of Haarlem*

painter of national history Charles Rochussen (1814–94), with its care for historical detail, was as typical of the new realist feeling as Albert Gerard
135 Bilders's (1838–65) *Landscape near Saint-Ange* (c. 1860). Both painters had studied the evidence; Rochussen had probably gone through historical books and had formed in his mind an idea, to him historically correct, of what had happened in 1573 when Haarlem was besieged by Spanish troops and a woman inspired the citizens to that fierce resistance which would lead to victory. In the seventeenth century the subject of heroism would never have been represented by one single episode; it would have been organized within an allegory. For Rochussen, however, it was a precise historical event which had taken place then and there. And similarly, for Bilders, that landscape was not a grand image of the world as God's creation, like so many landscapes in the seventeenth century; it was a specific fragment of nature – something he actually saw: that grass, those trees, those rocks, that sun, those various shades of green.

For all its simplicity and directness, this small landscape by Bilders is one of the truly radical paintings in Dutch nineteenth-century art. When the writer Kneppelhout, in 1862, complimented Bilders on one of these sketches from

nature, he wrote: 'It belongs to a category that will not find easy buyers. But then it is more something for an artist than for an art-lover.' How true this judgment was; Bilders painted his little landscape at a time when his older colleagues were still trying to evoke the grandeur of seventeenth-century art. Artists like J. A. Knip (1777–1847) and Rudolph Kleijn (1785–1816) 136, 137 working while the Netherlands were under Napoleonic rule, had produced landscapes in a Neo-classicist vein, serene and dignified; others adopted a

< 135 BILDERS *Landscape near Saint-Ange* c. 1860

136 KNIP *Italian Landscape* c. 1806

137 KLEIJN *The Park at Saint-Cloud* 1810

138 KOEKKOEK *The Old Oak* 1849

139 NUIJEN *Landscape with a Ruin* 1836

138 more Romantic approach – like B.C. Koekkoek (1803–62), Andreas
140, 139 Schelfhout (1787–1870) and Wijnand Nuijen (1813–39). Their landscapes,
which in themselves attain high pictorial quality, differ in one fundamental
aspect from Bilders's sketch: basically they are constructions. They bring
together selected elements in an attempt to evoke a more or less precise
mood. The landscape then is not a record of natural phenomena, of the visual
evidence – it is a vehicle for feelings about nature. To many artists and critics
nature itself was unworthy of art.

A winding, sandy track – only a succession of flat pastures and ploughed fields – here and there a simple dwelling – in the distance a dilapidated little bridge over a narrow stream: how poor the material seems, even for the most luxuriant imagination! But let a bird's wings whisper around you; become aware of the horse and the cow in the clover; watch the life of the countryside, and see how many objects of study this unprepossessing little track can offer!

Thus Potgieter, the Romantic poet and strong critic of realism, sketched a landscape as it really should be, and it is actually surprisingly close to Schelfhout's painting.

Maybe the most strikingly novel aspect in Bilders's landscape was the viewpoint adopted by the painter. This brings the viewer very close to, or even into, the landscape. Naturally this feeling of direct experience, of sharing the view with the painter, is very important to realism – as it was not for classic or for Romantic landscape painting. In pictures like, for instance, Nuijen's brilliant *Landscape with a Ruin* (1836), an elaborate foreground acts 139 as introduction to the main motif, the mysterious ruin; at the same time it puts the landscape at a certain distance. Within Romantic aesthetics this is very logical: this optical distance transforms the landscape into an image which is not there to be shared but to be contemplated. In the act of contemplation the painting then acts as a vehicle for the private emotions the beholder can associate with it.

140 SCHELFHOUT *Dune View with Rustic Hunters*

This question of viewpoint was one of the new problems which nineteenth-century realism introduced into art. It led to types of composition that were fundamentally different from the usual composition, which aimed for strong internal balance. Here there is a conscious avoidance of composition as an independent structure controlling the picture-space – its ultimate being the almost fixed frame through which reality passes as if by accident, as in the *Paleisstraat, Amsterdam* done in about 1896 by the great G.H. Breitner (1857–1923). This picture accepts all the consequences of purely visual realism. Instead of directing his glance towards the motive, capturing it within the internal order of a painting, Breitner gives the impression that the picture itself, an empty frame, is immobile and the motive is constituted by the people who happen to pass by. The picture is not structuring reality, it is *accepting* it – just like a photograph. In consequence, the title of the painting does not identify its content – it just indicates the place where the image was recorded. (Breitner, we know, was an avid

141

141 BREITNER *Paleisstraat, Amsterdam c.* 1896

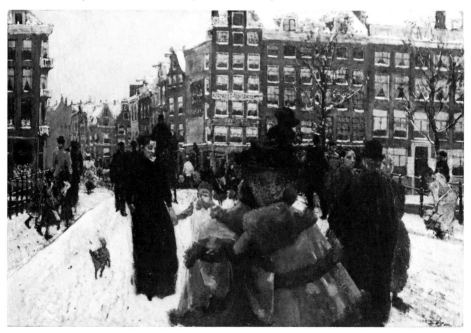

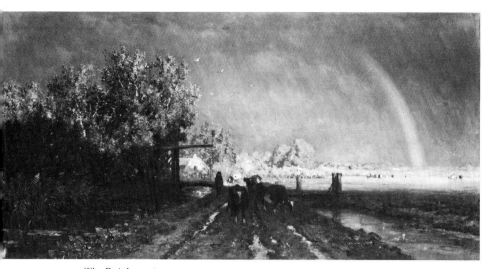

142 ROELOFS *The Rainbow* 1875

photographer, and the apparent incoherence of this painting, which nevertheless holds together, is no doubt due to his photographic experience.)

Before the astonishing ease and naturalness of this picture was achieved, older artists had to pioneer types of composition that were often consciously anti-classic and even dogmatic. One example is *The Rainbow*, a painting of 142 1875 by Willem Roelofs (1822–97). In order to organize a direct access to the picture-space, Roelofs employed the device of the straight path leading directly to the horizon, drawing the beholder's eye with it – while placing on the path a group of cows coming towards him, with an almost disorienting effect. This type of landscape layout had become a typical device in French Impressionism, where it was picked up by Jan Baptist Jongkind (1819–91) in his *Street in Nevers* (1874). Later it was also used by P.J.C. Gabriel 145 (1828–1903) in paintings such as the *Polder Landscape*, and in a very 144 subtle way by J.H. Weissenbruch (1824–1903) in *Souvenir de Haarlem* 143 (1875–80).

The second, and possibly the most important problem, with which nineteenth-century realist ideology confronted the painter was that of colour and light. In classical painting, up until Romanticism, colour had been subservient to meaning. Naturally objects had a certain colour, but that colour could be and was manipulated by the artist at will. The most conspicuous example, of course, was Rembrandt – but in what might be

161

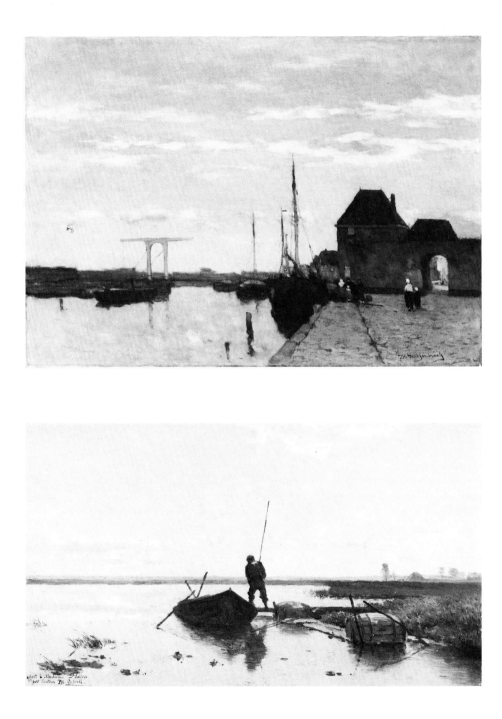

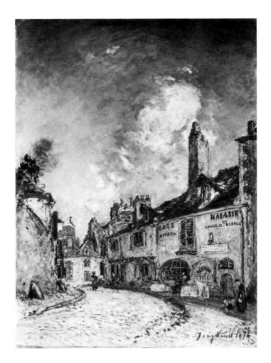

143 WEISSENBRUCH
Souvenir de Haarlem
1775–80

144 GABRIEL *Polder
Landscape c.* 1889

145 JONGKIND *Street in
Nevers* 1874

considered to be the most naturalistic achievement of Dutch painting, the landscape, the use of colour and the way light was allowed to touch colour were extremely formal. For example, a study of how the sky was painted in the seventeenth century reveals that only a few types were employed. The most common were: an evenly grey sky, used almost exclusively in the tonal period (in the work of Van Goyen and De Vliegher); a bright blue sky with a few white clouds, most often used in townscape painting and the quieter types of marine painting; and finally the restless sky, greyish-blue with dark, gathering clouds, which was the speciality of Ruisdael.

Of course this conventional scheme bore no relation to reality with its infinite variety of atmospheric conditions. It fell to the new realists to paint 'real' skies, 'real' light, as the prime condition under which the colours would appear. In effect, realism in Holland, particularly as it picked up more and more from the French Impressionists, came to be the painting of atmospheric conditions as such. Bilders's landscape was still an almost incidental fragment of nature, and as such untypical of later developments; Roelofs's *The Rainbow*, however, is basically a study of the effects of light – 142
sunlight shining through rain – on colour in landscape.

146 WEISSENBRUCH *Beach* 1901

147 MESDAG *Sunrise on the Dutch Coast* 1875

148 MARIS *Allotments near the Hague* 1878

Especially in the so-called 'Haagse School' – a group of Impressionist-oriented artists who found their aesthetic home on the coast and the low polders (reclaimed land) near The Hague – atmospheric painting was a speciality: in the beach-scenes of Weissenbruch or Hendrik Willem Mesdag (1831–1915), in the rain-swept skies of Jacob Maris (1837–99), or in the high summer landscapes of Gabriel. In France Jongkind developed into an Impressionist, as his beautifully clear and sensitive *La Ciotat* (1880) shows, while Breitner, a generation younger than his colleagues in The Hague and in his youth less affected by romantic feelings for nature, tried to capture the special atmosphere of the city in *The Dam, Amsterdam*.

The concern of the 'Haagse School' painters was totally with pictorial aesthetics: and that is how they chose their subjects. For what other motivation can there be in a beach picture by someone like Weissenbruch

146, 147
148
144
149

150

149 JONGKIND *La Ciotat* 1880

150 BREITNER *The Dam, Amsterdam* 1893–97

than an individual, aesthetic interest in those 'typically Dutch' silvery grey, liquid skies – and what is the function of a picture like *Polder Landscape* by Gabriel? This picture reads almost like a symbol of Impressionist realism at the end of the century. It is simple and direct in its viewpoint, which produces a motif highly suited to the display of the painter's considerable skills: the clear sky, the low land, the boatman linking them both, and finally the reflections. But apart from its virtuosity and its visual splendour, it is painting at a dead end. This very aloof aesthetic position, motivated by sheer individualism in perception and feeling, aloof from the world's turmoil, could only be continued into aesthetic exploration for its own sake. Such exploration finally led around 1910 to paintings like the landscapes by Jan Sluyters (1881–1957) and Leo Gestel (1881–1941) – 151, 152 paintings of considerable pictorial quality and intelligence, which are close to contemporary developments such as French Fauvism. 'Composition', wrote the leading Fauvist Henri Matisse in his famous *Notes d'un peintre*, 'is the art of arranging in a decorative manner the various elements at the painter's disposal for the expression of his feelings.'

More and more, however – and especially in the works of basically uncertain artists like Gestel and Sluyters, painters without a strong direction and dependent on external impetus – it became clear that 'feelings' were a basis too diffuse to produce art. Dependence on one's feelings easily led to idiosyncrasy and to pointless aestheticism. Matisse sensed this when he spoke of 'that state of condensation of sensations which constitutes a picture' which could only be reached with time and intellectual reflection; only then could the picture finally be recognized as 'a work of the mind'. Not every painter, however, could muster the self-control that Matisse was capable of.

The problem of nineteenth-century realism, then, was precisely the individualism it finally allowed. If the aim was to paint the world as visible reality, then traditional visual schemata had to be avoided, for they would immediately associate a subject with old, conventional attitudes. The artist had to develop new attitudes and viewpoints towards reality, for which the only guide could be his own personal decision. With some artists – like Courbet, of course, and in Holland possibly Breitner – excessive personal feeling was held in check by an idealist conception of an 'objective' realism dealing with the contemporary world – an art which, according to the Socialist philosopher and friend of Courbet, P.J. Proudhon, would be an 'idealist representation of nature and ourselves in view of the physical and moral perfection of our species'. Most other painters could not share these noble aspirations, at least not in their painting, and were guided only by individual aesthetic ideas. Individualism, however, is a weak basis for continuing to make art; and it is not surprising that towards the end of the

151 SLUYTERS *Landscape* 1910

152 GESTEL *Tree in Autumn*
1910–11

nineteenth century there emerged a relatively new phenomenon in the history of art: the formation of different groups each devoted to one particular ideology. Each ideology, of course, was its own ultimate truth and incompatible with all other ideologies. Such a phenomenon only occurs when a tradition, strong enough to carry many diverse developments, is no longer in existence.

The crucial problem, how to give meaning to art, was the central issue in the troubled life and work of the greatest Dutch painter of the nineteenth century, Vincent van Gogh (1853–90). Although he made drawings as a child, Vincent was rather late in deciding to become a painter – and in a sense his doing so was also prompted by the failure in his early work as a missionary. He was the son of a Protestant preacher, and was raised strongly within the Christian ethic. He was also a very nervous, unstable person, easily affected by human misery. After an abortive period as an assistant to an art-dealer in London (where he was affected by the humanitarian sentiment in the novels of Dickens), he decided that he could best fulfil his desire to help the poor by becoming a preacher. But the study of theology was too bookish for his taste. In 1878 he went to the Borinage district of Belgium, but the miners, living in a totally different world, did not understand Vincent's charity; they thought him a mere eccentric. Deeply disappointed and full of shame, Vincent left for home – and it was then that he decided to become a painter, hoping that by painting he could contribute to making the world better. He went to his uncle Anton Mauve, in The Hague, for formal training – but the two, so different in outlook and artistic ambition (Mauve the suave landscapist, Vincent the Christian revolutionary) soon quarrelled. Out of money, Vincent returned to his parental home in Brabant. His painting at this time was awkward, uneven and difficult – but how to paint was less of a problem than what to paint. He observed the peasants around the village where he lived, talking and working with them, making drawings and oil-sketches of their faces, their hands, their postures at work. In May 1885 he painted his first masterpiece and a manifesto of his goals as an artist, *The Potato Eaters*. It is a dark, disturbing painting – disturbing in its 153 formal coarseness and even more so in its totally unsentimental attitude. There is nothing of the pastoral serenity that was traditionally an element in paintings of peasant life, even in the pictures of the French realist Millet whom Van Gogh greatly admired. The peasant life was rough – and thus the painting was rough, with no aesthetic subtlety. In a letter to his brother Theo, who was living in Paris, Vincent wrote how he had tried – 'to emphasize that those people, eating potatoes in the lamplight, have dug the earth with those very hands they put in the dish, and so it speaks of *manual labour*, and how they have honestly earned their food'.

153 VAN GOGH *The Potato Eaters* 1885

The painting provoked a scandal in the village. Once more rejected, Vincent left for Paris, to join his brother Theo. He arrived there in February 1886, and Theo, who through his work with the art-dealer Goupil was well connected in the Parisian art-world, introduced him to other painters: Camille Pissarro, Henri de Toulouse-Lautrec, Emile Bernard and, most importantly, Paul Gauguin. He discovered the brilliance and richness of the Impressionist palette, and in his conversations with Gauguin he became convinced of the expressive powers of pure colour. But still his interest in the Parisian innovations was not aesthetic, still his hope was to create those radiant and hopeful images that would provide consolation to others in despair.

In February 1888 he travelled south to Arles in Provence, where he arrived when spring was in first bloom. Dazzled by the intense Mediterranean light, he embarked on frenzied painting – sometimes exulting in visions of landscapes in deeply burning colours (*View at Arles with Trees in Bloom*), sometimes concentrating, as in meditation, on extremely simple, strangely delicate still-lifes (*Still-life with Bottle*). After a few months, however, the loneliness became oppressive. He invited Gauguin to stay with him. The visit proved a disaster; ill-matched in character, background and intentions, they could not tolerate each other's

154
155

154 VAN GOGH *View at Arles with Trees in Bloom* 1888

155 VAN GOGH *Still-life with Bottle* 1888

presence. Shortly before Christmas 1888 Vincent had his first attack of madness, cutting off part of his left ear. He committed himself to a mental hospital, came out after a month and then after a few weeks went back again. The attacks came more often, but in between he continued to paint – after each attack with more vehemence. With his paintings he had hoped to console others, but actually he was consoling his own despair – his failure to express what he wanted, his nagging sense of not being understood by his fellow men. In May 1889 he had himself transferred to the mental hospital at Saint-Rémy. Each painting was 'a cry of anguish' he wrote to Theo, and of a 157 painting of the wheatfield behind the hospital, with a reaper, done in September 1889 he writes:

I see in this reaper – a vague figure fighting like a devil in the midst of the heat to get to the end of his task – I see in him the image of death, in the sense that humanity might be the wheat he is reaping. So it is – if you like – the opposite of that sower I tried to do before. But there is nothing sad in this death, it goes its way in broad daylight with a sun flooding everything with a light of pure gold.

In the spring of 1890 loneliness overcame him; the blazing, hot south, which at first had given him strength, now inspired fear. Theo advised him to go to Auvers-sur-Oise, and consult the physician Dr Paul Gachet, a friend of the Impressionists, who would understand his troubles. Staying in a small hotel in Auvers, he painted some of his most desolate and most disturbed landscapes, full of ominous movement, and yet completely empty and 156 hopeless, like *Wheatfields and Crows*. 'They are vast fields of wheat under troubled skies', he wrote to Theo, 'and I did not need to go out of my way to try to express sadness and extreme loneliness.' On 27 July 1890, on a walk, he shot himself. He died two days later.

156 VAN GOGH *Wheatfields and Crows* 1890

157 VAN GOGH *Wheatfield with a Reaper* 1889

158 TOOROP *Autumnal Landscape, Surrey* 1890–91

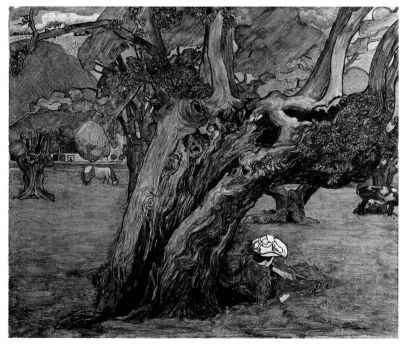

Vincent van Gogh's art, which coincides with his life, stands somewhat apart from the general developments of Post-Impressionist painting. Historically he is closest to Symbolist painters like Gauguin who tried, through the conscious manipulation of colour and design, to express something spiritual beyond the visible – following, almost, the famous anti-realist words of the great Romantic painter Delacroix: 'in his soul man has innate feelings which actual objects will never satisfy, and to these feelings the imagination of the painter or poet can give life'. But, seen beside the terrible urgency and vehemence of Van Gogh, most Symbolist art looks tame and elegant, like the refined *Autumnal Landscape, Surrey* by the most prominent Dutch Symbolist, Jan Toorop (1858–1928). What in Van Gogh's art is deeply felt, looks in this painting like adopted elements of style: strong, flat colour and flowing outline. Toorop, very unlike Van Gogh, treats his tree-trunk as an elaborate linear ornament, and the woman lying underneath the tree introduces a sweet mood of sentimentality. In Toorop's later work this sentimentality developed into a strangely fragile lyricism – as it did in the work of his contemporary Johan Thorn Prikker (1868–1932) whose *Bride* (1893) is a perfect example of the suave, highly literary trend in Symbolist art that was eventually to lead to Art Nouveau.

158

159

159 THORN PRIKKER *Bride* 1893

Another order

Twentieth-century developments

In the summer of 1917 the first issue was published of a curiously dogmatic and somewhat polemical magazine. Its title was *De Stijl* (*Style*, or *The Style*) – and in the course of its existence, until 1932, it was to have a profound impact on the subsequent development of modern art. As its founder and editor Theo van Doesburg (1883–1931) wrote in the introduction, its purpose was 'to state the logical principles of a style now ripening, based on a pure equivalence between the age and its means of expression . . . we wish to pave the way for a deeper artistic culture, based on a collective realization of the new awareness'. This statement of intent seems to be directed at a fundamental dilemma that confronted painting, and of which individual painters, throughout Europe, had gradually become aware. The problem was basic: *what* to paint and *how* to paint. A sense of individualism in nineteenth-century art had inexorably undermined the classic tradition, the Grand Tradition, being that collective set of artistic assumptions and convictions which had, since the Renaissance, upheld art, providing a strong, normative framework within which the painter could make his decisions. What to do, and how to do it: the answer had once followed with almost natural consequence from the tradition. Now it had become a decision for the individual artist.

It was to this situation that *De Stijl* addressed itself. If the individual is the measure of all things, then anything can be art if the artist presents it as such. And, moreover, such highly individual art could not be understood by the public, since it was not based on assumptions about art that were shared by both artist and public. At the root of De Stijl (as of the other artistic factions that sprang up around the same time) lay the longing for a new and contemporary tradition – a tradition that would reflect the 'awareness' of the age and hence could be shared with a contemporary public. But traditions do not originate overnight; and because the artists of De Stijl were not prepared to wait for it they tried to force it. Instead of a set of inherited assumptions, De Stijl proposed a theory – a coherent but essentially arbitrary set of new assumptions. This theory, however, was not something formulated out of hand; like most theories, at the time of its final formulation it reflected a

160 MONDRIAN *Summer's Night* 1907

praxis already in existence, however vague, however tentative. Its slow growth can best be followed in the art of the painter who was by far the best and most convincing representative of De Stijl, Piet Mondrian (1872–1944).

The beginnings of Mondrian lay in a kind of romantic Symbolist painting. He was a very slow, or maybe a very deliberate artist; he was forty years old when he found the style that would mark him as maybe the greatest of the twentieth-century Modernists. In 1907, when he painted a delicate

160 *Summer's Night* in a somewhat antiquated Symbolist manner, one would hardly have suspected that only a few years later his paintings would be radically different. Yet paintings like these must have been crucial for Mondrian – making him aware that this kind of painting could not go on. It could not go on because there was no real justification for it beyond the satisfaction of personal aesthetic needs. As a pictorial gesture it was almost empty of meaning – and for that reason *Summer's Night* must have been a difficult painting to do. Its aim is to express the visual experience of a moonlit night. As a subject it is conventional enough – within Dutch tradition it goes

96 back at least to the night scenes of Aert van der Neer; what is striking, however, in particular when compared to Van der Neer's sureness in treatment, is the extremely hesitant look of Mondrian's painting. It is as if

176

each individual brushstroke had to be thought over and individually decided on. And something else is noticeable too. As if to find, in the subject, a norm for the pictorial decisions he had to take, Mondrian looked for a structure – and found one, which is especially apparent in the middle part of the picture: the horizon and the trees are treated, almost abstractly, as the expression of a horizontal/vertical structure. The brushstrokes here follow this structure. One year after *Summer's Night*, in 1908, Mondrian painted *The Red Tree*. In 161 terms of pictorial problem, this picture is interesting for its direct dealing with colour. This becomes especially clear if it is compared with the Neo-Impressionist landscapes of Mondrian's somewhat younger contemporaries, Sluyters (1881–1957) and Gestel (1881–1941). Both Sluyters and Gestel had already visited the capital of art, Paris, at the time when Matisse and Derain were carrying Neo-Impressionism over into Fauvism, and Braque was painting his early, brightly coloured landscapes. From their paintings, *Landscape* (1910) and *Tree in Autumn* (1910/11), it is evident that Sluyters and 151, 152

161 MONDRIAN *The Red Tree* 1908

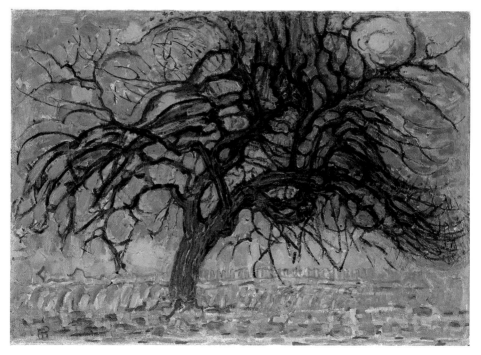

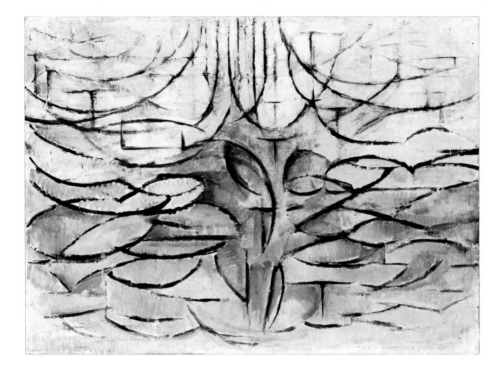

Gestel owe a lot to their Parisian visit. Their paintings, too, are based on bright and abundant colour; yet their handling is fundamentally different from Mondrian's. Sluyters and Gestel used colour to present a free and pictorial translation of nature's visual abundance – of the world as a kaleidoscope, essentially as the Impressionists had done. The problem in *The Red Tree* is not that of free, evocative colour but rather one of colour as a sharp definition of form. Where Sluyters and Gestel tended to hide form within an aggressive orchestration of colours, Mondrian restricted himself to a luminous blue background against which the individual, organic form of the tree is traced in bright red. In this restriction again lies Mondrian's search for the elementary in nature and in art.

He then went to Paris, in 1911, where the Cubism of Picasso and Braque had an immediate impact on his art. This is borne out by the second painting of a tree, *Apple Tree in Bloom,* of 1912, which almost reads as a correction of *The Red Tree*. Instead of portraying an individual form against a neutral background, as in *The Red Tree*, in *Apple Tree* Mondrian developed a loose pattern of similar forms in which the actual image of the tree dissolves. An interchange between shape and background is achieved here in an organization of more or less identical formal elements that does not express

162

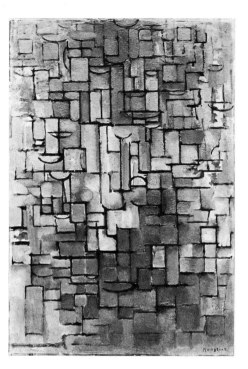

162 MONDRIAN *Apple Tree in Bloom* 1912

163 MONDRIAN *Composition* 1913

the form of the tree in its individual particularity (as *that* tree) – but expresses, abstractly, the typical expansiveness of a tree as it branches out into space.

During the next year, 1913, Mondrian more consciously than before adapted his subject to his stylistic concerns, working on a group of paintings which have for their actual visual source the elaborate architectural façades of Gothic cathedrals. The curved lines which appear in *Apple Tree* are here straightened out; to Mondrian's sense of balance between inner structure and overall form, they did not belong in a rectangular picture-field. In one of the architectural paintings, *Composition* (1913), a rectilinear structure holds, like a grid, flatly painted rectangular shapes in neutral colours like brown and grey. Only a few curving lines refer to the original visual source. Another remarkable aspect of *Composition* is that it has no clearly marked centre. In *Apple Tree* the visual source still left clear traces in the picture's structure: the central trunk is clearly visible, and from there the curving lines branch out, to be cut off at the edge of the picture-plane. The plane, in its rectangularity, is foreign to the internal structure – while in *Composition* it really carries the structure. Along the edge of the picture-plane the structure becomes vague, undefined; the lines stop before they intersect with the edge; thus the suggestion of the 'window' inviting the eye into an illusionistic space, is

163

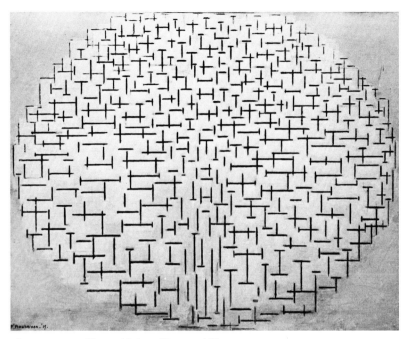

164 MONDRIAN *Composition 10: Ocean and Pier* 1915

consciously avoided. This development towards an abstract painting, in which the formal structure can no longer be read as an illusionist indication
164 of something else, continues in a painting like *Composition 10: Ocean and Pier* (1915). It is an oval structure in black and white, avoiding for the time being the problem of colour, composed of intersecting horizontal and vertical lines, almost independent of the rectangular picture-plane and yet only readable as part of that picture-plane – again with the typical avoidance of the picture's edge.

Mondrian arrived at these clear pictorial statements in Paris, at the time when the Cubists were slowly beginning to lose their initial vigour. They were going back to clearly defined, figurative shapes against a flat background and once again introduced the illusionist, spatial ground/shape relationship Mondrian was seeking to remove from painting. Naturally he was dissatisfied with this development. Cubism, he wrote, 'did not accept the logical consequences of its own discoveries; it was not developing towards its own goal, the expression of pure plastic form'.

While Mondrian was in Paris, Van Doesburg in Holland moved in a similar direction – but from a different background. Van Doesburg's first impulses came from contemporary Modernist art in Germany; the first

180

'modern' paintings he made around 1915, after the usual Romantic landscapes, were basically inspired by the free, intuitive abstractions of Kandinsky. After these, however, his style changed abruptly – as by revelation. Unlike the contemplative, philosophically inclined Mondrian, Van Doesburg was an activist intellectual; and as his abstractionist *Card-* 165 *players* (1917) may show, his conception and appreciation of Cubism seemed rather intellectual. The painting, which is the result of a resolute process of geometric stylization of an actual motive, looks indeed like a careful but orthodox application of the newly found formal principles – yet it is without the deep radicalism at which Mondrian had arrived, slowly and step by step. In essence, *Cardplayers* retains the typical spatial interplay between the constituent elements – an interplay between forms highly unequal in size and shape, as well as a chiaroscuro interplay between light and dark elements. Compared to this painting, whatever its individual importance to Van Doesburg's development, Mondrian's *Ocean and Pier* was certainly 164 much more advanced.

165 VAN DOESBURG *Cardplayers* 1917

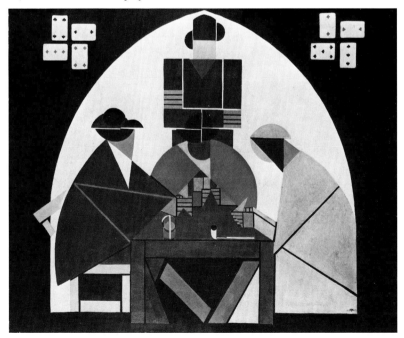

At this time the importance of Van Doesburg was more that of the articulate activist for the new principles than as a real innovator. It was he who took the initiative for the magazine *De Stijl*, forming round it a group of artists – not only painters, like Mondrian and Bart van der Leck (1876–1958), but also designers and architects. This made De Stijl into a different sort of group from the usual bands of painters such as the Fauves or the Cubists in Paris. De Stijl was more like an academy, where artists of different disciplines debated, defined and redefined the principles of a new visual language, to be applied to all visual phenomena.

Artists like Mondrian and Van Doesburg were deeply aware of the fact that they were changing the classic conceptions of art, that they were formulating a new system of plastic expression – and that somehow, to make themselves better understood, they had to define a set of rules. For if the real world was no longer relevant as a pictorial model, giving the basic relationships of size and position between objects, how then should a painting be organized? In an art which retains some connection with visible reality, however slight, organization of elements is basically simple: a tree is higher than a flower, a house stands on the ground, clouds are in the air, water is blue, and grass is green. In order to enhance expressive qualities one may take liberties with those laws, as Gestel did in his *Tree in Autumn* or as later Expressionist painters like Jan Wiegers or Herman Kruyder would do, but only to a certain extent. Mondrian, however, rejected the actual appearance of individual forms as the visual basis for painting: 'particularities of form obscure pure reality'. By this he meant that true reality is universal and general – that, for example, the true reality of a tree is not its specific form but, more abstractly, its verticality, its upwardness and its branching out in space. 'The truly modern artist', he wrote in the first issue of *De Stijl*,

152

172, 173

is aware of abstraction in an emotion of beauty; he is conscious of the fact that the emotion of beauty is cosmic, universal. This conscious recognition has for its corollary an abstract plasticism [*beelding*, generation of form], for man adheres only to what is universal. The new plastic idea cannot, therefore take the form of a natural or concrete representation, although the latter does always indicate the universal to a degree, or at least conceals it within. This new plastic idea will ignore the particulars of appearance, that is to say, natural form and colour. On the other hand it should find its expression in the abstraction of form and colour, that is to say, in the straight line and the clearly defined primary colour. These universal means of expression were discovered in modern painting by a logical and gradual prógress towards ever more abstract form and colour. Once the solution was discovered, there followed the exact representation of relations alone, that is to say, of the essential and fundamental element in any plastic emotion of the beautiful.

166 VAN DER LECK
Composition 1918

The problem, then, became one of definition of form and colour, as elements, and of placing these elements in relation to each other on the picture-plane. Basic rules for this problem were not found. Some clues could be found in basic formal properties of the picture-plane – placing the elements, as Bart van der Leck did in his refined and beautifully precise *Composition* (1918), in a certain relation to the four corners and to the centre.　166

But such precision, too dogmatic almost, is rare, especially in the later work of Van der Leck himself, who soon went back to more recognizable subjects, like still-lifes, breaking up their form into geometric shapes in blue, red and yellow. Mondrian, in his typical paintings of the 1920s, seems actually to avoid too close identification with corners, centre or axis of the　167 rectangular plane; these paintings are, on the other hand, consistently peripheral (as Van Doesburg called them) in that he tends to move the colour planes, controlled within a structure of lines, towards the edges, thus leaving the image as open as possible. Another solution was adopted by Van Doesburg; as his *Composition* (1920) shows, his structures are based on　168 proportional division of rectangular shapes, yet with each shape individual in colour and size. A few years later, Van Doesburg introduced a different aspect by tilting his proportional structures to a diagonal position on the picture-plane. These paintings he called 'contra-compositions' – thereby　170 indicating that in them the actual rectangular picture-plane was brought into conflict with the image it carried – an effect which was more dynamic and, to Van Doesburg, more in line with the tempo of modern living.

167 MONDRIAN
*Composition in Red,
Yellow and Blue* 1921

168 VAN DOESBURG
Composition 1920

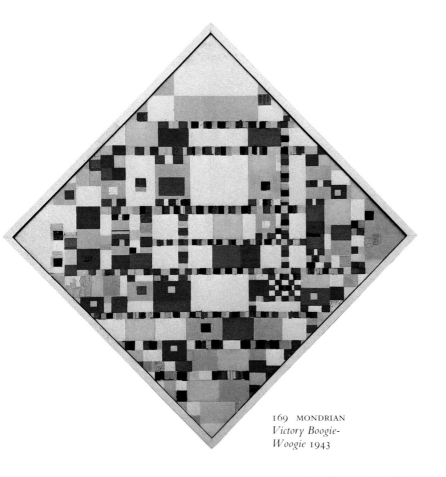

169 MONDRIAN
*Victory Boogie-
Woogie* 1943

These 'contra-compositions', if they are compared with Mondrian's extremely balanced pieces (like the *Composition* of 1921 or like the rarified *Composition* of black lines of differing width on white, of 1930), possibly 171 bring out the basic difference between the two artists. Van Doesburg, it seems, was primarily a designer of formal differentiation, of volumes of colour, and later this led him quite logically to architectural design. Mondrian, on the other hand, was much more a painter in the classical sense: his concern was, as in all art since the Renaissance, with the creation of pictorial space – only not now as illusionist space but as abstract, optical space. In Mondrian's classic paintings of the 1920s and 1930s, such as the *Composition* of 1921, space is evoked and structured by discreet visual signs, black lines and, often but not always, small blocks of primary colour; these signs are elements of form, but they do not *work* like forms; they are read as

185

170 VAN DOESBURG
Contra-Composition V
1924

171 MONDRIAN
Composition 1930

subtle fluctuations within an open space (as melody modulates silence), and in the end they are transparent against the space they help to construct.

Even when Mondrian acquired unexpected colourfulness in his late works, painted in New York from 1942 to 1944 (where he had gone when the war forced him to leave Paris), this quality of transparency remained. In

Victory Boogie-Woogie (1943) it is achieved through the strong contrasts 169
between the different colours; in their contrast they seem continuously to
dance on their underlying linear grid; they never close off the picture's
spatiality by attaching themselves to the picture-plane.

A major influence, or at least the most impressive and convincing model
for Expressionism – which next to abstraction was to be the most important
Modernist tradition in the twentieth century – was the art of Van Gogh. In
the early years of the century several large exhibitions, in Paris and
Amsterdam and in Cologne and Berlin, made his work better known – at a
time when subsequent developments, in Fauvist painting especially, had
already toned down the impact of this violent and personal art, making it
more acceptable and more understandable. These developments, taking up
some possibilities of dynamic design and the use of strong, heavy colour
already implied in Van Gogh's paintings, made it clear that Van Gogh's
pictorial idiosyncrasies, however personal in feeling and inspiration, could
be followed as examples of style. In fact they came to be regarded as the
start of a new episode in art – almost a new episode in feeling – which in the
early years of the twentieth century, running parallel to Cubism but
independent from it, started to bloom in several European centres, and
especially in Germany.

In the early 1920s a leading German Expressionist, Ernst Ludwig
Kirchner, while living in Switzerland, met a young Dutch artist, Jan
Wiegers (1893–1959), who was staying there to recover from an illness. In
Groningen, where he lived, Wiegers and some friends had formed the artists'
group De Ploeg (The Plough); inspired especially by the example of Van
Gogh, they tried to paint the northern landscape around their native city.
But for Wiegers the real breakthrough came when he encountered the
drastic, uncompromising Expressionist landscapes of Kirchner. Back in
Groningen he found his true style in paintings like *Landscape with Red Trees* 172
(1924), which stands out as one of the finest paintings produced in Dutch
Expressionism.

Another Expressionist was Herman Kruyder (1881–1935), who most of
his life lived as a recluse near Haarlem. He never travelled abroad, and never
had a formal training, but he picked up a subject where he encountered it.
Maybe for that reason his paintings, Expressionist in style and sentiment,
have that awkward, strange *naïveté* evident in the *Pig Killer* (1925). Kruyder 173
was an artist who had apparently learned certain stylistic devices, who knew
of Expressionism as an artistic ideology, but who was not interested in
employing it as a consistent style.

But even though there were some Expressionist painters of high
individual quality, Expressionism never really caught on in the Netherlands

172 WIEGERS *Landscape with Red Trees* 1924

between the wars. Whether that is because the Dutch character is not given
to the display of strong emotion (Van Gogh after all found his own style in
France) is difficult to decide. In fact Dutch art between the two wars, with
the exception of *De Stijl*, found itself curiously apart from international
developments. The Dutch either did not know about them, or rejected
them. Apart from some extremely isolated examples by semi-amateurs,
Dadaism passed Holland by; nor did Surrealism catch a significant foothold.
The artists who seem to have dominated the scene, and who at least tried to
do something original, were painting in a cold, precise, realist style. Some of
174 those painters were labelled Magic Realist: Carel Willink (b. 1900), Pyke
175 Koch (b. 1901) and Raoul Hynckes (b. 1893); others did not directly belong
to that group but developed a harsh realism that was very similar: Charley
176, 177 Toorop (1891–1955) and Dick Ket (1902–40). These paintings are usually

173　KRUYDER *Pig Killer* 1925

drily and flatly executed; the drawing is hard and hallucinatory in its precision. Objects, people, details in a landscape are described separately; there is little or no relation between them – each object is strangely alone. This precision has a fixating effect: objects and people are trapped in the picture and locked up in their own skin. The painter describes surfaces – and he does that with a sombre sentiment which may be best illustrated in these words by Willink:

Our vision is the confrontation with the never reassuring, never completely comprehensible world of phenomena in which the smallest and most familiar object can suddenly turn into something frightening; a world stranger and more dreadful in its haughty impenetrability than the most terrifying nightmare.

174 WILLINK *St Simeon the Stylite* 1939

175 KOCH *Shooting Gallery* 1931

176 CHARLEY TOOROP
*Still-life with
Cow's Skull* 1929

177 KET *Still-life with
Bread Rolls* 1933

Soon after the end of the Second World War, art began to manifest itself with a new vigour. The styles of the 1930s, and especially Magic Realism, seemed to have lost their meaning; they lacked critical bearing upon the new post-war reality. Only some form of vehement Expressionism suggested a certain degree of social involvement which indeed seemed to be then an essential requirement for art.

Having served to glorify and enhance the prestige and power of emperors and popes, western art has turned to a new master, the bourgeoisie, and has become an instrument for the glorification of bourgeois ideals. Now that these ideals have lost all significance since the economic conditions for their existence have vanished, we are entering upon a new era in which the entire cultural pattern of conventions will lose its meaning, and in which it will be possible to create a new freedom out of the most primary source of life.

178 Thus, in the Socialist euphoria of 1948, wrote Constant, designer of a Utopia called 'New Babylon', and painter of free, brilliantly sweeping

178 CONSTANT *Scorched Earth II* 1957

179 CORNEILLE *Great Bitter Earth* 1957

denunciations of the atrocities of war. Meanwhile, Willem Sandberg, the
new Director of the Stedelijk Museum in Amsterdam, launched a series of
exhibitions of twentieth-century classics such as Picasso, Chagall, Léger and
Braque. Contact with these masters gave young, uncertain artists the
opportunity to find some sense of direction. Constant (b. 1920) was one of
those; others were Karel Appel (b. 1921) and Corneille (b. 1922). Together
with Belgian and Danish colleagues of similar bent they founded, in 1948, an
international group which took its revolutionary sounding name COBRA
from the first letters of three European capitals.

180, 179

COBRA was primarily a casual coming together of unmistakably
different artistic personalities who, under the pressure of the times, had
suddenly found each other. Close to them was a group of young,
experimental poets of whom one, Lucebert (b. 1924) started to paint in the
middle 1950s – in a curiously witty style based on the manner of COBRA.
Together they hoped for a new, vivid kind of painting. To quote Constant,
the most versatile of the group, once more: 'A painting is no longer a
construction of colours and lines, but an animal, a night, a cry, a man, or all
of these together. Suggestion is boundless, and that is why we can say that,
after a period in which art represented nothing, art has now entered a period

181

in which it represents everything.' And Appel remarked: 'I paint like a barbarian in a barbarous age.'

In 1949 COBRA came into the open at the Stedelijk Museum. The exhibition provoked a veritable scandal. When the dust had settled, it became clear that a revolution had taken place. COBRA overcame powerful antagonism and restored some self-confidence to the Dutch art community. In 1951 the group was formally dissolved, to avoid becoming a stylistic clique; but artists who started painting in the 1950s, for instance Ger Lataster 182 (b. 1920), could hardly help being influenced by COBRA in some way or another.

In spite of all their conscious anti-traditionalism, the COBRA painters (like all good painters) were not immune to outside influences. Some of these influences came, not from established art, but from primitive art and from children's drawings which were admired for their freedom of imagination. But also Sandberg's exhibitions of modern classics were important. All these painters had been about twenty years old when the war started and had therefore seen little. Now they were presented with a rich survey of major developments since 1910. This confrontation left its marks; one finds reminiscences of Picasso's passionate works of the 1930s, culminating in *Guernica*, of Léger's heavy, sweeping contours, of the curious 'floating space' in Chagall's best paintings, of the free linearism of the more abstract

180 APPEL *Child and Beast II* 1951

181 LUCEBERT *The Flagon* 1972

182 LATASTER *The Victor* 1959

183 SCHOONHOVEN *Large Relief (Squares)* 1964

Surrealists like Miró. And finally, of course, there was the encounter with the emerging Tachism in Paris, where the COBRA painters spent most of their time, and where they must also have found photographic information on early Abstract Expressionism in New York.

Expressionism, especially in its post-war abstract varieties such as Tachism, needs strong motifs. Without them it turns into a Mannerist stylistic device. Several artists, growing up with the legacy of COBRA in the late 1950s and early 1960s, were dissatisfied in particular with the non-committal character of Tachism, and tried to establish working procedures that had some internal logic. Jan Schoonhoven (b. 1914), for instance, began as a Tachist painter and by the end of the 1950s was making free and bizarre-looking Tachist reliefs in papier-mâché, mostly monochromatic in shades of grey. Confronted by the fact that he could make these reliefs any way he liked, without any real difference, he decided just to make them geometric. Giving them a geometric and seemingly more structural character, and making them just in white (leaving colour out), he at least avoided the impression, still present in the individually motivated forms in the Tachist

183

reliefs, that he was expressing something. Fully accepting the contemporary viewpoint (most tellingly expressed by Marcel Duchamp) that a work of art was just an object which established itself as art within a specific cultural context, from 1960 onwards he produced white reliefs, each of them visually different by manipulation of the different elements, but all based on the same anti-Expressionist principle.

Around 1960 the viewpoint presented by Duchamp gained a new relevance in relation to Late Tachism. It proposed a basically negative definition of art – but this was precisely what seemed to be needed to escape the high claims of Tachist painting. In England and the United States, for instance, it had a strong ideological influence in the emergence of Pop Art; in Holland it helped Schoonhoven and others, like Armando (b. 1929), Daan 184 van Golden (b. 1936) or J.C.J. van der Heyden (b. 1928), to come to terms 185, 186 with the fact that they were producing simple visual objects whose artistic importance did not reside in a 'content' but an ideological position. In an extremely and even disturbingly off-hand manner their works questioned that nature of art, and the nature of art-making. Maybe they were cynical; but it was a kind of cynicism that was needed to produce any good art at all.

184 ARMANDO *Six Times Red*
1961

185 VAN GOLDEN
Composition with Blue
1964

186 VAN DER HEYDEN
Blue Cross
1965–66

Other artists, somewhat younger, sought a way out of the deadlock by going back to Mondrian's claim that art should not be based on private intuition, but that art-making required continuous and strict analysis of one's procedures. In this respect Mondrian had been the opposite of his contemporary Duchamp, who considered Mondrian's search for the objective laws of painting a futile underaking. Mondrian had of course not succeeded in establishing these objective laws; but to painters like Peter Struycken, Ad Dekkers or Bonies, in the early 1960s, the position that everything could be art, that art was in the mind of the beholder, was equally untenable. In the end, they argued, a relief by Schoonhoven was still a personal gesture. Continuing Mondrian's search, in a sense, they proposed that a painting should be analysed and broken down into its basic elements – such as colour, form, scale, surface and so on. From these elements a picture then should be reconstituted, as it were, according to a set of rules formulated beforehand; this would control the way in which the elements would come together to form a coherent pictorial structure. Admittedly the formulating of the structural rule was a matter of individual decision – but after that, and on the basis of the rule being explicit, the structure of the picture would be fully readable. That way a picture would lose its mysteriousness.

It proved to be a problem, however, to formulate rules powerful enough to arrive at really complex visual structures. When rules were formulated out of hand, they tended to be rather simple – unable to control a wide range of permutations of elements. The resulting pictures, too, were 'simple' images – but an artist like Ad Dekkers (1938–74) considered that an actual advantage. Throughout his career, tragically cut short, Dekkers guarded with great care the simplicity of the procedures through which he organized his reliefs. It should be absolutely clear, he contended, what the origins of the procedure were; only then would the art object no longer be obscure. Then it could be regarded and discussed as a perfectly reasonable and normal object; therefore the reliefs are, with a few exceptions in the early work, always white. That is, colour is absent, so as not to interfere with the clarity of the formal and structural statement of the work. The procedure used by Dekkers is always derived from the concrete properties of the material or the basic forms he worked with. The relief shown here consists of two 187 layers, the first square, the second with one corner rounded to show a quarter of a circle inscribed within the square. In other reliefs Dekkers employs many different combinations of basic geometrical forms.

A similar visual simplicity is found in the work of Bonies (b. 1937), 189 although he is much less systematic. His paintings, usually rather large, have a dry effectiveness in design which gives them a particular objectivity. They sometimes look as if they have not been designed at all – as if they are

187 DEKKERS *First Phase Square to Circle* 1970

188 STRUYCKEN *Computer-Structure 6g-4a* 1969

189 BONIES *Untitled* 1969

'naturally' so. This quality of extreme matter-of-factness is something Bonies quite consciously wants. In his work he feels himself motivated by Socialist ideas about art; ideas about the artist designing visual programmes which the people could take up and use for their own ends – for instance to make their own art. Yet geometric simplicity can hardly be an aesthetic end in itself – let alone a criterion; it would soon exhaust itself or turn into Mannerism. Aesthetic ends are only viable if they coincide with a particular function; and thus an artist like Peter Struycken (b. 1939), who in his early work was somewhat on the same track as Dekkers or Bonies, actually started to research into the structural complexities of visual 'statements'. He was led into this by his growing interest in urbanistic planning and environmental design. His type of art, he felt, could make a contribution to the organizational problems of complex structures such as modern cities. The problem there was, in his analysis, that the structure, instead of clarifying itself, tended to become confused and chaotic – and his research came to be directed towards the design of extremely complex visual structures that were yet kept under the control of a clear, recognizable structural principle. At some point he started to make use of a computer to generate visual 188 programmes; only then could he keep track of the many different changes a visual programme goes through in its build-up.

The computer itself, however, had no particular significance. Struycken was not involved in any kind of technological art; and in more general terms one must say that, even if his art – as well as that of Dekkers and Bonies – forces one to discuss procedures, it is still ultimately the resulting image which counts – its objective quality or even its beauty. While these artists, and particularly Struycken and Bonies (as distinguished from the more

190 WESTERIK *The Fishwife* 1951

classical Dekkers), tried to direct art towards what they saw as important
social needs, others continued to paint in a more traditional sense. Edgar
Fernhout (1912–74) started in the 1930s as a child prodigy, painting small,
realist pictures. During the 1950s his work changed, though his reliance on
visual appearance remained. His paintings then became highly sensitive
evocations, essentially abstract, of nature – of light, landscape and the
seasons. An artist who virtually stands alone (though he has quite a large
following) is Co Westerik (b. 1924) – a painter of exquisitely done little
190 realist scenes. The quality of these paintings is primarily in Westerik's
private, poetic vision of his subjects – in their atmosphere of melancholy.
Another painter, Reinier Lucassen (b. 1939), also works on the basis of a
highly personal imagination – yet he consistently makes use of recognizable
visual elements. These are brought together in usually rather ironic images –
191 as in *A Cosy Corner*, which is a witty evocation of bourgeois ideals of
domestic cosiness. It is obvious that Lucassen has been influenced by Pop
Art – but only in terms of 'method', so to speak. His paintings are about

191 LUCASSEN *A Cosy Corner*
1968

192 FERNHOUT *In Spring* 1973

193 VAN ELK *The Reality of Morandi* 1972

clichés, in life as well as in art; his material, consequently, comes from popular literature, advertising, comic books, as well as from other painting. Mostly it comes from other painting; and it would be apt to say that Lucassen's painting, quoting all the time from other painting, exists within painting. It is an art reflecting on its own history. In this respect another artist, Ger van Elk (b. 1941), who instead of painting employs photography and photomontage, is fairly close to Lucassen (on some occasions they have also worked together). A fairly typical work by him is about Giorgio

193 Morandi, the Italian painter mainly of still-lifes, *The Reality of Morandi*. It is a construction of two photographs. One is a reproduction of a Morandi still-life: a highly aesthetic arrangement of small bottles in soft pastel colours on a table-top; the other photograph has been set up by Van Elk and contains everything that Morandi has removed from his art: tubes, pencils, matches, his glasses and so on. Actually this witty comment on art and reality, or on the 'aesthetic state of mind' is based on factual information – acquired by Van Elk by studying photographs of Morandi's studio.

This art, then, is about other art, about visual codes and aesthetic practice. In a period in which art was no longer related to a precise social function, in which it had become Art as a separate human activity, this concern with the conventions of art itself seemed at least logical. It could express itself, as in the

work of Lucassen and Van Elk, in playful commentaries. It could also reach a
state of near-desperation – but desperation as a form of great seriousness.
This can perhaps be felt in the paintings of Jan Roeland (b. 1935), who takes 194
an object at random, for instance a table, and then tries to fit this object into
an abstract painting of extreme rarity.

Art about art; and as art can be defined as a particular form of perception
of reality, the conventions of perception itself could become a subject in art.
In the second half of the 1960s several artists, in different parts of the world,
began to be interested in this direction. In the Netherlands it was Jan Dibbets
(b. 1941) who, with the aid of photography, started to make constructions of 196
what might be called 'perceptual fragments'. Each individual fragment
(photograph) became an element in a structure, referring for instance to
landscape, which as such was independent of normal perception and which
structured perception itself in a new and unexpected way.

Jan Dibbets had started as a painter, but the way his artistic concerns
developed had led him away from painting. For what he wanted to do,
painting was no longer of any use. Of course, a configuration as in *Dutch*

194 ROELAND *Grand
Piano* 1972

195 DIBBETS *Dutch Mountain and Sea* 1971

196 DIBBETS *The Shortest Day* 1970

Mountain and Sea could have been painted on canvas but then it would have 195
failed to make the point: that it is a construction of perception itself,
perception abstracted from reality and reconstructed into an image which is
outside reality – which has its own reality as a work of art. During the 1960s
a considerable number of artists throughout the world, struggling with
problems they could not solve within the medium of painting, were forced
to turn to other means. Stanley Brouwn (b. 1935), for instance, whose work
is the presentation of measurements, related to the objective or general scale
of one metre and the individual scale of one step, can actually only document
these measurements. For this he used index-cards, books, card-files, sheets of
paper; and even if in some cases a work, like *one step on 1 m²*, looks like 197
drawing he insists that it should not be so called. It is just the presentation of
that particular measurement; and, indeed, it has nothing to do with classical
drawing. The work is not imagination; it is fact.

197 BROUWN *one step*
on 1m² 1975

Bibliography

1 The fifteenth and sixteenth centuries

Two monumental books are indispensable. One is M.J. Friedländer, *Die Altniederländische Malerei*, 14 vols, Berlin/Leiden 1924–37 (English edition Sijthoff, Leiden 1967, brought up to date by G. Lemmens *et al.*), which gives an acute summing-up of the style and development of all the major painters from the period 1420–1550, with lists of works and many illustrations. The other is E. Panofsky, *Early Netherlandish Painting: its Origins and Character*, 2 vols, Cambridge (Mass.) 1953 (also in paperback, Harper and Row, New York 1971). Panofsky's important discussion of content, iconographical style, and the character of the peculiar 'hidden symbolism' of the painting of this period, is supplemented by a rich bibliography.

Sixteenth-century art is a rather neglected field. The basic information can be found in G.J. Hoogewerff, *De Noord-Nederlandse Schilderkunst*, 5 vols, The Hague 1936–47. See also G. van der Osten and H. Vey, *Painting and Sculpture in Germany and the Netherlands 1500–1600*, Pelican History of Art, Baltimore 1969, and I. Veldman, *Maerten van Heemskerck and Dutch Humanism in the Sixteenth Century*, Maarssen 1977.

The best book on the problems of narrative style is M. Baxandall, *Giotto and the Orators*, Oxford 1971. It deals with Italian art, but since Italian art and theory became the model throughout Europe it applies to Dutch painting too. L.B. Alberti's book, *De pictura*, the most influential theoretical treatise of all time, has received an exemplary edition and translation: C. Grayson, *Leon Battista Alberti: On Painting and On Sculpture*, London 1972. For narrative in pre-Renaissance art, one might consult G. Henderson, *Early Medieval*, Penguin Style and Civilization, Harmondsworth 1972.

Dutch theoretical writing has always depended heavily on Italian sources – quite often by way of French translations. The most important text is C. van Mander's 'Den Grondt der Edel Vrij Schilder-const' (The Fundamentals of the Free Art of Painting), the preface to his *Schilder-Boeck*, Haarlem 1604. The original text, with a modern Dutch translation and copious notes, is now available in the Hessel Miedema edition (2 vols, Utrecht 1973). There is no English translation, although extracts can be found in W. Stechow, *Northern Renaissance Art 1400–1600: Sources and Documents*, Englewood Cliffs (N.J.) 1966.

Van Mander's text is thoroughly Mannerist in its aesthetics; it reflects the artistic atmosphere in late sixteenth-century Haarlem, where Van Mander founded some sort of academy. (See N. Pevsner, *Academies of Art: Past and Present*, Cambridge 1940.) No doubt the works of the major Italian theorists of Mannerism were discussed there. See also A. Blunt, *Artistic Theory in Italy 1450–1600*, Oxford 1940; and, for a systematic account of sixteenth- and seventeenth-century theory, R.W. Lee, *Ut Pictura Poesis: The Humanistic Theory of Painting*, New York 1967, an indispensable and beautiful little book.

On Mannerism as a style much has been written; a good general introduction is J. Shearman, *Mannerism*, Penguin Style and Civilization, Harmondsworth 1967. An exhaustive study of Dutch Mannerism does not exist; see, however, F. Antal, 'Zum Problem des niederländischen Manierismus', *Kritische Berichte zur Kunstgeschichtlichen Literatur*, II, 1928–29, also in his *Classicism and Romanticism, with Other Studies in Art History*, London 1966; W. Stechow, 'Cornelis Cornelisz. van Haarlem en de Hollandsche Laatmaniëristische Schilderkunst', *Elsevier's Maandschrift* 90, 1935; E.K.J. Reznicek, *Die Zeichnungen von Hendrick Goltzius*, 2 vols, Utrecht 1961; E.K.J. Reznicek, 'Realism as a "Side Road or Byway" in Dutch Art', *Studies in Western Art: Acts of the 20th International Congress of the History of Art*, vol II, Princeton (N.J.) 1963; and A. Lowenthal, 'Wtewael's Moses and Dutch Mannerism', *Studies in the History of Art*, National Gallery of Art, Washington, 6, 1974.

2 Genre painting in the seventeenth century

The most accessible general book on seventeenth-century painting is J. Rosenberg, S. Slive and E.H. ter Kuile, *Dutch Art and Architecture*, first published in 1966, now available in paperback, Pelican History of Art, Harmondsworth 1972; this work also contains a useful bibliography. W. Martin's classic, *De Hollandsche Schilderkunst in de 17de Eeuw*, 2 vols, The Hague 1942², is still indispensable. Eugène Fromentin, *Les Maîtres d'autrefois*, Paris 1876, is a delight to read; the best English edition is by H. Gerson, *The Masters of Past Time*, London 1948. M. Schapiro wrote a beautiful appraisal of Fromentin, in the *Partisan Review*, XVI, 1949. This essay, as well as H. van de Waal's brilliant introduction to his Dutch translation of Fromentin, *De Meesters van Weleer*, Rotterdam 1952, sketches the typical view of seventeenth-century Dutch art held at the period when modern art history originated. The best introduction to Dutch culture is still J. Huizinga, *Dutch Civilization in the Seventeenth Century*, London 1968; another useful book is J.L. Price, *Culture and Society in the Dutch Republic during the 17th Century*, London 1974, which contains a good bibliography.

For early realism, in Haarlem especially, see Å. Bengtsson, *Studies on the Rise of Realistic Landscape Painting in Holland: 1610–1625*, Stockholm 1952. See also H. Miedema, 'Over het realisme in de Nederlandse Schilderkunst van de 17de Eeuw,' *Oud-*

Holland, 89, 1975. As yet there is no new general book on Dutch genre painting; we will have to content ourselves with F. Würtenberger, *Das holländische Gesellschaftsbild*, Schramberg im Schwarzwald 1937. There are, however, some brilliant recent studies on iconological problems in genre by E. de Jong: *Zinneen Minnebeelden*, Amsterdam 1967; 'Erotica in Vogelperspectief', *Simiolus* 1968–69; 'Realisme en Schijnrealisme in de Hollandse Schilderkunst van de 17de Eeuw,' *Rembrandt en zijn Tijd*, exh. cat., Palais des Beaux-Arts, Brussels 1971; also the exhibition catalogue *Tot Lering en Vermaak*, Rijksmuseum, Amsterdam 1976. Other studies of general interest are Sturla Gudlaugsson, *Ikonographische Studien über die holländische Malerei und das Theater des 17. Jahrhunderts*, Würzburg 1938; S. Slive, 'Realism and Symbolism in Seventeenth-Century Dutch Painting', *Daedalus, Journal of the American Academy of Arts and Sciences*, summer 1972; E. Winternitz, *Musical Instruments and their Symbolism in Western Art*, London 1967; K. Renger, *Lockere Gesellschaft. Zur Ikonographie des Verlorenen Sohnes und Wirtshausszenen in der niederländischen Malerei*, Berlin 1970; P. Fischer, 'Music in Paintings of the Low Countries in the 16th and 17th Centuries', *Sonorum Speculum* 50/51, 1972; F. W. Robinson, *Gabriel Metsu. A Study of his Place in Dutch Genre Painting of the Golden Age*, New York 1974; A. Blankert, *Johannes Vermeer van Delft*, Utrecht/Antwerp 1975; L. de Vries, *Jan Steen, 'de kluchtenschilder'*, Groningen 1977; and S.J. Gudlaugsson, *The Comedians in the Work of Jan Steen and his Contemporaries*, Soest (Netherlands) 1975[2].

For emblematical literature, so vital for the decoding of genre painting, see M. Praz, *Studies in Seventeenth-Century Imagery*, Rome 1964[2]; J. Landwehr, *Emblem Books in the Low Countries 1554–1949. A Bibliography*, Utrecht 1970, and A. Henkel and A. Schöne, *Emblemata. Handbuch zur Sinnbildkunst des XVI. und XVII. Jahrhunderts*, Stuttgart 1967, with a wealth of illustration. For the related field of literature, see the anthology by T. Weevers, *Poetry of the Netherlands in its European Context 1170–1930*, London 1960.

3 History painting in the seventeenth century

The basic study is H. van de Waal's profound *Drie Eeuwen Vaderlandsche Geschieduitbeelding 1500–1800*, 2 vols, The Hague 1952. A more specific account of seventeenth-century art theory in the Republic is the brilliant study by J.A. Emmens, *Rembrandt en de Regels van de Kunst*, Utrecht 1968, which also provides a good bibliography. (Both books contain an extensive summary in English.) For the classicist theory, emerging towards the end of the seventeenth century, see G. Kauffmann, 'Studien zum grossen Malerbuch des Gerard de Lairesse', *Jahrbuch für Aesthetik und allgemeine Kunstwissenschaft*, 3, 1955–57,

and D.P. Snoep, 'Gerard Lairesse als plafond- en kamerschilder', *Bulletin van het Rijksmuseum* 18, 1970. Two interesting studies of the cultural climate surrounding history painting are S. Slive, 'Notes on the Relationship of Protestantism to Seventeenth-Century Dutch Painting', *The Art Quarterly* 19, 1956, and J.G. van Gelder, 'Two Aspects of the Dutch Baroque: Reason and Emotion', *De Artibus Opuscula: Essays in Honour of Erwin Panofsky*, New York 1961. The most important art-theoretical treatise of the mid-seventeenth century, S. van Hoogstraeten, *Inleyding tot de Hooge Schoole der Schilderkonst* (Introduction to the Academy of Painting) 1678, was re-issued in 1969 as a facsimile edition by Davaco Publishers, Soest (Netherlands).

Early history painting has been admirably treated by K. Bauch, *Der frühe Rembrandt und seine Zeit*, Berlin 1960. On the Caravaggists there is an older study, A. van Schneider, *Caravaggio und die Niederländer*, Marburg 1933, and two excellent monographs, B. Nicolson, *Hendrick Terbrugghen*, London 1958, and J.R. Judson, *Gerrit van Honthorst*, The Hague 1959.

The literature on Rembrandt is, of course, colossal. H. Gerson's monograph, *Rembrandt Paintings*, Amsterdam 1968, contains a good bibliography. Some specialized studies of interest are: S. Slive, *Rembrandt and his Critics, 1630–1730*, The Hague 1953; O. Benesch, *Rembrandt as a Draughtsman*, London 1960; H. Gerson, *Seven Letters by Rembrandt*, The Hague 1961; C. White, *Rembrandt and his World*, London 1964; J. Gantner, *Rembrandt und die Verwandlung klassischer Formen*, Bern/Munich 1964; K. Clark, *Rembrandt and the Italian Renaissance*, London 1968; R.H. Fuchs, *Rembrandt in Amsterdam*, New York 1969; B. Haak, *Rembrandt: his Life, his Work, his Time*, New York 1969; C. Tümpel, 'Ikonographische Beiträge zu Rembrandt', *Jahrbuch der Hamburger Kunstsammlungen* 13, 1968, and 'Studien zur Ikonographie der Historien Rembrandts', *Nederlands Kunsthistorisch Jaarboek* 20, 1969; J.S. Held, *Rembrandt's Aristotle and other Rembrandt Studies*, Princeton (N.J.) 1969 and *Rembrandt after Three Hundred Years. A Symposium*, The Art Institute of Chicago, 1973; O. von Simson and J. Kelch (eds), *Neue Beiträge zur Rembrandt-Forschung*, Berlin 1973; and H. van de Waal, *Steps towards Rembrandt: Collected Articles*, Amsterdam 1974.

4 Portraiture

Portraits are seldom spectacular; they have attracted considerably less attention from art historians than other themes. Hence the basic book is still W. Waetzold, *Die Kunst des Porträts*, Leipzig 1908. For general discussion, see H. Deckert, 'Zum Begriff des Porträts', *Marburger Jahrbuch für Kunstwissenschaft* 5, 1929; M.J. Friedländer, *Landscape, Portrait, Still-life*,

Oxford 1949; J. A. Emmens, 'Ay Rembrandt, maal Cornelis Stem', *Nederlands Kunsthistorisch Jaarboek*, 7, 1956; J. Gantner, *Schicksale des Menschenbildes*, Bern 1958. An important general study is J. Pope-Hennessy, *The Portrait in the Renaissance*, London 1966.

A survey of sixteenth-century Dutch portraiture is A. B. de Vries, *Het Noord-Nederlandsch Portret in de tweede helft van de 16de Eeuw*, Amsterdam 1934. For the seventeenth century, see F. Dülberg, *Das holländische Porträt des XVII. Jahrhunderts*, Leipzig 1923; H. Gerson, *Hollandse Portretschilders van de Zeventiende Eeuw*, Maarssen 1975; and recent monographs on major portraitists, especially S. Slive, *Frans Hals*, 3 vols, London 1970–74; S. J. Gudlaugsson, *Gerard ter Borch*, 2 vols, The Hague 1959–60 and C. Grimm, *Frans Hals*, Berlin 1972. Important studies on the group portrait are: A. Riegl, *Das holländische Gruppenporträt*, 2 vols, Vienna 1931; H. van de Waal, 'The Syndics and their Legend', in Van de Waal, *Steps towards Rembrandt*, Amsterdam 1974; and P. J. Vinken and E. de Jongh, 'De boosaardigheid van Hals' Regenten en Regentessen', *Oud-Holland* 78, 1963.

5 Landscape and still-life in the seventeenth century

K. Clark, *Landscape into Art*, London 1950, is probably still the best introduction to the art of landscape painting. M. Friedländer, *Landscape, Portrait, Still-life*, Oxford 1949, contains a perceptive essay. E. H. Gombrich, 'The Renaissance Theory of Art and the Rise of Landscape', in Gombrich, *Norm and Form*, London 1966, traces the origin of the notion of landscape as an autonomous category of art. See also A. R. Turner, *The Vision of Landscape in Renaissance Italy*, Princeton (N.J.) 1966. Important studies on the problems of historical interpretation of landscape are H. van de Waal, *Jan van Goyen*, Amsterdam 1941; A. Blunt, 'The heroic and the ideal landscape of Nicolas Poussin', *Journal of the Warburg and Courtauld Institutes* 7, 1944; H. Lützeler, 'Vom Wesen der Landschaftsmalerei', *Studium Generale* 3, 1950; M. Imdahl, 'Baumstellung und Baumwirkung', *Festschrift Martin Wackernagel*, Cologne 1958; and 'Ein Beitrag zu Hobbemas Allee von Middelharnis', *Festschrift Kurt Badt*, Berlin 1961; J. Bialostocki, 'Das Modusproblem in den Bildenden Künsten', in Bialostocki, *Stil und Ikonographie*, Dresden 1965; and R. H. Fuchs, 'Over het Landschap. Een verslag naar aanleiding van Jacob van Ruisdael, *Het Korenveld*', *Tijdschrift voor geschiedenis* 86, 1973.

The standard historical survey is W. Stechow, *Dutch Landscape Painting of the Seventeenth Century*, London 1966, containing a useful bibliography. See also Å. Bengtsson, *Studies on the Rise of Realistic Landscape Painting in Holland: 1610–1625*, Stockholm 1952. For the 'Italianate' artists see A. Blankert's

excellent exhibition catalogue, *Nederlandse Zeventiende Eeuwse Italianiserende Landschapschilders*, Centraal Museum, Utrecht 1965.

Most of the existing monographs are not very satisfactory; written a long time ago, before meaning in landscape became an issue, they deal exclusively with stylistic questions. However, two classics are worth consulting: J. Rosenberg, *Jacob van Ruisdael*, Berlin 1928, and H. Gerson, *Philips de Koninck*, Berlin 1936. A recent book on Cuyp is S. Reiss, *Aelbert Cuyp*, London 1975. Another interesting study is E. Schaar, *Studien zu Nicolaes Berchem*, Cologne 1958.

On landscape, architectural and marine painting, see H. Jantzen, *Das niederländische Architekturbild*, Leipzig 1910; *Nederlandse Architectuurschilders 1600–1900*, exh. cat., Centraal Museum, Utrecht 1953; C. Brown, *Dutch Townscape Painting*, Themes and Painters in the National Gallery Series, London 1972; F. Willis, *Die niederländische Marinemalerei*, Leipzig 1911, and L. J. Bol, *Die niederländische Marinemalerei des 17. Jahrhunderts*, Klinkhof und Biermann, Brunswick 1973. None of these books, however, is really satisfying; they sketch historical developments, but hardly deal with fundamental problems of meaning. Recent monographs and articles should therefore also be consulted: *Pieter Jansz. Saenredam*, exh. cat., Centraal Museum, Utrecht 1961; I. Manke, *Emanuel de Witte 1617–1692*, Amsterdam 1963; G. Schwartz, 'Saenredam, Huygens and the Utrecht Bull', *Simiolus* 1 (1966–67); and J. Walsh, 'The Dutch Marine Painters Jan and Julius Porcellis', *The Burlington Magazine*, November and December 1974.

For the history of still-life, by far the best book is C. Sterling, *Still-life Painting from Antiquity to the Present Time*, Paris/New York 1959[2]. (See also E. H. Gombrich's important review, 'Tradition and Expression in Western Still-life', in Gombrich, *Norm and Form*, London 1966.) The most comprehensive study of Dutch still-life is I. Bergström, *Dutch Still-life Painting in the Seventeenth Century*, New York 1956, with a full bibliography. See also J. G. van Gelder, *Catalogue of the Collection of Dutch and Flemish Still-life Pictures*, Ashmolean Museum, Oxford 1950, and E. de Jongh, 'Austerity and Extravagance in the Golden Age', *Apollo*, 86, 1967. An interesting monograph on early still-life is N. R. A. Vroom, *De Schilders van het Monochrome Banketje*, Amsterdam 1945. A classic study on problems of light and chiaroscuro, obviously very relevant to the art of still-life, is W. Schöne, *Über das Licht in der Malerei*, Berlin 1954.

6 The eighteenth and nineteenth centuries

The Dutch eighteenth century has been rather neglected by art historians. A rather cursory general introduction can be found in Rosenberg, Slive and

Ter Kuile, *Dutch Art and Architecture* (see above). A useful recent survey is provided in the exhibition catalogue, *Dutch Masterpieces from the Eighteenth Century*, Minneapolis Institute of Arts 1977. Some older studies, by pioneers in the period, are F.M. Huebner, *Nederlandsche en Vlaamsche Rococo-schilders*, The Hague 1943, and J. Knoef, *Tusschen Rococo en Romantiek*, The Hague 1943. An excellent study of the so-called 'conversation-piece' which was common in eighteenth-century iconography, is A. Staring, *De Hollanders Thuis. Gezelschap-stukken uit drie Eeuwen*, The Hague 1956. A good monograph has recently been published on the most interesting painter of the period by J.W. Niemeyer, *Cornelis Troost 1696–1750*, Assen 1973.

The nineteenth century is another neglected field. The basic survey is provided by G.H. Marius, *Dutch Painters of the Nineteenth Century*, English ed., Woodbridge 1973. See also G.H. Huebner, *De Romantische Schilderkunst in de Nederlanden: 1780–1840*, The Hague 1944; J. Knoef, *Van Romantiek tot Realisme*, The Hague 1947; and the exhibition catalogue *150 Jaar Nederlands Kunst: 1813–1963*, Stedelijk Museum, Amsterdam 1963. For the 'Haagse School' the standard monograph is J. de Gruyter, *De Haagse School*, 2 vols, Rotterdam 1968 (with English summary). A.M. Hammacher, *Amsterdamsche Impressionisten en hun Kring*, Amsterdam 1941, is a sensitive study of Breitner and his Amsterdam colleagues. P.H. Hefting and C.C.G. Quarles van Ufford, in *Breitner als Fotograaf*, Rotterdam 1966, treat the interesting use of photographs by Breitner. For late nineteenth- and early twentieth-century trends, between Van Gogh and Mondrian, see B. Polak, *Het Fin de Siècle in de Nederlandse Schilderkunst*, The Hague 1955 and A.B. Loosjes-Terpstra, *Moderne Kunst in Nederland 1900–1914*, Utrecht 1959 (English summary). The literature on Van Gogh is extensive. The basic study is the new edition of J.B. de la Faille's 1928 monograph and catalogue: *The Works of Vincent van Gogh. Paintings and Drawings*, Amsterdam 1968. The most perceptive essay on Van Gogh is M. Schapiro, *Vincent van Gogh*, New York 1950. Naturally, Dutch painting in the eighteenth and nineteenth centuries developed broadly along the same lines as in other countries. Some particularly interesting books which put the Dutch development into perspective: M. Levey, *Rococo to Revolution*, London 1966; R. Rosenblum, *Transformations in Late Eighteenth-Century Art*, Princeton (N.J.) 1967; L. Nochlin, *Realism*, Penguin Style and Civilization, Harmondsworth 1971; T.J. Clark, *Image of the People: Gustave Courbet and the 1848 Revolution*, London and Greenwich, Conn. 1973; T.J. Clark, *The Absolute Bourgeois: Artists and Politics in France 1848–1851*, London and Greenwich, Conn. 1973, and W. Vaughan, *Romantic Art*, London and New York 1978.

7 Twentieth-century developments

There is no good monograph on Dutch twentieth-century painting. The Stedelijk Museum (Amsterdam) catalogue of 1963, *150 Jaar Nederlandse Kunst 1813–1963*, actually comes closest to a reasonable survey. G.H. Hamilton, *Painting and Sculpture in Europe 1880 to 1940*, Pelican History of Art, Harmondsworth 1967, treats certain developments in Dutch painting very well.

Much, however, has been written on Mondrian and De Stijl. The basic study is H.L.C. Jaffé, *De Stijl 1917–1931. The Dutch Contribution to Modern Art*, Amsterdam 1956. Almost a companion volume is his 'documentary' *Mondrian und De Stijl*, Cologne 1967, containing many interesting extracts from *De Stijl*. A short introduction is P. Overy, *De Stijl*, London 1969. A complete reprint of *De Stijl* was published in 1968 (2 vols). The most comprehensive monograph on Mondrian is M. Seuphor, *Piet Mondrian: Life and Work*, New York 1957; J. Baljeu recently published a book on Van Doesburg, *Theo van Doesburg*, London 1974.

For Van der Leck see R.W.D. Oxenaar's exhibition catalogue *Bart van der Leck 1876–1958*, Rijksmuseum Kröller-Müller, Otterlo 1976 (English text). A very good history of abstract art in general, which puts the achievements of De Stijl in perspective and also studies its impact on post-war abstract painting, is C. Blok, *Geschichte der abstrakten Kunst 1900–1960*, Cologne 1975.

For other areas of twentieth-century painting, literature is scanty and often downright bad. I will mention what I think could be of interest: D. Welling, *The Expressionists*, Amsterdam 1968 (on pre-war Expressionism); L. Gans, *Neo-realism in Painting*, Amsterdam n.d.; W. Stokvis, *Cobra*, Utrecht 1973; *J.J. Schoonhoven*, exh. cat., Stedelijk Museum, Amsterdam 1973; *Armando*, exh. cat., Stedelijk Museum, Amsterdam 1974; *J.C.J. van der Heyden*, exh. cat., The Hague/Eindhoven 1977; *Ad Dekkers*, exh. cat., Gemeentemuseum, The Hague 1972; *P. Struycken*, exh. cat., Utrecht/Eindhoven/Rotterdam 1975; *Lucassen*, exh. cat., Frans Hals Museum, Haarlem 1973; *Ger van Elk*, exh. cat., Stedelijk Museum, Amsterdam 1975 (English text); *Jan Dibbets*, exh. cat., Stedelijk Museum, Amsterdam 1972 (English text); *Jan Dibbets*, exh. cat., Edinburgh/Bristol/Cardiff/Oxford 1976–77; *Stanley Brouwn*, exh. cat., Van Abbemuseum, Eindhoven 1976 (English text). For more general comments on recent art, see W.A.L. Beeren, *Beeldverhaal*, Amsterdam 1962, and C. Blotkamp, *Na de beeldenstorm*, Amsterdam 1970. A wide background is provided by L. Lippard, *Six Years of Dematerialization of the Art Object*, New York 1974, and T. Richardson and N. Stangos, *Concepts of Modern Art*, Harmondsworth 1974.

List of Illustrations

54). Collection Haags Gemeentemuseum, The Hague

GEERTGEN tot Sint Jans (1460/65–1490/95)
4 *The Holy Kindred* c. 1485. Panel 54⅛ × 41⅞ (137.5 × 105). Rijksmuseum, Amsterdam
9 *The Bones of John the Baptist* 1490–95. Panel 67⅞ × 54¾ (172 × 139). Kunsthistorisches Museum, Vienna

GELDER, Aert de (1645–1727)
52 *Holy Family* 1661. 30¾ × 38 (78 × 95.5). Gemäldegalerie, Staatliche Museen, Preussischer Kulturbesitz, Berlin-Dahlem

GESTEL, Leo (1881–1941)
152 *Tree in Autumn* 1910–11. 44½ × 34½ (113 × 87.5). Collection Haags Gemeentemuseum, The Hague

GHEYN II, Jacob de (1565–1629)
19 *Poseidon and Amphitrite* 1592. 41 × 54 (104 × 136). Wallraf-Richartz Museum, Cologne

GOGH, Vincent van (1853–90)
153 *The Potato Eaters* 1885. 32⅛ × 44⅞ (82 × 114). Rijksmuseum Vincent van Gogh, Amsterdam
154 *View at Arles with Trees in Bloom* 1888. 20⅞ × 25¾ (53 × 65.5). Rijksmuseum Vincent van Gogh, Amsterdam
155 *Still-life with Bottle* 1888. 21 × 24⅞ (53 × 63.5). Rijksmuseum Kröller-Müller, Otterlo
156 *Wheatfields and Crows* 1890. 19⅞ × 39⅝ (50.5 × 100.5). Rijksmuseum Vincent van Gogh, Amsterdam
157 *Wheatfield with a Reaper* 1889. 29¼ × 36¼ (74 × 92). Rijksmuseum Vincent van Gogh, Amsterdam

GOLDEN, Daan van (b. 1942)
185 *Composition with Blue* 1964. 27¾ × 27⅜ (70.5 × 70.5). Stedelijk Museum, Amsterdam

GOLTZIUS, Hendrick (1558–1616)
21 *Juno Receiving the Eyes of Argus* 1615. 51⅜ × 71¼ (131 × 181). Museum Boymans-van Beuningen, Rotterdam

GOSSAERT, Jan, known as Mabuse (1478–?1533)
17 *Venus and Amor* 1521. Panel 14⅛ × 9¼ (36 × 23.5). Koninklÿke Musea voor Schone Kunsten, Brussels

GOYEN, Jan van (1596–1656)
94 *Windmill by a River* 1642. Panel 11⅝ × 14¼ (29.4 × 36.3). National Gallery, London
97 *View of Nijmegen* 1643. Panel 16¼ × 23⅛ (41.3 × 58.7). Walters Art Gallery, Baltimore

HALS, Frans (1581–1666)
55 *The Laughing Cavalier* 1624. 33¾ × 27 (86 × 69). Wallace Collection, London. Crown Copyright
59 *Portrait of a Gentleman* c. 1650. 43½ × 34 (110.5 × 86.5). The Metropolitan Museum of Art, New York. Gift of Henry G. Marquand, 1890
62 *Freyntje van Steenkiste* 1635. 48⅜ × 36⅝ (123 × 93). Rijksmuseum, Amsterdam
65 *Isaac Massa and his Wife* c. 1621. 55⅛ × 65½ (140 × 166.5). Rijksmuseum, Amsterdam
72 *The Banquet of the Officers of the Company of*

St Hadrian 1616. 72 × 105 (183 × 266.5). Frans Hals Museum, Haarlem

HEDA, Willem Claesz. (1599–1680/82)
90 *Still-life* c. 1636. Panel 23 × 31⅛ (58.5 × 79). Frans Hals Museum, Haarlem

HEEMSKERCK, Maerten van (1498–1574)
58 *Pieter Bicker* 1529. Panel 33¼ × 25⅝ (84.5 × 65). Rijksmuseum, Amsterdam

HELST, Bartholomeus van der (1613–70)
66 *Abraham del Court and his Wife* 1654. 67¾ × 57¾ (172 × 146.5). Museum Boymans-van Beuningen, Rotterdam

HENDRICKS, Wybrand (1744–1831)
126 *Interior with a Sleeping Man and a Woman Mending Stockings.* Panel 15 × 13 (38 × 33). Frans Hals Museum, Haarlem

HEYDEN, Jan van der (1637–1712)
105 *The Dam, Amsterdam* c. 1665. Panel 26¾ × 21⅝ (68 × 55). Rijksmuseum, Amsterdam

HEYDEN, J.C.J. van der (b. 1928)
186 *Blue Cross* 1965–66. 78 × 74⅜ (198 × 189). Collection Haags Gemeentemuseum, The Hague

HOBBEMA, Meindert (1638–1709)
107 *View of the Haarlem Lock, Amsterdam* c. 1665. 30¼ × 38⅝ (76.8 × 98.1). National Gallery, London
114 *Wooded Landscape* 1667. 31⅝ × 41⅞ (80.3 × 106). Fitzwilliam Museum, Cambridge

HONTHORST, Gerard van (1590–1656)
34 *The Procuress* 1625. Panel 27⅞ × 40⅞ (71 × 104). Centraal Museum, Utrecht
43 *Christ before the High Priest* c. 1617. 107 × 72 (272 × 183). National Gallery, London

HOOCH, Pieter de (1629–after 1684)
38 *The Mother* c. 1660. 36¼ × 39⅜ (92 × 100). Gemäldegalerie, Staatliche Museen, Preussischer Kulturbesitz, Berlin-Dahlem

ISRAËLS, Josef (1824–1911)
128 *Sad Thoughts* 1896. 22½ × 17⅞ (57 × 45.5). Rijksmuseum, Amsterdam

JONGKIND, Jan Baptist (1819–91)
145 *Street in Nevers* 1874. 21⅜ × 16 (54 × 40). Stedelijk Museum, Amsterdam
149 *La Ciotat* 1880. 12¾ × 21⅞ (32.4 × 55.7). Museum Boymans-van Beuningen, Rotterdam

KALF, Willem (1619–93)
92 *Still-life*. 28¼ × 24¾ (71.5 × 62). Rijksmuseum, Amsterdam

KET, Dick (1902–40)
177 *Still-life with Bread Rolls* 1933. 27⅜ × 24 (69.5 × 61). Collection Haags Gemeentemuseum, The Hague

KETEL, Cornelis (1548–1616)
70 *The Militia Company of Captain Dirck Jacobsz. Roosecrans* c. 1588. 81⅞ × 161⅞ (208 × 410). Rijksmuseum, Amsterdam

KLEIJN, Rudolph (1785–1816)
137 *The Park at Saint-Cloud* 1810. 39 × 51⅛ (99 × 130). Rijksmuseum, Amsterdam

KNIP, J. A. (1777–1847)
136 *Italian Landscape* c. 1860. 35⅜ × 42⅞ (90 × 109). Rijksmuseum, Amsterdam

KOCH, Pyke (b. 1901)
175 *Shooting Gallery* 1931. 66⅞ × 51⅛ (170 × 130). Museum Boymans-van Beuningen, Rotterdam

KOEKKOEK, B.C. (1803–62)
138 *The Old Oak* 1849. 31⅛ × 41⅜ (79 × 105). Collection Haags Gemeentemuseum, The Hague

KONINCK, Philips de (1619–88)
122 *Landscape with Hawking Party.* 52¼ × 63⅛ (132.7 × 160.3). National Gallery, London

KRUSEMAN, J. A. (1804–62)
78 *Adriaen van der Hoop* c. 1835. 49¼ × 39 (125 × 99). Rijksmuseum, Amsterdam

KRUYDER, Herman (1881–1935)
173 *Pig Killer* 1925. 22⅜ × 27⅜ (56 × 68.5). Van Abbemuseum, Eindhoven

LAIRESSE, Gerard de (1640–1711)
50 *The Banquet of Antony and Cleopatra* c. 1680. 29⅛ × 37⅞ (74 × 95.5). Rijksmuseum, Amsterdam

LASTMAN, Pieter (1583–1633)
41 *Odysseus and Nausicaa* 1619. Panel 36 × 46⅛ (91.5 × 117.2). Alte Pinakothek, Munich

LATASTER, Gérard (b. 1920)
182 *The Victor* 1959. 80 × 76 (200 × 190). Van Abbemuseum, Eindhoven

LECK, Bart van der (1876–1958)
166 *Composition* 1918. 39¾ × 39⅝ (101 × 100). Stedelijk Museum, Amsterdam

LELIE, Adriaan de (1755–1820)
124 *The Collection of Jan Gildemeester* 1794. Panel 25⅛ × 33¼ (63.7 × 85.7). Rijksmuseum, Amsterdam

LUCAS VAN LEYDEN (c. 1490–1533)
18 *The Dance Around the Golden Calf* c. 1530. Panel 36⅝ × 26⅜ (93 × 67) centre, 35⅞ × 11⅞ (91 × 30) wing. Rijksmuseum, Amsterdam
56 *Portrait of a Man aged Thirty-eight* c. 1520. Panel 18¾ × 16 (47.6 × 40.6). National Gallery, London

LUCASSEN, Reinier (b. 1939)
191 *A Cosy Corner* 1968. 70⅞ × 95½ (180 × 240). Dordrechts Museum (Collection Bilderbeek-Lamaison)

LUCEBERT (b. 1924)
181 *The Flagon* 1972. 35⅜ × 51⅛ (90 × 130). Stedelijk Museum, Amsterdam

MARIS, Jacob (1837–99)
148 *Allotments near The Hague* 1878. 24⅞ × 21¼ (62.5 × 54). Collection Haags Gemeentemuseum, The Hague

MARIS, Willem (1844–1910)
132 *Ducks* c. 1885. 36⅝ × 44⅛ (93 × 112). Rijksmuseum, Amsterdam

MASTER OF THE VIRGIN AMONG VIRGINS (active 1475–1500)
5 *Madonna Surrounded by Four Female Saints* c. 1495. Panel 48¼ × 40⅛ (123 × 102). Rijksmuseum, Amsterdam

MAUVE, Anton (1838–88)
133 *Donkeys on the Beach* 1874–85. 14¾ × 19 (37 × 48). Museum Mesdag, The Hague

MESDAG, Hendrik Willem (1831–1915)
147 *Sunrise on the Dutch Coast* 1875. 46⅞ × 63 (119 × 160). Museum Boymans-van Beuningen, Rotterdam

METSU, Gabriel (1629–67)
26 *The Sleeping Sportsman.* 16⅝ × 14⅝ (42 × 37). Wallace Collection, London. Crown Copyright

MIEREVELD, Michiel van (1567–1644)
54 *Frederik Hendrik.* 44½ × 34⅞ (113 × 88.5). Rijksmuseum, Amsterdam

MIERIS, Frans van, the Elder (1635–81)
31 *Brothel Scene* 1658. Panel 16⅞ × 13 (43 × 33). Mauritshuis, The Hague

MIJN, George van der (1723–63)
77 *Cornelis Ploos van Amstel* 1748. 21⅝ × 18 (55 × 45.7). Mauritshuis, The Hague

MOLIJN, Pieter de (1595–1661)
81 *Landscape with Cottages* 1629. 14⅞ × 21¾ (37.5 × 55). The Metropolitan Museum of Art, New York. Gift of Henry G. Marquand, 1895

MONDRIAN, Piet (1872–1944)
160 *Summer's Night* 1907. 28⅜ × 44¼ (71 × 110.5). Collection Haags Gemeentemuseum, The Hague
161 *The Red Tree* 1908. 27½ × 39 (70 × 99). Collection Haags Gemeentemuseum, The Hague
162 *Apple Tree in Bloom* 1912. 30¾ × 41⅜ (78 × 106). Collection Haags Gemeentemuseum, The Hague
163 *Composition* 1913. 36⅝ × 25⅜ (93 × 64.5). Van Abbemuseum, Eindhoven
164 *Composition 10: Ocean and Pier* 1915. 33⅓ × 42½ (85 × 108). Rijksmuseum Kröller-Müller, Otterlo
167 *Composition in Red, Yellow and Blue* 1921. 31¼ × 19⅝ (80 × 50). Collection Haags Gemeentemuseum, The Hague
169 *Victory Boogie Woogie* 1943. Oil and paper on canvas 70¼ (178.5) diagonal. From the collection of Mr and Mrs Burton Tremaine, Meriden, Connecticut
171 *Composition* 1930. 19⅞ × 19⅞ (50.5 × 50.5). Van Abbemuseum, Eindhoven

MORO, Antonio (1519–74)
57 *Cardinal Granvelle* 1549. Panel 42⅛ × 32¼ (107 × 82). Kunsthistorisches Museum, Vienna

MOSTAERT, Jan (c. 1475–1555)
7 *Joseph Expounding the Dreams of the Butler and the Baker c.* 1495. Panel 12⅜ × 9⅞ (31.3 × 24.7). Mauritshuis, The Hague

NEER, Aert van der (1603/04–77)
96 *Burning Church.* Panel 14 × 17¼ (35 × 43). Private collection, Eindhoven

NETSCHER, Caspar (1635–84)
68 *Lady with an Orange* 1681. 19 × 15½ (48 × 39). Wallace Collection, London. Crown Copyright

NUIJEN, Wijnand (1813–39)
139 *Landscape with a Ruin* 1836. 39 × 55¾ (99 × 141.5). Rijksmuseum, Amsterdam

OSTADE, Adriaen van (1610–85)

29 *Carousing Peasants c.* 1638. Panel 11¾ × 14¼ (28.8 × 36.3). Bayer. Staatsgemäldesammlungen, Munich

OUWATER, Albert (active 1450–80)
2 *The Raising of Lazarus c.* 1455. Panel 48 × 36¼ (122 × 92). Staatliche Museen zu Berlin

OUWATER, Isaac (1750–93)
123 *View of the Westerkerk, Amsterdam* 1773. 21 × 25 (53.3 × 63.5). The National Gallery of Canada, Ottawa

PIENEMAN, Willem (1799–1853)
130 *The Battle of Waterloo* 1818–24. 226¾ × 329¼ (576 × 836). Rijksmuseum, Amsterdam

PIETER CLAESZ. (1597/98–1661)
88 *Still-life with Herring* 1636. Panel 14⅛ × 18⅛ (36 × 46). Museum Boymans-van Beuningen, Rotterdam

PIJNACKER, Adam (1621–73)
118 *Landscape with Wooden Bridge.* 49⅜ × 42⅛ (125.5 × 107). Rheinisches Landesmuseum, Bonn

POELENBURGH, Cornelis van (1568–1667)
119 *Waterfalls at Tivoli c.* 1620. Copper 9⅜ × 13⅛ (24 × 33.3). Bayer. Staatsgemäldesammlungen, Munich

PORCELLIS, Jan (1584–1632)
82 *Ships on a Stormy Sea c.* 1610. Panel 14 × 26¼ (35 × 67). Hallwylska Museet, Stockholm

REMBRANDT HARMENSZ. VAN RIJN (1606–69)
44 *Simeon in the Temple* 1628. Panel 21⅜ × 17⅜ (55 × 44). Kunsthalle, Hamburg
45 *The Ressurection* 1633. 36¼ × 26⅜ (92 × 67). Alte Pinakothek, Munich
46 *The Conspiracy of Claudius Civilis* 1661–62. 77⅜ × 121⅝ (196 × 309). National Museum, Stockholm
47 *The Wedding Banquet of Samson* 1638. 49⅜ × 68⅞ (126 × 175). Staatliche Kunstsammlungen, Dresden
48 *Jacob Blessing the Sons of Joseph* 1656. 69 × 82⅞ (175 × 210.5). Staatliche Kunstsammlungen, Kassel
49 *The Conspiracy of Claudius Civilis* (drawing). Pen and bistre wash, some white body colour 7¾ × 7⅛ (19.6 × 18). Staatliche graphische Sammlung, Munich
60 *Nicolaes Ruts* 1631. Panel 46 × 34⅜ (116.8 × 87.3). Copyright The Frick Collection, New York
61 *Maria Trip* 1639. Panel 42⅛ × 32¼ (107 × 82). Rijksmuseum, Amsterdam
63 *Self-portrait.* 45 × 37⅜ (114.3 × 95). Greater London Council, The Iveagh Bequest, Kenwood
64 *Titus at his Desk* 1655. 30⅜ × 24⅜ (77 × 63). Museum Boymans-van Beuningen, Rotterdam
71 *The Militia Company of Captain Frans Banning Cocq (The 'Nightwatch')* 1642. 141⅜ × 172⅝ (359 × 438). Rijksmuseum, Amsterdam
73 *The Syndics* 1661. 75⅜ × 109⅞ (191.5 × 279). Rijksmuseum, Amsterdam
99 *Landscape with Thunderstorm c.* 1637. Panel 20⅜ × 28⅜ (52 × 72). Herzog Anton Ulrich-Museum, Brunswick, Germany

ROCHUSSEN, Charles (1814–94)
134 *Kenau Simons Hasselaer at the Siege of Haarlem.* 23⅝ × 17⅛ (60 × 43.5). Stedelijk Museum, Amsterdam

ROELAND, Jan (b. 1935)
194 *Grand Piano* 1972. 59 × 47¼ (150 × 120). Stedelijk Museum, Amsterdam

ROELOFS, Willem (1822–97)
142 *The Rainbow* 1875. 22⅞ × 43½ (57.5 × 110.5). Collection Haags Gemeentemuseum, The Hague

RUISDAEL, Jacob van (1628/29–82)
109 *The Mill at Wijk bij Duurstede c.* 1665. 32⅝ × 39¾ (83 × 101). Rijksmuseum, Amsterdam
111 *Forest Scene c.* 1665. 42⅜ × 56¼ (107.5 × 142.9). National Gallery, London
112 *The Cornfield.* 24 × 28 (61 × 71). Museum Boymans-van Beuningen, Rotterdam
113 *View of Haarlem.* 16⅞ × 15 (42 × 38). Rijksmuseum, Amsterdam

RUYSDAEL, Salomon van (1600/03–70)
89 *River Scene* 1632. 13¼ × 19⅞ (33.6 × 50.5). Kunsthalle, Hamburg

SAENREDAM, Pieter Jansz. (1597–1665)
101 *Interior of the Buurkerk, Utrecht* 1644. Panel 23⅝ × 19¾ (60.1 × 50.1). National Gallery, London
102 *Interior of St Odolphus' Church, Assendelft* 1649. Panel 19⅝ × 29⅞ (50 × 76). Rijksmuseum, Amsterdam

SCHELFHOUT, Andreas (1787–1870)
140 *Dune View with Rustic Hunters.* Panel 27⅛ × 36¼ (69 × 92). Stedelijk Museum, Amsterdam

SCHOONHOVEN, Jan (b. 1914)
183 *Large Relief (Squares)* 1964. Painted papier mâché 40⅝ × 50 (103 × 127). Van Abbemuseum, Eindhoven

SCOREL, Jan van (1495–1562)
8 *The Baptism of Christ* 1528. Panel 47½ × 61⅝ (120.5 × 156.5). Frans Hals Museum, Haarlem

SEGHERS, Hercules (b. 1590 or 1598, active 1633)
98 *Mountainous Landscape c.* 1633. 21⅜ × 39⅜ (55 × 100). Uffizi, Florence

SLUYTERS, Jan (1881–1957)
151 *Landscape* 1910. 19⅛ × 25⅜ (48.5 × 64.5). Van Abbemuseum, Eindhoven

STEEN, Jan (1625–79)
24 *The Life of Man* 1665. 26⅞ × 32¼ (68.2 × 82). Mauritshuis, The Hague
25 *The Morning Toilet* 1663. Panel 25⅛ × 20¾ (64.8 × 52.1). Royal Collection. Reproduced by gracious permission of Her Majesty the Queen
36 *The Skittle Players* 1660–62. Panel 13¼ × 10⅞ (33.5 × 27). National Gallery, London

STEENWIJCK, Harmen (1612–56)
91 *Vanitas c.* 1640. Panel 14⅞ × 15 (37.7 × 38.2). Courtesy Museum De Lakenhal, Leiden

STRUYCKEN, Peter (b. 1939)
188 *Computer-structure 6g-4a* 1969. Perspex 59 × 59 (150 × 150). Museum Boymans-van Beuningen, Rotterdam

Index